Sound Souvenirs

Sound Souvenirs

Audio Technologies, Memory and Cultural Practices

Edited by Karin Bijsterveld & José van Dijck

Amsterdam University Press

The series *Transformations in Art and Culture* is dedicated to the study of histori-cal and contemporary transformations in arts and culture, emphasizing processes of cultural change as they manifest themselves over time, through space, and in various media. Main goal of the series is to examine the effects of globalization, commercialization and technologization on the form, content, meaning and functioning of cultural products and socio-cultural practices.
New means of cultural expression, give meaning to our existence, and give rise to new modes of artistic expression, interaction, and community formation. Books in this series will primarily concentrate on contemporary changes in cultural prac-tices, but will always account for their historical roots.

The publication of this book has been made possible by grants from the Nether-lands Organization for Scientific Research (NWO), the Faculty of Arts and Social Sciences, Maastricht University, and the Department of Media Studies, University of Amsterdam.

Cover design: Frederik de Wal, Schelluinen
Lay out: Het Steen Typografie, Maarssen

ISBN 978 90 8964 132 8
e-ISBN 978 90 4851 058 0
NUR 670

Contents

Acknowledgements

In 2003, the editors of this book started collaborating in a research group called Sound Technologies and Cultural Practices. The group soon generated interest among a number of our colleagues in Europe and the U.S., which ultimately led to a conference and the initial planning for this volume. During the Sound Souvenirs Workshop held in Maastricht in November 2007, one of the participants identified his "favorite line" in one of the papers. The idea caught on and, soon, others followed suit. Together we built up the communal "tune" that resulted in this book. It is hard to express the enormous pleasure of working with such a stimulating group of scholars. We would like to express our gratitude and our thanks to all of them for their cheerful *and* insightful contributions.

We are also grateful to the companies, institutions, and individuals who gave us permission to reproduce the illustrations. Several contributions to the volume have roots in journal articles or book chapters. Parts of José van Dijck's chapter were previously published in *Critical Studies in Media Communication* 25.5 (2006): 357-75. Parts of the third section of Karin Bijsterveld's and Annelies Jacobs' chapter are from Karin Bijsterveld's article, "'What Do I Do with My Tape Recorder...?' Sound hunting and the sounds of everyday Dutch life in the 1950s and 1960s," *Historical Journal of Film, Radio and Television*, 24.4 (October 2004): 613-634. Ruth Benschop has used some short excerpts from an earlier published article in her chapter. That article is "Memory machines or musical instruments? Soundscape compositions, recording technologies and reference," *International Journal of Cultural Studies*, 10.4 (2007): 485-502.

Our deepest gratitude goes to Margaret Meredith who carefully edited our English. Finally, we would like to thank the Department of Media Studies, University of Amsterdam, and the Faculty of Arts and Social Sciences, Maastricht University, for providing financial support for the copyediting, and the Dutch Foundation for Scientific Research (NWO) for funding the Sound Technologies and Cultural Practices project from which this book originated.

List of Figures

Introduction

Karin Bijsterveld and José van Dijck

To Philipp Perlmann, a linguist in the novel *Perlmann's Silence* by Pascal Mercier (2007 [1995]), things have lost their "presence." He seems only capable of fully experiencing life when remembering it, and he clings hopelessly to the sentences his acquaintances have expressed in the past. Because his own academic field has become utterly meaningless to him, he has started translating a text by a Russian colleague on the relation between language and remembering. It is through words, and only through words, the text argues, that people create and construct their memories, thus appropriating, as it were, what has happened. Perlmann cannot but agree with a message that is so close to his personal experiences, yet he is criti-cal about one particular issue. What about people's sensorial memories – are nar-ratives about one's past capable of retrospectively changing sensory perceptions? It is Perlmann's only original contribution to a text he nearly plagiarizes: the key event in the novel's tragic plot.

Perlmann's puzzle touches on the heart of this book. It is not merely through words that people either consciously or involuntarily recall past events and emo-tions, but also through sound and music. These memories of past events include the sensory experiences of having listened to particular recordings and interacted and tinkered materially with the devices that play them. Audio technologies allow people to reopen such experiences. This is one of the practices that particularly fascinated us when we began thinking about this volume. The result is this book about the cultural practices in which people make use of audio technologies to elicit, reconstruct, celebrate, and manage their memories, or even a past in which they did not participate.

In recent decades, the importance of sound for remembering and for creating a sense of belonging has increasingly been acknowledged. We keep "sound sou-venirs" such as reel-to-reel tapes, cassette tapes, and long-playing albums in our attics because we want to be able to recreate the music we once cherished and the everyday sounds that were once meaningful to us. Artists and ordinary listeners deploy the newest digital audio technologies to recycle past sounds into present tunes. Sound and memory are inextricably intertwined with each other, not just through the repetition of familiar tunes and commercially exploited nostalgia on

oldies radio stations, but through the exchange of valued songs by means of pristine recordings and recording apparatuses, as well as through cultural practices such as collecting, archiving, and listing. In this book, several types of cultural practices involving the remembrance and restoration of past sounds will be explored, including popular appropriations such as the digital simulation of analogue sounds, and more artistic forms of appropriation in soundscapes. At the same time, the cultural meaning of collecting, recycling, reciting, and remembering music and everyday sounds will be theorized and elaborated upon.

Over the past few years, a number of interesting scholarly books and special journal issues have come out on the subject of sound technologies and cultural practices (Bull 2000; Day 2000; DeNora 2000; Lastra 2000; Morton 2000; Alderman 2001; Taylor 2001; Braun 2002; Pinch and Trocco 2002; Bull and Back 2003; Sterne 2003; Van Dijck and Bijsterveld 2003; Lysloff and Gay 2003; Bijsterveld and Pinch 2004; Erlmann 2004; Katz 2004; Philip 2004; Greene and Porcello 2005; Ayers 2006; O'Hara and Brown 2006; Haring 2007; Auslander 2008 [1999]). None of these books, however, focuses specifically on the relations between sound, music, and memory. On the other hand, a large number of scholarly books on cultural memory have been published, but these rarely address sound because auditory factors are both underestimated and under-theorized as constitutive of remembrance. This book aims to bridge this gap by focusing on audio technologies in relation to personal and collective memory.

Sound Souvenirs and Audio Technologies

The notion of sound souvenirs is commonly associated with the cherished tapes and albums we keep in our attics. Originally, however, the term "sound souvenirs" – coined by the Canadian composer and environmentalist Raymond Murray Schafer in the 1970s – had less straightforward connotations. "Sound souvenirs" did not make it into the glossary of terms in Schafer's seminal work *The Soundscape: Our Sonic Environment and the Tuning of the World* (1994 [1977]). Yet, Schafer used it in passing for endangered sounds, such as the sounds of pre-industrial life, that could be captured by recording technologies or stored in archives, and thus remembered after their extinction (Schafer 1994 [1977], p. 240).

To Schafer, however, recording technologies also had a dark side. These devices could blow up the sounds they packaged, and therefore contribute to the problem of noise pollution. "We have split the sound from the maker of the sound. Sounds have been torn from their natural sockets and given an amplified and independent existence" (Schafer 1994 [1977], p. 90). His name for "the discovery of packaging and storing techniques for sound and the splitting of sounds from their original contexts" was "schizophonia" (Schafer 1994 [1977], p. 88; Benschop 2007). This

term *did* make it into his glossary, which underlined Schafer's anxiety about the downsides of recordings.

In this book, we will occasionally encounter sound souvenirs as "noise." In the 1960s, teenagers started to play their sound souvenirs on portable cassette players in public space – souvenirs that others would merely perceive as noise. Yet our main focus is on the role of recorded and electronically amplified sound in individual and collective memory practices involving sounds of the past. The sound souvenirs we will discuss are both musical and non-musical in character. The content of the various contributions suggests, however, that recorded music has been, and still is, far more popular in people's everyday mnemonic practices than non-musical recordings, such as recordings of family events. None of the authors addresses this difference explicitly. Still, the empirical data they present suggest that listening to recorded music to remember and relive past experiences can be embedded more easily in existing cultural practices, such as radio listening while commuting, than listening to recordings of non-musical events. Moreover, the need to understand the often hardly self-evident sonic details of what one is hearing in a recording of everyday family sounds seems to preclude rather than foster easy access to and reconstruction of one's past. In contrast, music's ability to elicit highly personal emotions and associations seems to help people to relive their past over and over again.

Perhaps the inverse relation between sound and memory can help us understand an intriguing finding – the finding that people use recorded music more often than recordings of everyday sounds as a way of gaining access into their memories. Both recorded and unrecorded sound can trigger and help to recall memories, but how easily do people remember sound and music without using recordings? People have remarkable capacities in recalling music. Actively remembering everyday sound and voices seems to be much harder to remember, however. Neurologist Oliver Sacks observes in *Musicophilia* that his spontaneous musical imagination – his mental remembrance of music – is highly detailed and varied. During his life, he also must have heard the barking of countless dogs or the humming of endless traffic. Yet, these sounds do not pop up as a mental background to past events in the way music does (2007, pp. 48-49). Historian of psychology Douwe Draaisma also stresses that people have great difficulty in recalling voices as time passes by.[1] People may *recognize* voices of the past, but that is not the same as *mentally imaging* voices.[2]

Sacks' explanation of this is that we can reconstruct our memories of visual and social situations in hundreds of different ways, but that the remembrance of music simply *has* to be close to the original – it has come to us in a fully constructed way. Sure, we listen selectively, with different interpretations and emotions, yet the musical characteristics and structure of a composition, such as its tempo, rhythm, and melodies, are often carefully stored in our minds (Sacks 2007, p. 55). As the

musicologist Huron (2006) has recently shown in *Sweet Anticipation*, listeners can often pinpoint the precise moment in a particular musical composition that elicits particular emotions and memories. Why this is the case is an issue of ongoing discussion in the fields of neurology and music cognition. But it may be the *combination* of the structural exactness of our memory of musical composition and the high variety of individual associations elicited by music that make music recordings such a popular tool for eliciting the past in people's mind.

The audio technologies discussed in the subsequent chapters include both older and newer ones: radios, reel-to-reel recorders, cassette recorders, transistor radios, and iPods. In addition to these playing devices, we'll also come across speakers, analogue amplifiers, digital audio storing formats, as well as electronic musical instruments such as the theremin. Because these technologies also play a significant role in people's dealings with the past and their memories, we have stretched the original meaning of audio technologies slightly in order to include all artifacts that enable people to listen to the sounds of the past. In only one contribution to this volume the focus is on memory and sound rather than recorded sound. In this chapter (by Carolyn Birdsall) audio technologies are absent. It concentrates instead on how sound can trigger memories, or how sound is uttered when words are insufficient to express a particular past experience (see also Lethen 2005). Although the reader will find this contribution in the last section of the book where we bring together contributions that focus on "earwitnessing" World War II, it may be worthwhile reading this chapter before the chapters on recorded sound.

Memory

Whereas the connection between memory and sound has been under-theorized in studies focusing on music and audio technologies, the role of audio perceptions and audio technologies has been even more seriously neglected in cultural theories of memory. In recent years, various scholars have examined the meaning of material artifacts and immaterial sensory perceptions in people's acts of remembering. Most studies tend to assume a natural division between individual memory and collective memory. But how "natural" is such a division?

The study of what constitutes individual (personal or autobiographical) memory has traditionally been the domain of psychologists and cognitive scientists. American psychologist Susan Bluck (2003) contends that autobiographical memory has three main functions: to preserve a sense of being a coherent person over time, to strengthen social bonds by sharing personal memories, and to use past experience to construct models for understanding the inner self in relation to others. Anthropologists and social psychologists have duly emphasized the cultural dimension as a constitutive factor of individual remembering, particularly the role of narratives in people's act of remembering (Nelson 2003, Wang and Brockmeier

2002). Through contributions of philosophers like Annette Kuhn (2000), we have learned the significance of cultural artifacts like photographs as a means for autobiographical reminiscence. Individual memory has been analyzed in some of its sensorial manifestations, particularly visual and verbal, but very few of these studies touch upon the role of sound. Some empirical cognitive studies examining the impact of music on the human ability to recall past experiences have yielded interesting results (Schulkind, Hennis, and Rubin 1999). However, "sound souvenirs" remain unexplored territory in contrast to the adequate recognition of photographs as mnemonic devices in academic scholarship.

A similar observation can be made when looking into theories of collective memory, also known as "social" or "public" memory. Just as individual or autobiographical memory is the designated domain of psychologists, collective memory has been the privileged area of historians and sociologists. Maurice Halbwachs, a student of Henri Bergson and Emile Durkheim, coined the term "collective memory" in 1925. According to Halbwachs, memory needs social frames connecting the individual to larger social circles such as family, community, and nation. As social creatures, humans experience events in relation to others, whether or not these communal events affect them personally. Thus, individual and collective memory are always closely connected (Halbwachs 1992). Halbwachs' theory has been embraced by many contemporary historians who have expanded his terminology into "new" territory characterized by a plethora of communicative forms: exhibitions, monuments, museums and, most prominently, mass media such as film and television (Hoskins 2001). Personal testimonies, like Holocaust survivors' diaries or photographs, are prominently displayed and thereby becoming public benchmarks of collective memory. Just as in theories of individual memory, we can observe a similar and understandable emphasis on visual media that serve as aids for collective memory. Very few cultural historians have singled out auditory manifestations as building blocks in the construction of historical collective identity (Kenney 1999).

One of the most intriguing features of contemporary memory theories is their common interest in media and media technologies. The "mediation of memory" has long been viewed as a prime source of mnemonic corruption. From the days of Plato, who considered the invention of writing and script as a degeneration of pure memory (i.e., untainted by technology), every new means of outsourcing our physical capacity to remember has generated resentment and suspicion. Both historians and psychologists have been influenced by a Platonic assumption of a sharp delineation between the human ability to remember and the technological potential to corrupt or enhance this ability. In recent years, science and technology studies scholars and cultural theorists have convincingly argued for the constitutive role of technological devices in the social practices of everyday life. Technologies, especially certain audio technologies, have become an intrinsic part of our

acts of remembrance, of individual and collective processes of remembering (Van Dijck 2007).

Cultural Practices

This intricate relationship between technology and remembrance has inspired our focus on the cultural practices of remembering that have originated around new audio technologies. Because of this focus, our interdisciplinary approach is closer to the fields of cultural history, anthropology, media studies, and science and technology studies than it is to psychology, neurology, or music cognition. We define "cultural practices" as the ways in which people are used to doing things and commonly attribute meanings to these routines. Both today and in the past, the invention of specific analogue audio technologies inspired new cultural uses of saving sounds for future reminiscence, such as creating family sound albums or making gift tapes. More recently, digital technologies confront us with new standards of professional recording and storing, while also forcing us to rearticulate definitions of auditory cultural heritage.

Phrasing the relationship between audio technologies and cultural practices in this way brings us to the notion of the appropriation of new technologies. With the introduction of new audio technologies, manufacturers usually advertise new use options which they aim to embed in both well-established and newly imagined cultural practices. How users appropriate the audio technologies in their everyday lives is never self-evident, however. Whereas the chapter by Karin Bijsterveld and Annelies Jacobs on the reel-to-reel recorder shows that manufacturers imagined a wider set of use options than users were willing to adopt, Heike Weber's contribution on mobile radio and cassette recorders illustrates how users were rather more creative in designing new and unanticipated use options. Such actual usages may, in turn, reshape the design of the audio technologies at stake (see O'Hara and Brown 2006, p. 4).

This book is divided into four sections. Each section covers a specific intersection of audio technologies, memory, and cultural practices and interweaves theory on sound technology and memory with concrete historical and contemporary case studies. The sections address, respectively, "storing sound," "auditory nostalgia," "technostalgia" and "earwitnessing." By selecting these four topics we do not claim to cover all memory practices related to audio technologies. However, we *do* aim to contribute to what Thomas Porcello has coined "techoustemology," a notion that foregrounds "the implication of forms of technological mediation on individuals' knowledge and interpretations of, sensations in, and consequent actions upon their acoustic environments as grounded in the specific times and places of the production and reception of sound." Porcello has derived this notion from "acoustemology," the contraction of "epistemology" and "acoustics" used

by Steven Feld to describe how the members of a non-Western nation understood their world in terms of sound (Porcello 2005, p. 270). Like Porcello, we study the role of mediating technologies in how people understand sound. Yet in contrast to his work, we will focus fully on how people use mediated sound for remembering the past.

Storing Sound

Although over the past decades, the number of technologies that enable us to record and retain sound have expanded enormously, the cultural practices of archiving and retrieving our sound souvenirs have elicited far less scholarly commentary than playing and listening to recorded sound. As many of the chapters illustrate, the cultural practices of archiving and retrieving have intriguing consequences for remembering. We will dive into the history and "philosophy" of archiving sound recordings with Karin Bijsterveld and Annelies Jacobs' chapter and Jonathan Sterne, respectively.

The first two authors show how retracing audible memories and keeping personal sound souvenirs of family events on magnetic tapes in the 1950s and 1960s involved such a complex endeavor that it hampered a straightforward domestication of the reel-to-reel recorder. Their contribution also illustrates how the marketing of new cultural practices (creating family sound albums) in terms of existing cultural practices (creating family photo albums) could fail. This often happened when manufacturers had only a limited imagination of the practical details, skills, customs, and symbolic values implied in particular use options.

Jonathan Sterne, by contrast, questions the very meaning of preserving whatever we can record as such. We may well convert all sound souvenirs we have stored on analogue formats into digital ones, but what are the consequences? Are we really able to preserve everything endlessly in this manner? If not, what does this imply? Or, if indeed we can, does that really leave us with fewer problems in our management of the past? Sterne lures the reader into the paradox of preservation and offers the reader a way out by providing an answer that may actually be a relief to those who fear losing their grasp of the sonic past.

Between these two chapters, Bas Jansen offers an analysis of the mediation of memories through the practice of creating cassette mix tapes, often meant to serve as a gift of stored sound to a beloved person. This chapter is situated historically between the rise of the analogue tape recorder and digital technologies. Jansen makes the cultural meaning of mix taping understandable by unraveling the material, artistic, and identity issues connected with this cultural practice. He gives particular attention to which versions of their former selves the makers of mix tapes encounter when listening to the tapes they created in the past.

Auditory Nostalgia

Four of the chapters are dedicated to the connection between portable audio tech-
nologies and musical reminiscence. Recording devices, from the radio-cassette
player to the Apple iPod, epitomize the inclination of people to create personal-
ized auditory realms while moving through urban settings. Traversing space and
time, portable stereos also serve as auditory mnemonics – personalized apparatus-
es which help recreate past experiences. When it comes to popular music, audito-
ry nostalgia is also mediated through narratives and emotional affects, a reflex
perfectly understood by the commercial music industry exploiting this reflex in
"classic rock" and "oldies" stations.

In chapter 4, Heike Weber singles out the cultural practice of mobile listening.
From the 1950s onwards, portable audio technologies have shaped the auditory
memory of young people. An entire generation re-shaped previous listening cul-
tures by normalizing certain forms of mobile listening practices. This chapter con-
centrates on the West German consumer context, highlighting three key portable
technologies in consecutive historical phases: the portable radio, the radio cas-
sette recorder, and the Walkman. Weber argues that subsequent mobile audio de-
vices enabled different modes of combining technical and cultural use, such as the
rewind and the forward mode, fostering both individual identity and group be-
longing. Drawing examples from consumer magazines and marketing surveys,
she explores the nexus of social practice and technological-push strategies.

From the historical practices of integrating mobile audio technologies in every-
day routines, we turn to the latest novelty in digital audio sensation. In just a few
years, the iPod has become a symbol of contemporary youth culture. Michael Bull
explores how iPod listening has become an integral part of reminiscing. In fact,
users of MP3 players deploy a strategy of control: the transcendence of time and
place through evoking various forms of auditory nostalgia. Drawing on inter-
views with hundreds of iPod users, he observes how these little devices allow them
to turn inward while on the move – creating an interiorized universe of their own
making, enclosed safely within their private auditory soundscape. The nature of
this privatized, auditory nostalgia is subject to scrutiny in Bull's analysis of respon-
dents' reported experiences of iPod use.

Auditory nostalgia is not only re-lived through recording devices; live perform-
ances of 1960s music are at the heart of an American phenomenon described by
Timothy Taylor. In his chapter, we enter the "oldies circuit" of doo-wop bands in
New Jersey, whose performances are welcomed by scores of aged fans who are
faithful patrons of these bands' concerts. The obvious affection they show toward
this music is a result of a complicated mixture of nostalgia for times past and a lost
youth. Beyond personal nostalgic yearning for the 1960s, the music has also come
to signify a moment in American history when many people felt that racial integra-

tion could be peacefully achieved, in sharp contrast to the kind of hard-edged racial dynamics frequently articulated in today's hip-hop music. Connecting personal and collective auditory nostalgia, Taylor opens up a cultural-historical window on the world of doo-wop.

Auditory nostalgia is indeed created in the public spaces between individuals and communities where memory gets shaped and negotiated. José van Dijck addresses the convergence of individual and collective memory by analyzing the *Top 2000* in the Netherlands. Every year between Christmas Day and New Year's Eve, millions of people vote for their favorite popular song, and swamp the radio station with stories of how music triggers their fondest or deepest memories. This process of narrating, discussing, and negotiating personal musical reminiscences and collective musical heritage, as Van Dijck argues, is far more important than the ultimate ranking of songs.

Technostalgia

Why do people treasure the sound of analogue amps or worn-out electronic guitars in the digital age? Why do musicians take the effort to put the theremin, a cumbersome electronic musical instrument from the 1920s, on stage when they could also use an up-to-date and user-friendly synthesizer? And what messages do pop songs convey that take the 'old-fashioned' transistor radio as object of veneration?

The answer is "technostalgia" in several varieties, as the third section of this volume clarifies. Andreas Fickers analyzes the different ways in which the transistor radio has been represented in pop songs – old songs that give a contemporary comment on the transistor radio *and* in songs that present the songwriter's memories of the transistor radio. Both types of songs can be considered forms of sonic cultural heritage that contribute to the living memory of the transistor radio. Only a part of this living memory is technostalgic in the sense that it taps into the bittersweet longing for a past technology. Many of the other songs are better captured by using the term "technomelancholia," as Fickers explains in his chapter.

Technological nostalgia is not simply restricted to recording devices and popular music, but also relates to musical instruments and staged performance. At first sight, the recent revival of the theremin appears to be rooted in a straightforward form of "technostalgia," since the initial success of this musical instrument and its remarkable sound in the 1920s and 1930s was short-lived. Yet Hans-Joachim Braun argues for explanations that go beyond technostalgia, leading us along phenomena as distinct and intriguing as the performative turn in the arts, the re-mystification of music, and the rise of a new virtuosity.

Even the run on vintage gear in pop music, Trevor Pinch and David Reinecke

claim, cannot be seen only as a "desired return to an ideal past in response to a troubled present," as mere technostalgia. Relic guitars, analogue amplifiers, and old synthesizers stand for much more than keeping the sonic memory of admired pop musiciams alive and kicking. It is, indeed, all about sound – the sounds of the past and the sounds of the future.

Earwitnessing

The fourth and last section of our book features two contributions, by Carolyn Birdsall and Ruth Benschop, both of which focus on "earwitnessing" World War II. While Birdsall presents sound memories of the Nazi period as expressed by German survivors, and thus by earwitnesses of the war, Benschop discusses how the makers of artistic soundscapes construct the war's sonic past in such a way that the soundscapes function as authentic earwitnesses that evoke a historical sensation among the audience. The paradox is, however, that this authentic resounding of the past, this re-enactment of the war, can only be attained with the help of non-authentic recording technology. How does soundscape art manage to deal with this tension? With this question which drives Benschop's analysis, we have returned to the double connotation of sound souvenirs – treasured sounds that can be preserved with help of recording technology, but are threatened by the very same technology – expressed by Raymond Murray Schafer's debts to and doubts about sound souvenirs.

Conclusion

Philipp Perlmann relives his memories of past events more intensely than he experienced them as they actually occurred. Thus, the past is more "here" than the present. The loss of the present keeps bothering him, however, and he does not find a satisfying solution to his problem. Many of the respondents interviewed by the authors of chapters in this volume seek to do the opposite. They consciously elicit the emotion of nostalgia – longing for a past they cannot directly return to – through listening to recorded music and sound. To them, the past is less "here" than the present, but they seem to be able to cope with it: they try to control the inaccessible by using audio technologies.

 Working on this book has given both the editors and the authors many opportunities for identification, as we shared the thoughts and experiences gained during our research in early November 2007, when we collectively discussed the chapters for this book. We hope our readers will experience this as well. Although the book positions itself at the crossroads of media theory, science and technology studies, and cultural studies, we expect most readers from other backgrounds to be able to relate to the technologies and practices we describe. The case studies in

each of the twelve chapters relate to the authors' various cultural or national backgrounds. They, however, evoke ubiquitous recognition, even if the authors came from seven different countries. For scholars interested in audio technologies and memory, each individual case study appeared as a unique way to communicate trans-generational experiences between the authors whose age varied from twenty-six to over sixty. Our common interest in audio technologies, memory, and cultural practices transcended national or age-related boundaries, and if this book shares a tiny part of our enthusiasm with its readers, we will be more than a little satisfied.

Notes

1. Douwe Draaisma made this claim in his presentation about sound and memory at the Symposium on Sound Souvenirs (10 November 2006, Maastricht), entitled "Het menselijke geheugen en herinneringen aan geluid."
2. See for a similar difference in recalling or imaging timbre and recognizing timbre: Fales 2005, p. 162.

Part I
Storing Sound

Chapter One

Storing Sound Souvenirs: The Multi-Sited Domestication of the Tape Recorder[1]

Karin Bijsterveld and Annelies Jacobs

Introduction

Loek van IJzendoorn, a Dutch Philips employee caught by the fever of recording, purchased his first reel-to-reel recorder in the mid-1960s. With all the wires attached to the recorder, the device "looked dreadful," so he locked it behind the closed doors of a cupboard in his living room. He bought the reel-to-reel mainly to record radio music. Late each evening, Van IJzendoorn would sit down and wait for hours for the best German stereophonic radio programs to be broadcast. At that time, however, the electric energy radiated by cars, mopeds, and scooters still interfered with the reception of his radio, and thus with the recording process. A moped passing by would completely ruin his recording. "Yes, I used quite a bit of bad language. You had to stop the recording, rewind, and then wait for the next song." In a notebook, he carefully listed what he had recorded – what song could be found where on which tape. But after losing the notebook, he had a hard time finding his former favorite songs again: the sequential character of the tapes made searching a time-consuming affair – his compact disks were much easier to work with (Interview 5, p. 15, 1, 12).

Van IJzendoorn was a recording enthusiast. At the same time, his story shows some of the problems involved in using magnetic reel-to-reel recorders, such as finding a good place for the device and retrieving the tapes' contents after producing the recordings. Van IJzendoorn's experiences reflect some of the reasons the magnetic reel-to-reel recorder, introduced to mass consumers in the late 1940s, never became the commercial hit manufacturers had dreamed it would be. Manufacturers aimed to position the reel-to-reel as a device clearly distinct from the gramophone and the radio. Their marketing departments promoted it as an

acoustic family album, a device that consumers should actively and creatively use. The recorder was not meant to be yet another instrument for replaying music which users would listen to passively.

From the late 1950s onwards, this marketing strategy shifted as recording and replaying music acquired a more dominant position among the array of options promoted by manufacturers. Moreover, manufacturers fanatically introduced more and more ideas for using the recorder. Most users, however, only partially or temporarily accepted these options and increasingly turned to the reel-to-reel to do precisely what the producers wished to prevent: its use as a music recording and replaying device. In contrast to the cassette tape recorder, which became very popular in the 1960s, the reel-to-reel audio device never was adopted or domesticated in the way originally hoped for by manufacturers (Weber 2008). Why didn't this happen?

This chapter will confront the manufacturers' intended purposes of use with the cultural practices of reel-to-reel users. The research for the paper is based on the archives of the recorder manufacturers Philips and Grundig, tape producer BASF, and several sound hunting societies, as well as interviews with two groups of reel-to-reel recorder users: "regular" users and users who treasure their family recordings.[2] By analyzing the producers' advertisements using concepts derived from domestication theory, we will show how ambivalent the spatial and social positioning of the reel-to-reel recorder was in the domestic context. In addition, the archives of the sound hunters societies and interviews with everyday users provide insights in users' appropriation of the reel-to-reel recorder, or "tape recorder," as the device was commonly called in the Anglo-Saxon world.

Our claim is that the domestication of the tape recorder was a *multi-sited* one, which, when viewed in this way, uncovers the often-contested nature of the activities allowed in domestic spaces, such as the living room and the kitchen. The limited success of the reel-to-reel tape recorder, however, is also due to the complexity of *storing and retrieving recordings as traceable memories*. By taking this issue into account, we broach a topic that has clearly been understudied thus far, both in media studies as well as in science and technology studies (STS). Making traceable memories is one thing, storing and retrieving them is quite another.

Domestication Theory

In STS, the domestication of technology refers to processes in which new technologies gradually acquire a familiar embedding and function in everyday life. The notion originally stems from cultural and media studies, which focus on the cultural appropriation of technology through symbolic exchange. Such studies stress the symbolic value of material things "as sources and markers" of social relations and identities, and the cultural expertise and creativity of consumers in ac-

tively making consumer goods the constituents of their performed identity (Ouds-hoorn and Pinch 2003, pp. 12-13).

In the British version of domestication theory, scholars analyze how house-holds communicate their status to the outside world with the help of devices they buy for their home. Roger Silverstone, for instance, distinguishes four phases in the domestication process: appropriation, objectification, incorporation, and conversion. "Appropriation" entails the process of buying an object. "Objectifi-cation" refers to the ways in which households express their norms and desired so-cial status through the display of it. "Incorporation," then, is what happens when household members incorporate an object into their everyday practices, and "conversion" refers to the role of the device in the relationship between its owners and persons outside the owners' households (Silverstone and Hirsch 1992). The combined result is a "process in which both technical objects and people may change. The use of technological objects may change the form and the practical and symbolic functions of artifacts, and it may enable or constrain performances of identities and negotiations of status and social positions" (Oudshoorn and Pinch 2003, p. 14).

Scholars from STS have extended this type of research to other domains by claiming that domestication theory should not only be applied to the study of arti-facts in the home, but also to the use of technologies outside the home, such as at work and during leisure time (Lie and Sørensen 1996). This shift and the subse-quent merger between domestication theory and user-oriented approaches to technology have proven to be very fruitful for STS. One particular downside of this shift, however, has been the neglect of the original distinction between the four phases of domestication. Nevertheless, these distinctions offer important insights for the study of domestication processes involving artifacts largely intended for home use.

Since the reel-to-reel tape recorder is such a device, we will examine its domes-tication employing Silverstone's terminology, notably objectification, incorpora-tion, and conversion. We will also analyze the symbolic, practical, and cognitive work that Silverstone considers part and parcel of what users do during the do-mestication of new devices, that is, create meaning, create forms of use, and learn about the object. However, we want to add two items to this approach. First, and in line with the more traditional STS focus on technology design, we will begin by looking at the variety of uses the manufacturers intended the reel-to-reel tape recorder to offer. Second, we will also consider the array of alternative forms the device's domestication took by examining the tensions between the ways in which manufacturers and users displayed it.

In doing so, we will show the *multi-sited domestication* of the tape recorder. In many of the seminal examples of domestication research, new technologies such as the gramophone and the radio became fully domesticated showpieces of furni-

ture. Television even became the new "electronic hearth of the house" (Tichi 1991). The tape recorder never acquired the position of television as the home's fireplace, but neither did it acquire the basement-and-attic status of the two-way radio sets of radio hams (Haring 2007). Instead, we found that it was positioned at many locations in the house, due to the often contested nature of domestic space, a situation which has been acknowledged by domestication theorists, but rarely explored empirically.

The Manufacturer's Dream: The Family Sound Album and Other Use Options[3]

Prior to the 1950s, tape recorders were almost exclusively made for professional and semi-professional markets. In 1953, Philips, already the leading Dutch electronics company, introduced its first tape recorder for consumers: the *EL 3530* was a two-track recorder that operated on a fixed electricity supply and came with a price tag of 740 guilders.[4] A year later the company put a portable battery-operated recorder on the market (Purves 1962, pp. 31-34). In 1958 Philips became the first company to develop and market a stereo tape recorder, a feat that was followed eight years later with the introduction of the first radio-cassette recorder.[5]

In 1960, one could find a tape recorder in 6.4 percent of Dutch households. Five years later this figure had risen to 12.3 percent. However, this was also including sales of the compact cassette recorder introduced in 1963.[6] The mix of both types of recorders in the figures makes a comparison over time difficult. It is clear, however, that the sales figures, which were not substantially higher in other European countries, disappointed Philips. Comparing the percentage of households with a tape recorder to the percentage owning a gramophone (40 percent) triggered the company's pessimistic forecast that the tape recorder was probably not going to make it.[7]

At first sight, it is tempting to trace the low sales rates of the tape recorder to its relatively high price at over 700 guilders. Magnetic tapes were costly as well.[8] In the mid-1950s, a Philips gramophone cost less than 200 guilders, a Philips portable radio 175 guilders, and a Kodak camera between 175 and 230 guilders. Price cannot be the sole explanation, however. A comparison with the television is instructive. Consumer television sets and tape recorders both entered the Dutch market in the early 1950s, when even the cheapest television set was still about 1000 guilders (Jacobs 2006, pp. 25-26). Yet, in 1960, already 34 percent of Dutch households owned one, a figure which rose to 75 percent in 1966 (Bezit 2000). Explaining the difference in the commercial success of the television and reel-to-reel tape recorder by referring to the visual character of Western culture would not be very convincing either, since that would render the pervasiveness of the gramophone and radio incomprehensible.

It is therefore becomes relevant to analyze how manufacturers promoted the tape recorder. How, exactly, was the device's future owner supposed to put it to use? Remarkably, the tape recorder was not marketed primarily as a music-playing device. On the contrary, the industry's initial advertisements, leaflets, and tape recorder guide books presented it as a device with a host of options, of which playing music was merely one.[9]

In most cases, the family sound album topped the list of things to do with a tape recorder. The function of such a "talking family album"[10] was to record precious moments of family life, such as "little John's first speech," and then sharing the tape with "relatives, friends, and acquaintances living elsewhere."[11] Every family, after all, had one or more albums with photos of important or happy moments. From now on, Philips argued, these memorable moments could be relived more completely, thanks to "a faithful reproduction of all that was said and done, played and sung."[12] The tape recorder, in other words, was introduced as a family "memory" device (Lloyd 1975 [1958], p. 9). "Even though your constantly crying and screaming baby may almost give you a nervous breakdown, I do not want to refrain from advising you to record this sound," as the author of a guide book put it (Koekoek 1968, p. 91). The sound of grandpa snoring, another handbook claimed, was another eligible moment for recording (Van Bussel 1965). In a 1962 Philips ad, the significance of saving audible memories was pushed even further: "Treasure her songs in front of the chimney.... What a bounty of memories gets lost as children grow up. It is really a shame.... You should be able to save it all. Forever."[13]

The notion of the sound tape as a family album, as David Morton (2000) rightly observes, implied a comparison between sound recording and amateur photography. This analogy was also made explicit in tape recorder guide books: playing sounds out loud was like blowing up a photo; the sound level indicator could be compared to the light meter, and the recorder was to the sound hobbyist what the camera was to the photographer. But, according to a handbook published by Philips, the advantage of the tape recorder over the photo camera was that the sound "print" was readily available, while it could also be erased at all times (Nijsen 1964, introduction). Moreover, the book emphasized that sounds carried more meaning than photos. As one importer of Grundig recorders asserted, the power of sound was "that it remains vivacious and binds people together more forcefully than any picture. In a person's voice we encounter his personal moods; in the sound of a running machine we can hear force and speed; the sound of birds connects us with nature."[14] The sounds of a vacation, the author of a guide book claimed, "may engulf and entirely absorb you again; you do not only hear it again, you *experience* it all over." (Koekoek 1968, p. 93)

Other possibilities that were promoted for tape recorder use at home were creating voice letters for family overseas, rehearsing lectures or amateur music per-

formances, and making radio plays (Bijsterveld 2004). In the course of time, the list of tape recorder functions grew from dozens to hundreds. Remarkably, the position of music within the burgeoning list of use options shifted substantially. At first, recording radio programs was mentioned as one use among many. A radio recording offered the opportunity to listen to your "favorite melody" or "favorite lecture" over and over again.[15] You might even use the tape recorder to put together your own music collection (Knobloch 1963 [1954], pp. 152-54). BASF encouraged consumers to put their tapes in cases on bookshelves, next to a "row of 'classics'"; after all, listening to a self-recorded tape could be "as pleasant" as reading "good books."[16] From the late 1950s on, though, recorded music increasingly topped the list of things to do at home with a tape recorder. It was also promoted as a means to provide several hours of nonstop background music during a dance party at home.[17] The introduction of the stereo tape recorder stressed the role of music even further: the rich sound of a complete orchestra could now be spatially reproduced in one's living room.

In addition, advertisements emphasized the uniqueness of making outdoor recordings and bringing home sounds from elsewhere, such as the sound of a street organ, a military parade, or guitar playing at a campsite or a picnic with your sweetheart. This particular use of the tape recorder was highlighted in the Philips ad campaigns that accompanied the introduction in 1961 of what was for that time an exceptionally compact portable transistor-battery recorder, the $EL\ 3585$ – a highly successful product.[18] Again, music proved to be an important selling point. "Popular-music fans," so went one ad, "can now record and replay concerts and jam sessions and all their favorite music *wherever* they like."[19] Subsequent ad campaigns increasingly relied on pictures of youthful people in outdoor situations: a young couple in a sailboat, attending a boat race or near a car, their portable tape recorder always at their side.[20]

Over time, the promotion of the tape recorder's multiple options was carried to great extremes. Apparently, the recorder's usefulness had to be established against all odds, for tape recorder books also highlighted, exasperatingly so, that after an initial period of great enthusiasm, many people no longer knew what to do with their tape recorders. "'I bought it on impulse for my family, but after some time of using it the fun wore off. After all, you cannot go on making recordings of Frits's nursery rhymes and little Margot's recorder tunes…. And recording living room conversations becomes tedious quite soon as well,"' read the first lines of a guide book (Gobits and Broekhuizen 1969 [1964], p. 5). This and other publications underlined that the tape recorder, unlike the gramophone, radio, or television set, did not produce sounds automatically, and their quality depended on the effort and creativity of the user, the hidden secret for user satisfaction. "So don't begrudge the little bit of effort it costs to get all your machine has to offer," a Philips handbook explained (Purves 1962, pp. 131-32). As an importer of BASF tapes

stressed, creativity and effort were needed to raise the tape recorder above the level of the music box, and turn it into a "musical instrument" that managed to enthrall "player" and "listener" alike.[21]

In other words, users had to *work* with the tape recorder. Consequently, authors of tape recorder books discussed extensively microphone positions, music recordings, outdoor recordings, tricks, reverberation, tape speeds, editing, reel sizes, the options of two- and four-track recorders, plugs, cables, splices, and the role of dust or dirt on tapes. In a series of ads for sound tapes in *Radio Electronica* in the early 1960s, Philips targeted men exclusively. It was imperative, the ad claimed, that they start "tinkering" and experimenting with sound again.[22]

It is understandable why manufacturers stressed the need for active involvement with the tape recorder. Had they promoted it as an ordinary music machine, the reel-to-reel recorder would have lost out to competition with the gramophone and radio for being less user-friendly and more expensive. However, the manufacturers' emphasis on the creative use of the tape recorder and the endless lists of user

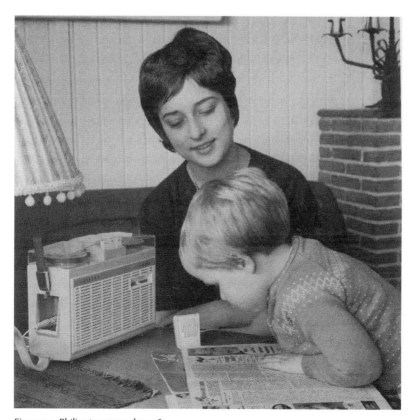

Figure 1.1 - Philips tape recorder, 1961

options they suggested also resulted in the ambivalent spatial and social position-
ing of the recorder in the domestic context. In the first place, the tape recorder was
not promoted exclusively as a device for men or for women, although each sex was
supposed to do different things with the device. Typically, Philips and BASF adver-
tisements portrayed men as creators of sound effects, such as for radio plays, and
women as the ones taking care of recording their children. A 1965 article in the
German magazine for recording amateurs *Ton + Band*, underlined that women
should not complain about their husbands using kitchen devices for making
sounds, since recording activities would, at least, keep their husbands at home. By
the same token, the author advised women to think about the future, and make
recordings of their daughters' babble, asking if that wouldn't be a "wonderful
memory?" (Liebe 1965) Most of the women portrayed in the advertisements
recorded their children's voices in or around the house. Where exactly the men
made their recordings is less clear (figures 1.1 and 1.2).

Figure 1.2 - BASF advertisement, 1960

One explanation for the use of non-specific locations in these depictions might be
that the manufacturers hoped to prevent a potential conflict expressed in women's
complaints about husbands creating an undesirable chaos in the kitchen or living
room. This is a first indication of the contested character of the responses to the
everyday questions of *where* exactly the recording activities should take place,
which rooms in the house were most apt for using the tape recorder, and how
leisure and other activities could be combined.

 Even more ambivalent is the spatial position of the tape recorder. An analysis of
thirty pictures used for Philips advertisements between 1953 and 1967 shows that

these usually position the recorder in the living room. A series from 1962, however, displays the recorder in the kitchen, bedroom, drawing room, and dining room. All eleven pictures made prior to 1965 portray the recorder as a distinct, detached object, the position of which is not permanent: it is often displayed sitting in a slanted position on small or large tables. In four of the five photos made after 1964, however, the recorder has a permanent position in some sort of wall unit (figures 1.3, 1.4, and 1.5).

Moreover, while the pre-1965 photos picture the tape recorder with an enormous variety of objects, ranging from a doll and flowers to a slide projector and a bed, the later series juxtaposes it with books, audio sets, the TV, and decorative objects. The post-1964 images link the recorder up with a class of objects that signify cultural sophistication and distinction (Tichi 1991, p. 21).[23] In the earlier phase, the connotation of the tape recorder is that of a moving device that remained only temporarily in one spot. In the later phase, the tape recorder is presented more often as an object in the living room that elevates the wealth and status of its owners. The design of the bigger tape recorders also changed from a portable object with a handle to a non-portable device in a wooden box.

At first sight, the ads seem to suggest a transition from a period of ambivalent positioning in line with the manufacturers' initial focus on active use, to a standard domestication, in which the wooden box and fixed wall-unit location refer to passive leisure. In many domestication stories, this transition also implies a change of connotation from a male activity to a female passivity and hominess

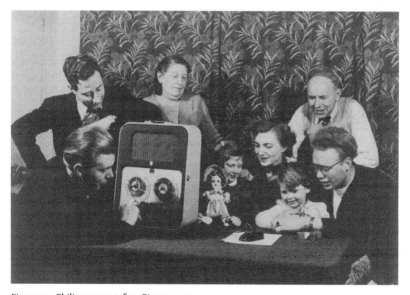

Figure 1.3 - Philips *magnetofoon* EL 3530, 1953

Figure 1.4 - Philips tape recorder, 1963

(Fickers 2006; Haring 2003; Spigel 1992). In the marketing of the tape recorder, however, femininity implied the active recording of children right from the start. Moreover, even the post-1964 images portraying the tape recorder as a piece of furniture seem to waver between active and passive uses, as evidenced by the postures of the subjects depicted. What is more, in the pictures that employ a standard scene of domestication, the positioning of the tape recorder in the users' households does not match its actual use, as we will show in the next section.

Use and Display of the Tape Recorder: Objectification and Incorporation

How did the users we interviewed *objectify* and *incorporate* the tape recorder? How, in other words, did they display their tape recorder and incorporate it in their everyday routines? One particular group of users, the sound hunters, focused on buying high-quality tape recorders to gather outdoor sounds in a sports-like manner that highlighted the complex activities needed to capture the sounds (Bijsterveld 2004).

We found different patterns of use in the group of "regular" users, however. First, six of the interviewees purchased their reel-to-reel mainly to record and play music. Two had been fascinated by the recorder's technology, and two others acquired the device for other reasons. Not one interviewee mentioned making a family sound album as the sole reason for buying a tape recorder. In spite of the manufacturer's original intentions, playing music was thus the main reason for purchasing one. In the use of the tape recorder, collecting and playing popular and classical music was still the predominant activity. Many of these music fans recorded their music from the radio, and a few borrowed gramophones to record their music collections. In addition, two users focused on recording family events, and one made both music and family recordings.

As the story by Loek van IJzendoorn, the Philips engineer, already suggested, recording music from the radio could be quite troublesome because of the interference of its reception by electromagnetic waves caused by car and other engines. Dutch rediffusion radio, broadcast through telephone lines, did not suffer from this disadvantage. Yet, apart from the interference problem, it was an "art" in and of itself to record songs without hearing a DJ talking in between (Interview 1, p. 12, 2). Han Lijn, for instance, considered his interest for music recording "neurotic." He ate his meals as fast as he could just to record the broadcast of one particular song (Interview 1, pp. 15-16). If users made radio recordings without using a wire between the radio and tape recorder, but used a microphone instead, they had to make sure not to sneeze or cough (Interview 9, p. 4).

Figure 1.5 - Philips stereo tape recorder 4408, 1967

As for the tape recorder's physical display, six users had originally installed it in the living room, but only two subsequently *kept* it there. One tape recorder started its domestic life in a children's bedroom and later made it into the living room. In most cases, however, the recorder changed places from the living room to the bedroom, the study, and other rooms. Moreover, out of seven users who temporarily positioned the tape recorder in the living room, five placed the device somewhere out of view. They did so by placing it on a book shelf "around the corner," (Interview 2, p. 15) below a small table, on a board that could be pulled out from a cupboard, behind the doors of a cupboard – as Loek Van IJzendoorn did – or under a tablecloth. Unlike what Tichi described regarding the television set (1991), the tape recorder never became a part of household furniture.

The tape recorder thus moved through the house, and if it had a semi-permanent position in the living room, it was hidden from view. "My wife wanted it neat and didn't like the wire chaos," Cor Haan explained (Interview 7, p. 10). Tapes were not popular items for the living room either. Mr. Stijfhoorn's wife considered them "a hideous sight" (Interview 2, p. 15). Again, these examples reflect conflicts about what domestic space should be used for. Apparently, to the users' wives, the living room was not a place for tinkering and messiness, but for displaying their capacity for being orderly housewives.

As Trevor Pinch, one of the contributors to this volume, recalls from his and his friend Graham's youth in 1960s Britain, bedrooms were initially too small to allow for extensive tinkering activities. Moreover, the sounds to be recorded were those of the radio or the television set in the living room:

> … but of course no self-respecting 1960s stay-at-home-house-proud-mum was going to allow her kids (or I suspect even her husband) to leave that huge mess of wires and tapes around for long. So after recording the show we were always forced to pack the gear up and take it back up to Graham's bedroom so the "front room" could look "nice" again.

The tape recorder was thus constantly on the move. This resulted in a *multi-sited* domestication of the tape-recorder, in contrast to the furniture-like domestication of stably located artifacts that have been described so often in the secondary literature on domestication processes.

Storing and Retrieving Sound Souvenirs: Conversion

The question of *where* to store tapes and tape recorders turned out not to be the only problem. *How* to preserve and retrieve the sound souvenirs properly was not self-evident either. Given the many contemporary websites devoted to solving problems with retrieving digital photos and video movies, archiving traceable

memories is a serious issue. Memory archives have hardly been a serious topic of research in media and technology studies. So far, observations have not yet stretched beyond the identification of women as the "guardians of memory, selecting and preserving the family archive" (Spence and Holland 1991, p. 9).

Preserving and retrieving tape-recorded sounds may even have been more complex in the past than it is in the context of today's digital overload. Five interviewed users employed the tape counter on their recorder to keep track of exactly what they had recorded on which tape. Subsequently, they added information about these recordings in notebooks. Loek van IJzendoorn even considered it his "holy plight" to jot down track numbers (Interview 5, p. 12). One couple used diaries and separate notes for archiving their recordings. Three interviewees numbered their tapes and made lists of the recordings on each tape, while two pasted sticker labels on their tapes. But such systems happened to be far from robust. Users lost or threw away their notes and notebooks; they had tape boxes without labels, or labels without any comprehensible system. Cor Haan, for instance, soon discovered that he had to add dates to the notes of his recordings to keep his recordings of children's birthday parties and other events retrievable over time (Interview 7, p. 5).

Even if the system employed by recording enthusiasts was consistent, the lack of standardization between tapes and tape recorders hampered their playing, particularly after buying a new recorder, as Carolien de Roo experienced (Interview 3, p. 3). Finding a particular moment of recording through winding the tape could be very time consuming (Interview 8, pp. 2-3). Moreover, the length of tapes varied considerably, which made it hard to estimate how many minutes of sound had been captured on a particular tape.

Both tape recorder manufacturers and tape producers acknowledged storing and retrieving problems. Philips therefore published tables from which users could learn, per tape type, recording speed and reel-diameter, the corresponding tape length, and duration.[24] The tape manufacturer BASF educated customers about transforming their recordings into traceable memories by providing archiving cards and boxes (figure 1.6). Moreover, BASF advertised the use of the *Bandlängenuhr* (tape-length clock) and the *Spielzeitanzeiger* (playing-length indicator) (figure 1.7). Again, these tools were meant to help tape recorder users to estimate which recording was where on a tape. None of the persons interviewed, however, used these aids or archival systems.

The seemingly simple, but practically complex issue of storing and retrieving recordings was a significant part and prerequisite of the act of *conversion*, the work needed to provide tapes and tape recorders with a meaningful role in the relationship between users and people outside their household. In the case of music collections, users played their recordings at parties or as background music at home. Since with the tape recorder one could play back music for hours on end without having to change records or without disturbances in the sound caused by

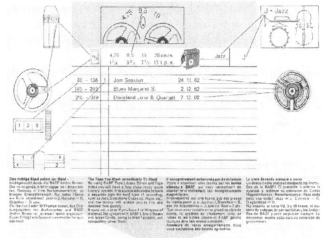

Figure 1.6 - BASF archiving card, 1963

Figure 1.7 - BASF *Bandlängenuhr/Spielzeitanzeiger*

dancing motions (in contrast to the turntable), the conversion process involved no problems as long as the tape recorder was used for music.

Conversion of family recordings was much less straightforward, however. Han Lijn secretly recorded the gossip at his family's Christmas dinner in order to send it to his sister in Africa, who loved these recordings. Later he professionalized his style by doing interviews (Interview 1, pp. 9, 11). Another tape recorder user, however, experienced how family members discarded the recordings because they felt ashamed of their own senseless talk and gossip captured on the tapes (Interview 6, p. 10). Other users, such as Mr. Polanus, just didn't know what to do with his family recordings. As he put it, if one had the sounds, one simply "had" them, and family members only heard them once (Interview 4, p. 2). Apparently, he only recorded sounds to "own" them, not to frequently listen to them. Looking at photos, he asserted, was much easier than playing tapes (Interview 4, p. 11). Mr. Stijfhoorn secretly recorded telephone calls, military parades, and his children's chatter and songs (Interview 2, p. 4). With his old friends he would occasionally listen to the military recordings. His wife, however, preferred not to be reminded of the past, no matter which past. She listened only when he ignored her objections and played some recordings from the days when their children were still young (Interview 2, p. 10). Often Stijfhoorn would go out, park his car somewhere, and simply record his comments about what he observed. He almost duplicated his life in sound, only to find out that hardly anybody was interested in it.

One reason for this may have been that listeners did not comprehend the content of specific recordings. One of the respondents admitted he had a recording labeled "party at Rudy's," but he could neither remember who Rudy was nor recall the occasion for the party. He recognized some of the voices, but not all of them. "For whatever reasons he had recorded it, it seemed to have lost much of its meaning with time" (Van Kimmenade 2006, p. 24). Or as the interviewee Paul pointed out

> ... if someone on TV is speaking ... that person's name is projected on the screen.... This is different for tape, of course ... you can only recognize someone on the basis of voice, and that is, if you actually heard or knew the person. So ... my children for example, well, my mother they would recognize – the grandmother – the voice, the voice on tape. There it more or less ends. So it is of a temporary nature. It passes, the information thus disappears. (Van Kimmenade 2006, p. 25)

Only when families listened to recordings as part of their family tradition and family rituals would the tapes' preservation seem guaranteed. Family members who commented on the tapes thus passed on necessary information to new generations (Van Kimmenade 2006, pp. 26-27).

Conclusion

Compared to the big commercial success of the compact cassette recorder, the tape recorder was a failure in terms of sales. It was also a marketing failure, since its actual use significantly diverged from the use promoted by manufacturers. It simply did not become the sound souvenir device its makers originally had in mind. Only one of the uses of the tape recorder – to record and replay music – fostered the later rise and success of the compact cassette recorder.

The history of the tape recorder, however, is not so much an example of a failed domestication, but of a different kind of domestication. It did not become the standard piece of furniture in the living room as the gramophone, radio, and the television did – all realizations of the ideal types of domestication theory. Instead, the tape recorder became a semi-portable device that traveled through the house, from room to room, from cupboard to table, from bookshelf to attic. Its ambivalent positioning in the house, as advertised by manufacturers and confirmed in everyday use, created a multi-sited domestication. The tape recorder neither became a full-fledged piece of furniture nor an attic-and-basement device, as with two-way radio. It did not even become the kind of portable device that is stored behind locked doors only to be taken out for use, as exemplified by the video camera. Instead, its domestication rendered it an artifact commonly stored in multiple places: in the living room (preferably out of sight), or, after its banning from there, in other rooms.

In promoting the tape recorder as a family sound album, manufacturers simply overlooked the practical consequences of the family photo album analogy. Apparently, manufacturers underestimated or misunderstood the cultural practice of preserving and using traceable memories, which contributed to the multi-sited character of the tape recorder's domestication. The manufacturers' initial image of the audio family album only included the *making* of sound souvenirs, not the *practice of retrieving* or listening to them in a collective setting. While a photo album can easily be retrieved from a book shelf, the tape recorder could not live up to that level of portability. While photos can be browsed and photo albums leafed through, the linearity of tapes and recording machines turned out to be lot more cumbersome for analogous activities with sound souvenirs. Using the forward and rewind buttons was an option, but a time-consuming one. And while it is easy to make notes below pictures in a photo album, recording oral comments notes prior to a recording, or making notes in a separate notebook takes a lot of planning. Without such arduous archiving and listing activities, the recordings could hardly be expected to reveal any information to later users, the heirs of the tapes. Even though BASF attempted to teach tape recorders users to be good archivists by designing special devices for storing and archiving sound recordings, most preferred to devise their own systems.

Even for the most capable and experienced users, listening to family recordings during family gatherings did not become as common a ritual as exchanging photos. Some of the respondents told us that merely looking at pictures was easier than listening to tapes. We would like to suggest two more possible explanations in line with our focus on sound recording as a cultural practice. Unlike watching and commenting on photos during family meetings, listening to recordings required all people present to be involved in the activity at the same time. Everyone in the room had to be quiet, whereas people had become increasingly used to combine listening to music with other activities (Douglas 1999). In addition, families treasuring their sound souvenirs often discovered years later that the hardware they needed for listening to their tapes no longer worked or had been replaced by hardware that was incompatible. And even if they still had a working set-up, and the tapes had not lost their original quality, the tapes could no longer speak for themselves. It is hard to treasure one's memories, most notably those in sound.

Interviews

1. Interview Annelies Jacobs (AJ) with Han Lijn, Nijmegen, 5 February 2007.
2. Interview AJ with Hans Stijfhoorn, Roden, 9 February 2007.
3. Interview AJ with Carolien de Roo-Aerts, Dordrecht, 15 February 2007.
4. Interview AJ with René Polanus, Hoofddorp, 15 February 2007.
5. Interview AJ with Loek van IJzendoorn, Sittard, 22 February 2007.
6. Interview AJ with Toos Kranen-Brummans, Helden-Panningen, 26 February 2007.
7. Interview AJ with Cor Haan, by telephone, 13 March & 19 April 2007.
8. Interview AJ with Eti Deckers, Vaals, 28 March 2007.
9. Interview AJ with Theo Gorissen, Maastricht, 3 April 2007.
10. Interview AJ with Lenny Seifert, Linne, 10 April 2007.

Notes

1. We would like to thank the Sound Souvenirs Workshop participants, especially Trevor Pinch and José van Dijck, for their valuable comments on this chapter.
2. Because the official Grundig archives are privately owned and not easily accessible, we consulted the Grundig archives at the *Rundfunkmuseum*, Fürth/Nürnberg. We examined the archives of two sound hunting societies, the *Nederlandse Vereniging voor Geluid- en Beeldregistratie* (formerly the *Nederlandse Vereniging voor Geluidsjagers* (NVG)) originally at Wassenaar, now at Ommen, the Netherlands, and the *Schweizerische Bild und Tonjägerverband* (acquired digitally). Interviews with tape recorder users include two groups. One consisted of nine former tape recorder users selected from seventy-one respondents to our website, who

said they treasured their family recordings. The second group of users has been selected from the same set of respondents, excluding the sound hunters, "family recorders" who had already been interviewed, and users who had not made the recordings themselves. Of the remaining users, twelve were selected, ten of which agreed to be interviewed by Annelies Jacobs. In the selection of the two groups, we sought to reflect the distribution between users who possessed a few tapes and those who had many, those with recording experience as a child and those with recording experience as an adult, and between male and female respondents. Most users had recordings dating from the 1960s and later; some users also had recordings from the 1950s.

3. The first half of this section is based largely on Bijsterveld (2004).

4. Philips Company Archives (PCA), Prod. Doc. 811.232, brochure 68/C/4489, esp. 4/53. See also Purves 1962, p. 31; for the price of the *EL3530*, see *Radio-Bulletin*, 22, no. 12 (December 1953): 750.

5. *Kroniek der Elektrotechniek* 3, no. 5 (1958): 51.

6. PCA, DA CE 811.232: 822, "Recorder Market July 1967, C.V. & P. Market Research," p. 2-10.

7. PCA, DA CE 811.232: 822, Arnesen and Arno, "Prognosis for the sales of tape-recorders 1965-1968" for Denmark, December 16, 1964, Copenhagen, p. 3.

8. Personal interview Karin Bijsterveld with Mark van der Kloet; See also *De Geluidsjager* 8 (April 1961): 3.

9. The tape and tape recorder industry was behind the publication of some, but not all, of the guidebooks.

10. PCA, Prod. Doc 811.232, model *EL 3510*, brochure 69/c/4934 N 7/54, 1954.

11. PCA, file 811.232, model *EL 3511*, brochure "Enkele van de Vele Toepassingsmogelijkgeheden," 1956.

12. PCA, file 811.232, model *EL 3516*, brochure no. 10.1958.

13. PCA, 1960-69: model *EL 3541, 3541 H*, ad no. 2 4574, 1962.

14. "De Bandrecorder als Hobby-Object," *Bandopname* (September 1963): 35.

15. PCA, Prod. Doc. 811.232, model *EL 3511*, "Enkele van de Vele Toepassingsmogelijkheden" 1956.

16. *Geluid+Band: BASF-Mededelingen voor Geluidsbandvrienden* 16 (Fall 1964): 13.

17. PCA, Prod. Doc 811.232, model *EL 3538*, brochure for the retail trade model *EL 3542* and model *EL 3536*; model *EL 3527* and 3516-G, 70.153 B/E – 6/60, 1960.

18. PCA, 1960-69, Series Ads *EL 3585*, 1962.

19. PCA, Prod. Doc 811.232, *EL 3585*, 70.164/Eng/9-61, 1961; see also *EL 3585*, 70-181B/E-5-'61, 1961; *EL 3585*, 70.271 B/E – 8/62, 1963.

Chapter Two

Tape Cassettes and Former Selves: How Mix Tapes Mediate Memories

Bas Jansen

I didn't properly anticipate the "nostalgia" factor when making (and keeping) cassettes – the idea that the tape would be "interesting" in a year, 5 years, 10 years ... or 25 + years![1]

Introduction

Old cassette mix tapes tend to bring back memories. There is something accidental about this ability, because evoking memories was not their intended purpose. In the digital age, however, it is their evocative quality that they are mostly appreciated for. Besides conjuring up a wealth of autobiographical memories related to a specific tape, mix tapes naturally trigger memories of the outdated technology of the cassette recorder and of spending many an hour mixing tapes. Unlike making a playlist, mix taping involves a lot of work. As songs were generally rerecorded in real time, the process of making a mix tape was time consuming and required considerable skill; every project required a new empty cassette and a long and agonizing process of selecting and ordering songs for each particular mix. Tapes were often compiled with a specific person in mind and given as tokens of love or friendship or as a way to introduce the recipient to new music.

Mix taping became a widespread practice between the late 1970s and early 1990s, after which its popularity declined, gradually giving way to digital forms of rerecording. Soon after its decline, however, mix taping began to reappear in a number of cultural narratives in novels and essays which calibrated its meaning from an innocent pastime to a socio-cultural practice of existential significance. The novel *High Fidelity* (Hornby 1995) was the first indication of such a cultural turn, highlighting the nostalgic and romantic meaning of mix tapes. Stephen Frears' film adaptation, which appeared in 2000, became an instant hit. A project seminar at the *Institut für Volkskunde* [Institute for Ethnography] of the Universi-

ty of Hamburg in 2001 culminated in the exhibition *KassettenGeschichten: Von Menschen und ihren Mixtapes* [Cassette Stories: Of People and their Mix Tapes] (see Herlyn and Overdick 2005), which later traveled to Frankfurt, Nürnberg, and Bern, Switzerland. In 2004, *Sonic Youth* guitarist Thurston Moore published an edited collection of anecdotal stories about mix tapes, *Mix Tape: The Art of Cassette Culture*. Both it and the film adaptation of *High Fidelity* generated, in turn, a profusion of stories about mix tapes in personal weblogs.

Less than a decade after their demise, mix tapes became objects of nostalgic and memorial value. It is important to notice, however, that while memories may have been mediated by the *objects* of rerecorded music, it is through *stories* about mix tapes that their memorial value became personally and culturally significant. This chapter addresses the question of what is specifically characteristic of the mix tape as a mediator of memory. Mix tapes are often compared to photos and diaries as memory triggers. After exploring the merits of this analogy, I will deconstruct it. The metaphor that best captures the analogy is the image of a "frozen mirror." Old photographs can show you a former self, as if you are looking into a mirror in which time has been frozen. Re-reading old diaries can similarly evoke a sensation of encountering a previous self, preserved in the medium of writing. The diary is a different sort of mirror, one which does not reflect a former exterior, but rather a former state of mind. Would it be analytically fruitful, then, to apply the metaphor of the frozen mirror to the mix tape? How are mix tapes different from photos and diaries as reflectors of the self in frozen moments in the past?

This paper is based on a selection of about one hundred mix tape stories, written either by mix tapers or by gift tape recipients, with the aim of examining how listening to old mix tapes serves as a way of regaining access to our former selves. The stories were taken from three sources: thirty-nine were drawn from Thurston Moore's collection *Mix Tape*; forty were found through Google Blog Search using "mix tape" as the search entry, and the remaining twenty-one stories were obtained from the *KassettenGeschichten* exhibition website.[2] Although these stories provide much information about mix taping that is useful, the sample is not entirely representative of the practice as it actually occurred.[3] Both Moore's book and the weblogs show clear biases and preoccupations. Both were written by the most active mix tapers and both focus predominantly on compiling gift tapes. Both also emphasize and celebrate the personal and artistic value of mix tapes. These stories, however, *are* representative of a contemporary discourse that celebrates mix tapes and seeks to elevate their status retrospectively, implicitly reinterpreting them as a memory technology. Just as mix taping was considered to be a form of sculpting self-identity, narratives about mix taping construct a coherent story about a former self – in hindsight.

Mix Taping as Self-Expression and Lifestyle

To many mix tapers, compiling songs on a magnetic tape is nothing less than an art form. As one mix taper writes, "Good mix-tapes were a skill. Perfect mix-tapes were an art."⁴ The attribution of the term "art" needs some legitimating, however, and mix tapers supply it by pointing out such things as the skill and technique which mix taping requires, the surge of energy or inspiration needed to make the tape, or the balanced and cohesive quality of the resulting product. But, most importantly, they stress that mix taping is a form of self-expression:

> The mix tape is a list of quotations, a poetic form in fact: the cento is a poem made up of lines pulled from other poems. The new poet collects and remixes.... All we can agree upon is that it's not the same thing as making art. Or is it? A mix tape can never be perfect. My taste as a mixer tells you even more about me than my taste as a consumer already does. (Moore 2004, p. 35)

> [T]he Mix Tape as Self-Portrait. Even when we make mix tapes for other people – especially when we make mix tapes for other people – we make them for ourselves.⁵

The "work," in short, reflects the artist. Quite a few cultural theorists would likely have qualms about the romantic flavor of these statements, as they celebrate mix taping as an expression of a mix taper's emotional state or personality. However, one may also make sense of such comments by invoking familiar concepts like subculture (Hebdige 1979; Willis et al. 1990) or lifestyle (Sobel 1981; Chaney 1996) to argue that the activity of mix taping constructs identity or expresses the self. Although the academic literature on mix taping is scant, the little work that has been published on the subject underscores this point. Rob Drew (2005), who examines the appropriation of the notion of the mix tape for commercial purposes, does not explicitly characterize the practice itself or its relationship to identity. However, his article does reveal, if unintentionally, that identity construction is foundational to mix tape making as a cultural phenomenon. For instance, Drew describes a trend in which companies seek to capitalize on the concept of the mix tape or the "home mix" by selling inexpensive CD samplers as promotional vehicles for their brands. He asserts that "[s]uch mixes aim to tap into and complement the "lifestyle" defined by the company's products" (p. 539), and that magazines too have turned to mix tapes "as vehicles for defining themselves and their audiences" (p. 540).

The publication that accompanied the *KassettenGeschichten* exhibition (Herlyn and Overdick 2005) does not explicitly address the relationship between mix taping and identity either. It does, however, describe the mix tape as a means for

communicating (and hence also of expressing) personal emotions (Hasbargen and Krämer 2005, pp. 72-76). It also offers a typology of mix tapers who make gifts of their cassettes based on the degree to which they allow the recipient's taste in music affect their compilation. The typology spans a spectrum running from the "communicator" to the "egomaniac," which, in the case of the latter, "[t]he tape solely reflects his own taste." (Peiseler, Tsitsigias, and Radzuweit 2005, p. 67; my translation).

These interpretations seem highly compatible with the application of the metaphor of the frozen mirror to explain how old mix tapes bring back memories. When mix tapers refer to "former selves," and their renewed ability to access them when listening to an old tape, they describe an experience of being confronted with a representation of themselves, or an expression of their own identities or emotions, which have not aged or changed as they themselves have. Like an old photograph or diary, mix tapes allow a person to encounter oneself as an "Other." Before reexamining this reading of mix tape stories, I will describe what it is that mix tapers actually do when they compile a tape.

Mix Taping and the Quest for Cohesion

A mix tape is always a recombination of existing elements: a tape cassette, several songs, and possibly clippings from papers or magazines to create artistic packaging. Mix tapers are very different in how they approach this act of *bricolage*. Some interact with their material in a playful or improvising manner, taking joy in the traces that chance leaves in their efforts:

> [W]hen I make a mix tape, I don't put a lot of forethought into what it will sound like to somebody else later. I put onto it whatever *I* want to listen to *right now*, and that tends to involve a lot of terrible segues and bizarre mood swings.... When other people hear my mix tapes, after a few songs they start looking at me as though they've just discovered that I'm the tragic victim of a hallucinatory insanity.[6]

> I reworked tapes ad infinitum on loose-leaf, but despite these sessions, beauty emerged with chance, enabling you to discover something new about a song you thought you understood simply by placing it next to something else. There was a cassette, *1/2 David Bowie and 1/2 Einstürzende Neubauten*, that made me imagine David Bowie had a German accent, and a pop-punk cassette whose songs fell into a pattern that made me hate every single track.[7]

However, many hardcore mix tape enthusiasts – and these are likely to be overrepresented among mix tape story writers – leave nothing to chance. They seek

first and foremost to create a whole that is more than the sum of its parts, a tape which is understood as a work in its own right rather than as a collection of disparate elements. What needs to be achieved, in other words, is cohesion. The new overall unity competes with the preexisting unity of the individual songs. Thus, a tension appears between the whole and its parts, and this interplay allows new meanings to emerge:

> We compose meaning from the use of distinctly different parts, but strip those original pieces of their initial meaning and replace them with the some sort of new meaning found only when placed in juxtaposition. Suddenly, the context plays a larger role in the meaning, assigning greater importance to the order, selection, and general flow of the tape.[8]

In order to achieve cohesion, mix tapers make sure that their compilations are recognizably *not* arbitrary. The selection and sequence of songs on a tape is subject to a number of constraints which are both materially defined and self-imposed. Hardcore mix tapers enjoy walking the fine line between a maximally challenging task and an impossible one:

> I think the more limitations placed on both the listener and the creator, the better. This is the beauty of the true mix *tape*. The creator must not only choose songs that go well together, but he can't just decide to end it after 30 minutes. He has to fill both sides to their predetermined length, with as little blank space at the end of each side as possible. A mix tape is a work of art.[9]

> There was a certain art to finishing the tape. Choosing those last few tunes was rough because you had to find tunes that fit the sound of the other songs, were worthy of being on the tape, and fit into the remaining amount of tape.[10]

Self-imposed constraints come in several different types. First of all, there are constraints which purely belong to the cultural form of the mix tape. A cassette may have an overarching "theme," so that all songs share a common characteristic. As one mix taper explains "Once I had to record a tape with 'green songs' for a girl. That became too difficult at some point. So then I recorded songs which refer to colors in general" (my translation).[11] In addition to the theme, the mix's "flow" might need to be taken into account. The notion of "flow" here refers both to the sequence of songs chosen and the relation each song has with the adjoining ones:

> When picking the next song in a mix, I ... look for a "unifying dominant factor" which is the one singular stand-out characteristic of a song that links it to the next song even though the two song choices appear dissimilar on the surface.[12]

There are also social constraints, which are especially significant in the case of gift tapes. The mix taper has to take his or her own preferences into account as well as the tastes of the recipient. Mix tapers clearly differ in the relative weight they give both of these considerations.

> Try to put songs on there that your friend hasn't heard, but that you think they would like…. [M]ix tapes should attempt to bring to light new music and expose someone to new things."[13]

> Sometimes you also think: Okay, now I have to save your soul, your musical one, and give you sensible music for a change."[14]

The fact that a gift tape has both a sender and a recipient to satisfy sets up a productive tension. Ideally, the songs define something like a musical "common ground," that is, they create a musical experience that is appreciated by both and therefore truly shared.

Finally, technical constraints also influence the end results. Mix tapers seem to invariably challenge themselves by trying to use the tape's time frame maximally without cutting off any song:

> There truly was no joy like what I experienced following a tense couple of minutes of watching the last few inches of spooling strand of shiny brown wind through my player's works, hoping I would still see brown for the whole of the last cut's fade-out – then: YAY! The last lingering whisper … followed a split second later by the clear non-recording segment of end-tape.[15]

Sixty and ninety minutes are the most common time frames that a mix taper has to fill. That these time frames are always divided into two equal halves, too, presents opportunities for structuring. As one mix taper puts it, "cassette tapes have two sides, allowing for a first act, an intermission, and a second act."[16]

If the mix taper values coherence – and coherence is especially favored among those who consider mix taping to be an art form – the selection of each song will be informed by at least five constraining considerations: The song must fit the overall theme, continue the flow of the tape, be "true of the mix taper," take into account the tape giver's assessment of the musical taste of the recipient, and fit the predetermined time frame and two-act structure of the tape cassette. The result is a cohesive tape in which no song can be randomly replaced with another without destroying the structure. If this is the case, the tape can hardly be said to be a simple expression of personality or identity, because it is over-determined by the mix taper's immediate environment during its production by technological

conditions, by mores and conventions of the mix taping community, by available record collections, and so on.

Mix Tapes and Memory

In a sense, all the mix tape stories analyzed, which were usually written in the past tense, are about the relationship between mix tapes and memories. Whenever they describe past events from the narrator's life, they implicitly support commonsensical theories about how objects from our personal past play a role in the act of recollection. By default, mix tapes seem to bring back memories. Thus, whenever the role of mix tapes in recollection is explicitly addressed as a subject in these stories, it is to make a less obvious point than the mere observation that mix tapes serve as memory triggers.

Out of a total of eighteen explicit allusions to the way in which mix tapes support memory, three use the familiar metaphor of transportation through time and speak of a mix tape as "transporting one back" to the past. One mix taper writes: "Listening to that tape now, even just looking at it, takes me back to my young, hopeful, desperate life in an apartment filled with furniture culled from the street" (Moore 2004, p. 74). The metaphor of the time capsule, even though it is less common in everyday language, appears three times. As one mix tape story writer has it, "This is one example of a series of cassette tapes that I received from him, a surviving time-capsule of sorts" (Moore 2004, p. 50). Both of these descriptions are at odds with the metaphor of the mix tape as a frozen mirror, which enables one to encounter oneself as another. When a person is transported back in time, the contemporary self confronts a past life-world, not a past self. A time capsule may be partly analogical to a frozen mirror, but it, too, reflects a former life-world rather than a former self.

However, there are also three instances where mix tapers speak of mix tapes in relation to something like a former self. These initially seem to support the notion that one may encounter oneself as another upon listening to an old tape. An example:

> It's ten years later now and so many things about that time seem so far away, yet when the Creed Taylor Orchestra kicks in and wafts through the speakers in its stereophonic majesty, the joy and excitement of being alive, then, is still inside me. (Moore 2004, p. 74)

Yet this example places the idea of a "former self" in a different light. Instead of encountering oneself as another, as a person tends to do when seeing old photographs or rereading an old diary, listening to an old mix tape seemingly gives this mix tape story writer a renewed sense of how it was to be that person or self at that time.

Self as Idem and Ipse

The word "self" has different meanings. The insistence on using the notion of the "self" to mean self-expression, as found in the mix tape stories, or to emphasize self-representation or the construction of identity, as found in many cultural theories, has led to the assumption that "self" is synonymous with "character" or "lifestyle identity." The philosopher Paul Ricoeur (1992) argues that this meaning of the "self" is one of two meanings of the term, and that much unclear thinking has resulted from the confusion of them. He examines the concept of the "self" in terms of self-identity and describes two very different ways in which someone may be said to be self-identical, or to be the same over time. He refers to these two uses of identity as *idem*, from the Latin word meaning sameness, and *ipse*, the Latin word for self. Ricoeur relates *idem*-identity to a person's inclinations, habits, and identifications. These tend to show the continuity of identity over time, which he calls "character." *Ipse*-identity is closely tied to the first-person dimension of experience. Ricoeur describes it as "the terrestrial and corporeal condition" of being on earth in a body. It is the phenomenological structure of one's being-in-the-world.

Apart from the distinction between *idem* and *ipse* identity, the other key element in Ricoeur's analysis of the "self" is the idea that identity is narrative. A subject perceives him- or herself in a narrative light. The changes with which life continuously confronts a person drive him or her to search for meaningful causal connections between events and to construct a "narrative unity of life." According to Ricoeur, "the contingency of the event contributes to the necessity, retroactive so to speak, of the history of a life, to which is equated the identity of the character." (1992, p. 147) The past is continuously narrativized, so as to create and maintain an ongoing, meaningful "thread of life," which has *idem*-identity as its protagonist. *Idem*-identity, then, is an object of thought. With *idem*-identity, one encounters "oneself as another," to use the phrase in the title of Ricoeur's book. *Ipse*-identity, however, cannot become an object of thought in the same way. In first-person experience, one never encounters the actual "experiencer." Instead one only finds conditions, such as the "terrestrial and corporeal condition," which determine "what it is like" to be that person. The narrative unification of past life, in which *idem*-identity is constructed, in turn, affects present *ipse*-experience by conferring meaning upon it and placing it in a particular light. Therefore narrative is, in Ricoeur's view, the mediating element in an ongoing dialectic between *idem* and *ipse*.

Ricoeur's distinction between *idem* and *ipse* allows us to reexamine the mix tape's specific character as a mediator of memory. While the mix tape clearly reconnects the listener to a "former self," in contrast to the photograph and the diary, with this medium the "former self" that is discovered is of the *ipseic* sort.

A mix tape ties together reminders of many heterogeneous elements of a past life-world, which include music, technology, and social relations. These elements of the mix taper's past environment may not be on par with such overarching conditions as Ricoeur's "corporeal and terrestrial condition" (being-on-earth-in-a-body), but they nonetheless play their part in structuring the listener's experience. It follows that the mix tape should be ideally suited for triggering memories in the listener of "what-it-was-like" to be him- or herself at the particular place and time the tape mix brings the listener back to. The mix tape offers a "what-it-was-like" experience, which can be described as the mix taper's "being-in-connection-with" the technology and music of the day, the people, the vocabulary, the important issues, and so on.

This reading of the mix tape stories harmonizes the metaphor of the former self with that of time travel and time capsules. If the former self to which the listener finds renewed access in the act of listening to a mix tape is a sense of "what-it-was-like" to be then, s/he does not encounter him- or herself as another. This sensation of "what-it-was-like" is primarily a first-person experience. An analysis of the sensation will not bring into focus the "experiencer," but only the conditions and the elements of the life-world which gave the listener's past experience its particular "feel," as if these conditions and elements had been kept exactly as they had been in a time capsule, or as if a time machine had taken the listener back to them. In contrast, with old photographs and diary entries, one mostly encounters a former self as another, as a reflection seen in a frozen mirror, so to say. The protagonist of the life story takes center stage while the conditions provide the background. The fact that the mix tape stories support this *ipseic* reading of the way they mediate memories adds nuance to the widely held view of mix tapes as a form of self-expression or an element of lifestyle, which implicitly links it to the tape compiler's character and identifications, and thus to *idem*-identity.

This reading of the metaphors of former selves, time capsules, and time machines also helps to explain why, in a sample of mix tape stories in which every story implicitly deals with the topic of mix tapes and memory, metaphors had to be inserted to elucidate their meaning. Mix tapes are non-narrative *artifacts* that preserve the mix taper's being-in-connection-with his or her immediate surroundings, whereas mix tape *stories* are retrospective narrative accounts. It follows that they should be well-suited for the construction of the mix taper's *idem*-identity, the continuous narrative thread running through her or his particular characteristics and identifications, which in turn confers meaning on his or her *ipse*-identity. In fact, this type of reference to the self in the past, which is present throughout mix tape stories, does not require a break with the narrative mode of the story or need to be made explicit. The example below shows this clearly:

The Bangles, "Hazy Shade of Winter," and "Eternal Flame." You heard me humming "hazy shade of winter" from the other room. You told me that you had bought the record when you quit politics and had listened to that song. One morning, a little later, when I was so low from packing and my troubles in New York, I got a package from you. It had a Bangles CD! I listened to "Hazy Shade" first, and then I listened to "Eternal Flame." I closed my eyes and tried to see your face in my mind.... Felix, I am packing now to come to you, and you have just bought a ticket so you can help me move. (Moore 2004, p. 54)

This fragment is structured like a history of intertwined identifications by the author with the music of a particular band and a person. The narrative thread it constructs runs all the way from the past to the present moment and places the mix tape in a personally continuous, meaningful light.

Conclusion

This analysis of the former self, time travel, and time capsule metaphors, then, is by no means a disqualification of the importance of narrative to cultural memory, a significance which is argued in-depth elsewhere in this volume (see Van Dijck's contribution to this volume). On the contrary, it helps to identify the processes of *idem*-identity construction that pervades mix tape stories. The construction of former selves occurs in the act of storytelling. And although old mix tapes clearly have a strong tendency to evoke storytelling behavior, they are not themselves stories. Their characteristic role in fostering the enactment of recollection is to present the mix tape enthusiast with a multitude of elements which furnish the past *ipseic* self its structure and "feel."

The quest for cohesion, which characterizes the way mix tapers gave structure to their tapes, thus connects the cassette to its compiler in two ways. The cohesive new whole of the mix tape confers a kind of authorship onto the mix taper, who, after all, is the person who made the effort of compiling it. But it also holds together, in the closest possible proximity, some of the building blocks of what it is like to be this person and to exist in connection to music, technology, people, and ideas in a certain place and time. And it is not surprising that, when an old mix tape confronts its listeners with such elements from a past *ipseic* experience, they begin to tell stories, thus reconnecting themselves to the past by a narrative thread which has the *idem*-identity as its protagonist. In their retrospective narrative attempts to make sense of their lives, authors writing about mix tapes as objects of memory exhibit a tendency to strive for cohesion and unified meaning similar to that of the mix taper. As one mix taper put it: "No mix tape is accidental" (Moore 2004, p. 35). And, one could add, neither are mix tape stories.

Notes

1. Ron Kane, "The Cassette Project, Part 2," *20th Century Music*,
 http://20thcentmusic. blogspot.com/2005/08/cassette-project-part-2.html, 19 May 2006.
2. *Kassettengeschichten: Von Menschen und ihren Mixtapes*, http://www.kassettengeschichten.
 de 10 September 2007. A few things need to be pointed out about this heterogeneous sam-
 ple. First, unlike the other two parts of the sample, the mix tape stories in Moore's collection
 were mostly written by recognized artists and professional musicians. Second, the weblog
 entries on mix taping were often either inspired by Moore's book *Mix Tape* or by Hornby's
 novel *High Fidelity*. Third and last, the German part of the sample, taken from the *Kasset-
 tengeschichten* website, were versions of interviews, condensed as a series of direct quota-
 tions.
3. The German part of the sample, in which a group of interviewers has influenced the choice of
 topics and respondents, can in this light be seen as a sort of control population. Even if sta-
 tistical relevance cannot be shown, the set of German stories quite clearly does not share the
 three mentioned tendencies of the rest of the sample, or at least does not have them to the
 same degree. However unrepresentative this may make Moore's book and the weblog en-
 tries of the practice as it actually was, for a chapter on the memorial aspects of the mix tape
 the characteristics of this retrospective discourse are especially interesting.
4. Ultrastar175g, "Perfect Timing. Mix-Tapes Rip. Long Live the Digital Age," *Paradise Circus*
 http://paradisecircus.blogspot.com/2005/03/perfect-timing-mix-tapes-rip-long-live.html,
 19 May 2006.
5. Sara Bir, "Mix Emotions: the Mix Tape, Cultural Touchstone of the Analogue Generation,"
 Metroactive, http://www.metroactive.com/papers/sonoma/06.22.05/mixtapes-0525.html,
 19 May 2006.
6. Daisy Wreath, "Now with Less Drama and Crazy Mix Cds!" *Rough Around the Edges*,
 http:// daisywreath.net/journal/2005/12/08/now-with-less-drama-and-crazy-mix-cds/, 19
 May 2006.
7. Brian Stosuy, "High Fidelity: from A to B and Back Again: This Is Your Correspondent, Run-
 ning out of Mix Tapes," *The Village Voice*, http://villagevoice.com/music/0524,essay,
 64876,22.html, 19 May 2006.
8. Ryansenseless, *The Truth Is in the Details*, http://senseless.blogspot.com/2005/07/i-had-
 conversation-last-night-about.html, 19 May 2006.
9. Barrett Chase, "Philosophy of the Mix," *The Product*, http://www.barrettchase.com/2005/
 10/philosophy_of_the_mix.html, 19 May 2006.
10. Jim, "The Halcyon Days of the Maxell Xlii 90," *11 a.m. Air Raid*, http://11amairraid.blogspot.
 com/2005/10/halcyon-days-of-maxell-xlii-90.html, 19 May 2006.
11. "Steven: Grüne Songs," *KassettenGeschichten: Von Menschen und ihren Mixtapes*, http://
 www. kassettengeschichten.de, 10 September 2007.
12. Steve, "I Make Awesome Mix Tapes," *The Stevenomicon*, http://slh1065.livejournal.com/
 47652.html, 19 May 2006.

13. Brad Wolfe, "Mix Tapes," *bradwolfe.blogspot*, http://bradwolfe.blogspot.com/2005/11/mix-tapes.html, 19 May 2006.

14. *KassettenGeschichten: Von Menschen und ihren Mixtapes*, http://www.kassettengeschichten.de, 10 September 2007; my translation.

15. Perry, "Imix, Remix, We Allmix for Mix Tapes," http://blog.lib.umn.edu/archives/perry032/impossible/imix_remix_we_allmix.html, 10 January 2006.

16. Sara Bir, "Mix Emotions: the Mix Tape, Cultural Touchstone of the Analogue Generation," *Metroactive*, http://www.metroactive.com/papers/sonoma/06.22.05/mixtapes-0525.html, 19 May 2006.

Chapter Three

The Preservation Paradox in Digital Audio[1]

Jonathan Sterne

Introduction

Perhaps it is historians' special way of shaking a fist at the image of their own mortality, but every generation must lament that its artifacts, its milieu, will largely be lost to history. One can find countless laments in the early days of recording about what might have been had we just been able to get Lincoln's voice on a cylinder, or the speeches of some other great leader. But one can just as easily turn to one's own professional journals, such as the *Historical Journal of Film, Radio and Television*. Here is Phillip M. Taylor, a historian at Leeds, making the case for "preserving our contemporary communications heritage" in 1995:

> In 2095, when history students look back to our century as we now look back to the nineteenth, they will read that the twentieth century was indeed different from all that went before it by virtue of the enormous explosion in media and communications technologies.... But when they come to examine the primary sources for this period, they will alas find only a ramshackle patchwork of surviving evidence because *we* currently lack the foresight, let alone the imagination, to preserve our contemporary media and communications heritage. By not addressing the issue now, we are relegating our future history to relative obscurity and our future historians to sampling and guesswork (Taylor 1996, p. 420).

Later in the piece Taylor writes that "even the [British] National Film and Television Archive was only able to preserve just over 25 percent of the total broadcast output of ITV and Channel 4 in 1993-94. That means 75 percent lost for posterity ... only a fragment of our contemporary record" (Taylor 1996, p. 424).

Taylor's suppositions are relatively straightforward. We live in a world saturated with media. In some cases, they define contemporary experience. Yet, if the

goal of history is to reconstruct the experience of the past, and most of the past is lost, there is no hope of recovering that lost experience. The logic seems impeccable, so long as one believes that history is about reconstituting lost experience in its fullness and that the route to this lofty goal is best taken through an archive that approaches some ideal of completeness. Our lives are awash in documents that will be rinsed away long before the historians of 2095 come to examine them. I will disagree with Taylor below, but let us hold on to his assumptions for a moment longer.

As it goes for media in general, so it goes for sound recordings and digital sound recordings in particular. Consider the following broad categories of issues in the preservation of digital music "documents" encountered by archivists: digital music documents exist in varying formats, which may correspond to scores, to audio recordings, or "control formats," such as MIDI or MAX/MSP algorithms that are essentially performance instructions for computers. The storage media themselves are unstable. Even if an old hard drive or disc were properly preserved, its "readability" is an open question, given the wide range of software and operating systems in use at any given time. Even then, issues of intelligibility arise: much of what makes digital audio work today relies upon some kind of "metadata," whether we are talking about the names of songs and albums in CDDB or the information on preferred tracks and takes in a multitrack recording (Lee 2000). As in the case of Van IJzendoorn, the Dutch recording enthusiast who lost the notebook indicating the placement of songs on long reels of tape (see Bijsterveld and Jacobs' chapter 1), a collection itself is at best laborious to use without a guide. Even that analogy is inexact, since without metadata, digital files may simply be unplayable, or even impossible to identify as sound files: it would be as if Van IJzendoorn not only lost his notebook, but forgot that his audio tapes actually *were* audio tapes. Even if all of the technocultural considerations were covered, the archivist would still be confronted with the usual set of archival problems. Is the document worth keeping? Is it representative or special in some way? And is it worth elevating as an exemplar of some aspect of the past? For an obsessive collector or hobbyist, this is perhaps less of an issue than for an institution with limited space and budget and the need for some kind of guiding collections policy.

Collecting and Forgetting

One can only imagine the lamenting historian's horror at this state of affairs. The world is populated with an unprecedented number of recordings, yet they exist in countless different formats and with seemingly endless preservation problems. It's cruel. We have made recordings more portable and easier to store than ever before, but in so doing we have also made them more ephemeral. Most of them will be lost to posterity, and despite the efforts of archivists, there is really not much we

can do about it. But of course, there is more than one way to think about forgetting. Here is Friedrich Nietzsche, who offers a very different perspective on the matter from Taylor's:

> Anyone who cannot set himself down on the crest of the moment, forgetting everything from the past, who is not capable of standing on a single point, like a goddess of victory, without dizziness or fear, will never know what happiness is.… A person who wanted to feel utterly and only historically would be like someone who was forced to abstain from sleep or like the beast that is to continue its life only from rumination to constantly repeated rumination" (Nietzsche [1873]1957).

Nietzsche was writing against what he felt to be a paralyzing historicism that dominated German scholarship in his lifetime. While he is probably not the first or best stop for political or aesthetic advice, Nietzsche does offer a useful reminder that forgetting is also an important part of living. It is perhaps too much to say that historians ought to be happy about forgetting, but in order to do their work, and in order for archives to make sense, in order for a document like a recording to have any historical value, a great deal of forgetting must happen first.

Forgetting is both personal and collective. It is sometimes unconscious and sometimes willful. Nietzsche ties it to life, Marc Augé (2004) ties it to death, and Paul Ricoeur (2004) ties it to forgiveness. The term is broad and unwieldy, but for the purposes of this paper, we may think of the collective forgetting that makes a given recording historical, meaningful, or valuable as that which subtends Taylor's drive toward the impossible task of preserving everything. From the point of view of archival institutions, selection and memory are willful acts that define the nature and range of objects available in a given collection. But outside the institution the reality is considerably more messy. Lost master tapes of famous recordings, stacks of unsold compact discs taken to a landfill, or for that matter, a poorly documented file on someone's hard drive are all small moments that may not in themselves constitute a form of willful forgetting, but in the aggregate certainly lead to forgetting nonetheless. Why are some recordings available to us today and others not? The answer has much to do with will and selection choice, but also with broader cultural attitudes about recordings and the sound they contain.

Countless writers have commented that recording in one way or another destroys sound's ephemeral qualities. Sound itself, they write, was rendered durable and repeatable by Edison. Thanks to recording, sound exists in the memories of machines and surfaces as well as the memories of people. Certainly, this is one of the almost magical powers of recording. As Bijsterveld and Jacobs remind us in chapter one, it has been a selling point for new recording technologies at different

times. And certainly, the possibility of preservation opens up the fantasy of cheat-ing time – and death – through an unbroken chain of preservation. But the fantasy that we can commune with the voices of the dead, that what is recorded today will be preserved forever, is just that, a fantasy. Sound recording is an extension of ephemerality, not its undoing. The same could be said of any form of recording, whether we are talking about ancient tablets, dusty account files in a file cabinet, tape backups of the university's mainframe, or the CD-R I burned yesterday. Most records available today are simply waiting to become lost records.

More and more of my friends – whether or not they are serious about music – are unloading their collections of CDs and LPs, preferring instead to keep their collections readily available on hard drives. In making this simple move, while re-taining the music for themselves in the near term, they make it much less likely that any part of their collections will outlive them, given the short lifespan of hard drives. What will happen when this comes to pass and their collections either fade away or disappear rapidly? If it happens too soon, they will recognize their loss and perhaps seek to replace the missing music. But the lack of durability also means that their collections are less likely to outlive them and therefore to recircu-late through various kinds of used markets or other people's collections. In turn, they will never make it into archives. This process is less a simple kind of forget-ting, like forgetting where one left one's car keys; it is more properly a forgetting of forgetting. Our descendents won't even know what is missing.

In important ways, the "forgetting of forgetting" already structures the history of recording. The preciousness that characterizes all recording is perhaps most ap-parent in early examples of surviving phonography. Originally used to describe early printed books, especially those from before 1500, media archivists have ex-panded the term "incunabulum" to include early examples of any recording medi-um. In the case of sound recordings, an incunabulum is any recording from before 1900 (Smart 1980, p. 424). Relatively few recordings from this period exist, and those that do are treated like treasures by archivists. James R. Smart, Library of Congress archivist, puts it thus in a 1980 article:

> They are historic documents in sound which, more than any photograph or paragraph, illustrate nineteenth-century performance styles in music, in vaude-ville routines, in dramatic readings. They teach us, more than any book can, just what our ancestors enjoyed in popular music, what appealed to their sense of the ridiculous or their sense of the dramatic (Smart 1980, p. 424).

Smart's point here is that old recordings, when they are preserved and properly cu-rated, become living documents of history in the present, a point he makes even more emphatically elsewhere in his essay. Even though no playable recordings ex-ist from the first ten years of sound recording's history, he writes that

we now have a large and priceless heritage of recordings reaching back a full nine-ty years. When one considers that many early performers were already fifty years old when they recorded, then it can be realized that we have the means of study-ing the styles and techniques taught as far back as the Civil War. Gladstone and Tennyson, both contemporaries of Abraham Lincoln, are represented on now nearly worn-out recordings, but Pope Leo XIII, born 169 years ago [counting back from 1980–JS], can be heard on two good recordings (Smart 1980, p. 422).

For Smart, the rarity of early recordings is paired with the rarity of memory itself. He partakes of an ideology of transparency that has been widely criticized by sound scholars, myself included, and yet it is undeniable that one of the reasons people find recordings precious is because they offer some kind of access to lost or otherwise inaccessible moments (Williams 1980; Altman 1992; Lastra 2000; Aus-lander 2008 [1999]; Sterne 2003). The curated recording is a hedge against mor-tality, the fragility of memory, and the ever-receding substance of history. The in-terplay between a *bit* of access and large sections of inaccessibility are precisely what makes the past intriguing, mysterious, and potentially revelatory. Thus, the idea that recordings can provide access to the past requires two important prior conditions: 1) as Smart himself argues, it presupposes that certain recordings will be elevated to the status of official historical documents and curated in an appro-priate fashion; and 2) in order for that process to occur, there must be an essential rarity of recordings from the period. Most recordings must become lost record-ings before any recordings can be elevated as historical documents. Given the wide range of recordings made, the only way for a recording to become rare is if most of the recordings like it are lost.

Permanence and Ephemerality

It may seem odd to think that most of the recordings ever made must be lost before any of them can be found and made into historical documents. But in fact the vast majority of recordings in history are lost. For all the grandiloquence about mes-sages to future generations and hearing the voices of the dead, most recordings have (and I would argue, are still) treated by their makers, owners, and users as ephemera, as items to be used for a while and then to be disposed of. This has been a fundamental condition of recording throughout its history. As D.L. LeMahieu wrote of the gramophone in Britain, "popular records became almost as transito-ry in the marketplace as the ephemeral sounds which they preserved…. Within a few generations, records produced by the thousands and millions became rare items. Many were lost altogether" (LeMahieu 1988, p. 89).

Sound recording did as much to promote ephemerality as it did to promote per-manence in the auditory life of a culture. Inasmuch as we can claim it promoted

permanence, sound recording also helped to accelerate the pace of fashion and turnover in popular music. "Songs which a few generations before might have remained popular for decades now rose and fell within a year, or even months" (LeMahieu 1988, p.89). The fundamental classification of recordings as ephemera continues down to the present day, as record collections are routinely mistreated, disposed of, and occasionally recirculated (Keil and Feld 1996; Straw 2000).

In this way, sound recordings became quite typical modern commodities, and the fluctuation of their commercial and historical value depends on their mass disposal and disappearance. Michael Thompson's very interesting book *Rubbish Theory* chronicles the life cycles of similar modern commodities. Thompson argues that mass-produced ephemera begin their lives at a relatively stable level of economic value which diminishes over time as they lose the luster of newness and become increasingly common and available. This loss in value eventually results in their becoming worthless, at which point most of the objects in question are thrown out. Once the objects become relatively rare – through this process of devaluation and disposal – they can again begin to accrue value for collectors through their oddity or rarity. Thompson is interested in old houses, Victorian keepsakes, consumer packaging, and a whole range of odds and ends because of the relationship between their symbolic and economic value (Thompson 1979). His thesis applies equally well to the ebb and flow of cultural value for sound recordings, which were often treated poorly by their owners to begin with. Even when cherished, analog recordings could be worn out or destroyed simply through loving use. Either way, for all the talk of permanence, the careers of individual recordings followed the pattern of ephemera for most of recording technology's history.

Scarcity is a fundamental condition of possibility for historicity, but that scarcity has to be created from a condition of abundance. When history is not struggling with loss, it must struggle with plenitude. That is to say, many recordings must be lost in order for a few recordings to be "found." And plenitude is on the minds of many archivists today because at first blush, it would seem that we have denser saturation than ever before in the history of sound recording. Over forty thousand albums are released each year, worldwide, and in a given month over 1.5 billion music files are exchanged on the Internet. With digital recording, one would think that recording is more plentiful than ever, that in a certain sense it is harder than ever to "lose" recordings. Instead, their ubiquity has become the main point of interest: as MP3s became popular in 1999 and 2000, writers began to put forward the idea of the Internet as "celestial jukebox" where every recording ever made would be available to anyone, anytime, and anywhere.[2] While this imaginary plenitude of recordings continues to be a selling point for online MP3 services, it also raises new issues of selectivity and indexing. After all, no single person can listen to a meaningful fraction of everything ever recorded.

Consider the case of an illegal recording genre such as mashups.[3] A mashup is made by combining two or more recordings and beat-matching them in such a way that they "work" together as a new kind of song. Strictly speaking, mashups are illegal because they are made without any kind of permission or sample clearance. Many of them are anonymous and circulate through file sharing services that are themselves of controversial legality in some countries. Although such recordings are available in abundance and for free, I know of no legitimate archival institution that has begun the process of collecting them despite the fact that many music libraries and sound archives – including national archives – now understand the importance of preserving popular music (a key basis for the kinds of cultural memory explored in Van Dijck's contribution to this volume).

In many cases, current selection and collection policies would actively preclude archival institutions like the U.S. Library of Congress from collecting and cataloging mashups. Thus, an important popular cultural form of the current decade will remain largely undocumented. Eventually, many of the currently popular mashups will move out of circulation and perhaps even disappear from most of their owners' collections if they are not cared for and backed up. A few dedicated collectors will no doubt keep meticulously organized collections, and perhaps, a few decades hence, one such collection will find its way into a major archival institution that exists in a world of more enlightened intellectual property laws. One person's idiosyncratic collection could thus become an important historical resource for anyone interested in what mashups might tell them about the first decade of the 2000s. If this story sounds strange or speculative, recall that the condescension of archival institutions toward popular culture in the early part of the twentieth century meant that they collected nothing for decades. Highly idiosyncratic collections, such as the Warshaw Collection at the Smithsonian National Museum of American History in Washington, D.C., have since come to play important roles in current historiography, despite the fact that the collections themselves had no clear logic of acquisition beyond the collectors' idiosyncratic tastes.

Thus, in many ways, the reaction to digital sound recording is a replay of attitudes that emerged a century ago, in the earliest ages of recording. People hail the possibility for keeping, cataloguing, and making available all of the world's music, all of the world's recorded sound, at the same time that they lament the passing of time and the decline of the available material into obscurity. These laments often go hand-in-hand with practices that actually hasten the disappearance of the music itself. In drawing parallels between the turn of the twentieth century and the present, in deliberately blurring the two periods, Mike Featherstone writes of "an expanding consumer culture and the genesis of world cities that leads to the globalization of culture and the increase in the volume of cultural production and reproduction beyond our capacity to recover the various cultural objects, images and fragments into a framework through which we can make sense of it" (Feath-

erstone 2000, p. 163). For Featherstone, the torrents of media ultimately point to "the failure of subjective culture to deal adequately with the problem of selectivity…" (Featherstone 2000, p. 162). "If everything can potentially be of significance should not part of the archive fever be to record and document everything, as it could one day be useful? The problem then becomes, not what to put into the archive, but what one dare leave out" (Featherstone 2000, p. 170).

Selecting and Forgetting in the Digital Age

Featherstone describes the crux of the problem for collector cultures: there's too much to collect and not enough of a sense of, or agreement about, what should be collected. Current criteria for archival selection are quite underdeveloped. For instance, the National Library of Australia's Guidelines for the Preservation of Digital Heritage are woefully vague, suggesting simply that institutions should preserve materials based on the material's value in "supporting the mission of the organization taking preservation responsibility"; that since future costs of preservation are unpredictable, it would be "irresponsible" to refuse materials that are difficult to preserve; and that some exemplary ephemera should be included with materials that have clear, obvious importance at the present moment (National Library of Australia 2003). The problem with this approach, as with all archival selection, is that it is not future-proof in any meaningful way. The values that guide archival collecting today may be irrelevant to future users of the same material – certainly this has been the case in the past. When you add the seemingly endless permutations of recording formats, software updates and reference-quality standards, even the most basic decisions about preservation become incredibly complex.

Perhaps, by accident, or at least by becoming less stable than their analog predecessors, digital recording formats are less *aides-memoir* than *aides-oubliez*. They will help us forget. While such a proposition would horrify Taylor, there are other ways to consider it given that more recordings now exist – by far – than at any other time in human history. In his essay "Forgetting is a Feature, Not a Bug," Liam Bannon argues that with the massive proliferation of information occasioned by digital technologies, design must be oriented toward forgetting as well as remembering (Bannon 2006). Though his examples are banal, the self-destructing tape of spy movies, "digital shelters" that jam electronic signals, and "sweeper" technologies that indicate whether a recording device is present, his larger point is that the overemphasis on memory is actually debilitating. He is not alone. In 2005, the art group monochrom held a "Magnetism Party" to delete performatively data from hard drives, room cards, audio and video cassettes, floppy discs, drivers licenses, etc. The performance was a critique of information overload, but as Melanie Swalwell points out, it was merely an extreme version of a more basic bu-

reaucratic imperative to delete. Swalwell gives the example of calling the records managers of a regional office of the New Zealand Customs Department in search of a now-defunct system for importing drivers' licenses (the system was important for her research on the history of the game industry). The managers responded, with quite some delight in their voices, that the system was lost to history, because "they don't *have* to keep anything longer than seven years" (Swalwell 2007, 261).

Considering digital technologies primarily in terms of preservation also often begs the question of what exactly is being preserved. Perhaps alluding to personal photography and recordings, Bannon writes that "the issue of what is being preserved when we do make some form of record of an event is also open to question, as usually it is the personal experience of *being there* that is valued, not simply the visual or aural signal captured by the machine" (Bannon 2006, p. 12). Certainly, a good deal of audio recording, if not most, is now about "the recording itself" and not preserving an external event. But this distinction fades a bit as we telescope forward to the recording's life in an archive at some future date. Materials in archives live on as evidence, meaning that for historians, they tend to point toward things outside themselves, and thus even the totally self-contained recording that was never meant as a representation of a live event (as much recorded music now is) comes to represent some aspect of "being there" in the history. This is exactly why Taylor is so worried about the loss of television broadcasts. Without the mediatic dimension of everyday life, without its flow, he worries that future historians will not be able to capture accurately the sense of "being here" in the present.

We can already see this process at work in the preservation of early digital games. Swalwell describes the problems facing the curation of "Malzek," a 1981 arcade game:

> this game still cannot be played as it was intended: no one has seen it working for 20 years, no one knows the correct colours, collisions are not working, and there is no sound. Anyone can download a copy of this (sort of) mass-produced digital work, but in this case redundancy does not ensure the survival of the game (Swalwell 2007, p. 264).

The same conditions apply to digital audio. Not only will metadata be lost, so too might aspects of the files themselves. Archival specialists also expect that preserving digital sound recordings will require more in resources than preserving their analog counterparts. The added expenses come not from storage, since digital storage continues to become cheaper, but rather all the things that come with digital storage: duplication and backup, the need to maintain proper equipment and expertise for "reading" the digital files in whatever format they exist, and all other aspects of infrastructure and maintenance (Russell 1999).

Though there are really no data upon which we can rely with absolute certainty, estimates for the durability of digital media are relatively low. Unused hard drives fail within a few years, and CD-R lifespan is the subject of a broad international debate. Even optimistic industry estimates for the lifespan of compact discs are relatively short by archival standards. A public relations piece for Roxio, a company that makes software for burning CDs and DVDs, estimates the lifespan of a compact disc at seventy to two hundred years (Starrett 2000). A 1996 report by Yale preservation librarian Paul Conway argues that there is a general decline in durability of recorded media over the history of recorded text (Conway 2005). Though he is primarily concerned with written documents, the same reasoning applies to recording: a Berliner zinc or shellac disc will likely be playable long after a compact disc.

Apart from the physical issues associated with decay of digital media, there are a variety of other forces that work against any kind of preservation. Foremost among these is digital rights management (DRM), a generic name for anti-piracy algorithms built into digital files. DRM can limit the number of copies that can be made of a file or the range of media on which a file can be played. For instance, some compact discs are now released with DRM which make them unplayable on computers. This is especially problematic for preservation because all archived sound recordings are, sooner or later, "reformatted" due to the speed with which recordings undergo physical decay (Brylawski 2002). DRM that prevents copying and transfer to new formats will effectively render it impossible to recover or preserve digital files beyond the life spans of their original formats and the companies that control the DRM embedded in the recordings. The life span of a recording with DRM is in the order of years, and perhaps decades, not centuries (Gillespie 2007).

The Preservation Paradox

Although digital technology allows for unprecedented ease in the transfer and stockpiling of recordings, the current condition of plenitude is something of an illusion. If early recordings were destined to become lost recordings, digital recordings move in the same direction, but they do so more quickly and more fitfully. For while a damaged disc or magnetic tape may yield a little information – it may be possible to hear an old recording through the waves of hisses or crackles of a needle as it passes through damaged grooves – digital data have a more radical threshold of intelligibility. One moment they are intelligible, but once their decay becomes palpable, the file is rendered entirely unreadable. In other words, digital files do not age with any grace. Where analog recordings fade slowly into nothingness, digital recordings fall off a cliff from presence into absence.

We can go a step further to argue that the very thing that makes digital record-

ings so convivial, so portable, and so easily stored is their relative ephemerality. It would be wrong to compare digital media with their analog counterparts to argue that digital "dematerializes" recorded sound. On the contrary, the materiality of digital storage is what makes it fragile and ephemeral. The fading ink on the CD-R, the fading magnetic pattern on the surface of a hard drive are banal chemical and physical processes, and not at all related to the "discontinuity" or "disembodiment" attributed to digital audio in other texts (Evans 2005; Sterne 2006a).

So what should we make of a future where most digital recordings will be lost, damaged, unplayable, or separated from their metadata, hopelessly swimming in a potentially infinite universe of meaning? We could follow Taylor's lament and shed some tears for a future that will never be able to reconstruct the fullness of the present we inhabit. But how much history really does that? The conceit behind Taylor's account is that the historian is merely a poorer ethnographer, an ethnographer whose subjects cannot talk back. But Taylor confuses a fantasy of historical writing with its reality. History deals in fragments, with traces, and whereas the fundamental condition for the ethnographer is some kind of co-presence, the fundamental condition for the historian is absence. Most of human history is only available for present analysis in extremely skewed and partial form. We make use of the traces left behind, interpreting them, imposing our own frameworks and questions, and making them speak to our present. As with Bas Jansen's account of the mix tape (see chapter 2), the referent of historical recordings are not the selves "as characters" so much as what he calls the "what-it-was-like." Our fate will be no different for the future, and whatever recordings do survive will be part of that history writing process. They will be open to interpretation and subjected to questions and frameworks we cannot imagine and of which we might not approve – or know to approve. But the future does not need our consent or approval. This is not an abdication of the responsibility to preserve or to remember. It is only an acknowledgement that history, like all forms of memory, is first predicated on forgetting.

Notes

1. Thanks to Jeremy Morris for the title suggestion and important research assistance, to the volume editors for their helpful suggestions, and to Carrie Rentschler for a much-needed read. Additional thanks to Matthew Noble-Olson for help with final edits.
2. See for example, Jenelle Brown, *The Jukebox Manifesto*, 13 November 2000, Salon.com. http://www.salon.com/tech/feature/2000/11/13/jukebox/ (accessed 12 December 2005).
3. This discussion is based on a personal conversation with Samuel Brylawski, former head of the Recorded Sound Division at the Library of Congress, and Mark Katz, "The Second Digital Revolution in Music," Music Library Association Meeting, Pittsburgh 2007.

Part II
Auditory Nostalgia

Chapter Four

Taking Your Favorite Sound Along: Portable Audio Technologies for Mobile Music Listening

Heike Weber

Introduction

In the second half of the twentieth century, portability became a significant design feature in consumer electronics.[1] Manufacturers promoted portable electronics for use anytime and anywhere in contrast to domestic appliances that still depended on a fixed power supply. The rise of portable electronics coincided with an increase in travel and transportation. Mobile technologies that addressed the aural rather than the visual sense came to be seen as the perfect companions for people on the move.

As we know from both Michael Bull's and Tia DeNora's work, users of audio technologies employ recorded music to create and maintain emotions, to elicit memories, and to activate and relax themselves (Bull 2000; DeNora 2000). This happens during both dedicated and "secondary" listening. While secondary listening – listening to music while doing something else – has also been practiced widely with stationary audio equipment, mobile music players naturalized this habit. But mobile music listeners also created novel music listening practices. The emergence of these new practices was not self-explanatory, since the consumption of music was once spatially restricted to certain places, for instance, the concert hall, the festival, and the living room. Hence, mobile listening practices, such as listening to music while strolling around town or taking walks in nature, initially seemed odd to the average citizen and had to be socially negotiated. Ultimately, the users of portable audio technologies, most notably young users, reshaped previous listening cultures and normalized new forms of mobile listening practices. While producers initially conceptualized and marketed the portable radio and the Walkman as a "companion" for travelers and pedestrians respectively, users car-

ried them to ever more diverse places than producers had had in mind, and they developed unforeseen meanings and practices around portable electronics. Users of portable audio technologies thus played a substantial role in shaping their technological designs and meanings, as has been the case for many other technological artifacts (Oudshoorn and Pinch 2003).

This chapter focuses on three key portable technologies: the portable radio, the radio cassette recorder, and the Walkman, in the context of the West German consumer. It will contrast the producers' initial ideas about the use of portable audio devices with the users' subsequent and ongoing conceptions and practices.[2] A number of sources were consulted for making this comparison. For insight into the producers' conceptions of their products' uses, the technical and trade journals used by the industry for information about consumer trends were examined. In addition, this paper draws upon advertisements that publicized these portable devices to users, consumer magazines that represented consumer interests, and market studies that sought to help producers understand users.[3] Furthermore, an expanding data set on music consumption patterns has become available in recent decades, resulting from producers' increasing reliance on research into everyday user behavior. In the long run, however, the official statistics collected during the twentieth century have focused largely on the stationary equipment of private households.

Based on these case studies, portable audio devices are interpreted as mobile "sound souvenirs." While tourists bring along souvenirs from distant places to commemorate their experiences in a foreign culture, portable sounds function inversely. As mobile "sound souvenirs," they help to configure and shape peoples' cultural identities when they travel elsewhere. In the next chapter, Michael Bull shows how the music compiled on portable MP3 players enables users to channel their emotions. Earlier portable audio devices served similar purposes (Weber 2008). Portable radios and tape recorders became a means of creating a personally controlled auditory sphere when away from home, during holiday travels, on the way to work, on the subway, or while shopping. From these case studies, four different modes of using sound souvenirs emerge: the rewind and forward modes, and the modes that fostered group and individual identities.

"Into the great outdoors!":[4] Listening to Mobile Radio in the 1950s and 1960s

At the start of the twenty-first century, the average German household owned six to seven radio receivers, half of which were portable (Breunig 2006, p. 5). Possessing more than one radio became customary during the 1950s and 1960s. The portable radio gradually began to supplement the stationary receiver, which had become a standard domestic technology during the 1930s and was present in

roughly 80 percent of West German households in 1953 (Pater and Schmidt 2007; Schildt 1995, p. 104). The rising sales of portable radios demonstrated West Germany's transformation from a postwar economy of scarcity and tight household budgets to a mass consumer society with increasing consumption, leisure, and mobility. By the end of the 1960s, coinciding with a period of economic boom, a portable radio set was a standard household appliance.

The West German radio industry began the mass production of portable radios in 1950, but lagged a decade behind the US (Schiffer 1991). At first, portable radios were seasonal offers, marketed and sold during the warmer periods of the year. By 1957, portable models accounted for roughly 8 percent of West German radio production.[5] While early designs realized portability by integrating a battery receiver into a closable briefcase or a hinged traveling bag, the "suitcase radio" (*Kofferradio*), whose chassis mimicked a suitcase, soon prevailed. With a handle on top and the speaker and operating knobs on the front, one needed to open the casing only to change the batteries or to switch to another supply voltage.

The portable radio of the 1950s was marketed primarily as a sporty and entertaining piece of equipment to accompany outdoor leisure activities. Both its casing and the labeling of it as a "travel receiver" reflected the promotion of the portable as a "companion" or "partner" during journeys. Grundig, a firm that would soon turn into West Germany's leading consumer electronics manufacturer, invited its customers from the very early 1950s onwards to take the *Grundig Boy* "into the great outdoors." It advertised the *Boy* as a "happy companion for sport and travel," and presented it alongside an image of a female sunbather dressed in a sexy, fashionable bathing suit.[6] These ads appeared at a time when the regular family tour on the weekend and the annual holiday were more of a dream than a reality for most West German families (figure 4.1).

Typical for the West German market was the high-quality performance of the portable audio device. Many sets could receive FM broadcasts, since West Germany's public broadcasting corporations had augmented their medium wavelength programming with shortwave broadcasts since the early 1950s (Weber 2008; Fickers 1998). While FM was introduced as a result of a deficit of medium-wave frequencies, its higher sound quality also fit perfectly with West German radio listeners' preferences for high fidelity broadcasts. The average West German portable radio thus guaranteed excellent sound quality but was also quite heavy (2 to 5 kilograms), thereby making it inappropriate for longer manual transport. Moreover, except for car drivers or bikers, radio listeners rarely used their portable sets while on the move. Rather, the portable radio was taken along as a mute piece of luggage to one's destination and activated once the picnic spot or the sports field was reached. In addition to this, the valves of early portable devices needed time to warm up before operation, making listening while in transit impractical. Portable devices were also used as stationary devices were, as users set

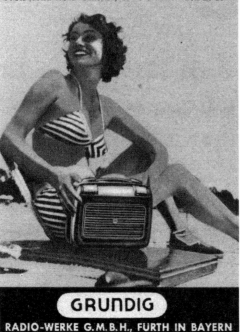

Hinaus ins Freie
mit GRUNDIG-Reisesupern

Jetzt beginnt die Urlaubs- und Reisezeit. Unsere „Boys" warten schon darauf, Sie auf Ihren Fahrten und Wanderungen begleiten zu dürfen. Den „Boys" ist Langeweile ein unbekannter Begriff. Als aufmerksame Gesellschafter werden die kleinen Gesellen Sie stets so unterhalten, wie Sie es gerade wünschen.

Auf solche charmanten Begleiter werden Sie doch keinesfalls verzichten wollen. Jeder Rundfunkhändler vermittelt Ihnen gerne die Bekanntschaft mit den „Grundig-Boys".

Und hier die persönlichen Daten :

„Der kleine Boy"
6-Kreis-Reisesuper für Batterie- und Allstrombetrieb, 4 Röhren und Trockengleichrichter, Schwundregelung, Spezial-Lautsprecher. Formschönes Gehäuse, eingebaute Rahmenantenne. Umschaltung und Batteriewechsel durch einfachen Daumendruck. Gewicht 2,75 kg (betriebsfertig).
Preis (ausschließlich Batterien) **DM 196.—**

„Der große Boy"
7-Kreis-Reisesuper für Batterie- und Allstrombetrieb, 5 Röhren und Trockengleichrichter, Schwundregelung, Tonblende, großer Spezial-Lautsprecher, 3 Wellenbereiche (Kurz – Mittel – Lang), Formschönes Luxusgehäuse, eingebaute Rahmenantenne und mitgelieferte Wurfantenne, besonders leistungsfähige Batterien, ausreichend für ca. 150 Betriebsstunden. Gewicht ca. 5 kg (betriebsfertig).
Preis (ausschließlich Batterien) **DM 276.—**

GRUNDIG
RADIO-WERKE G.M.B.H., FÜRTH IN BAYERN

Figure 4.1 - "Into the great outdoors – with Grundig travel radios," early advertisement for the Grundig portable radio

up their portable sets at home to expand their domestic listening radius, and most West German portable radios operated on both a battery and a fixed power supply.

By the end of the 1950s, the portable radio had lost its seasonal character. The transition coincided with the replacement of radio valves by transistors. In the case of the West German market, this "transistorization" was not driven by a targeted miniaturization, but by the fact that transistors substantially reduced the expensive battery consumption of valve radios. The transistorization, however, was a slow and multi-phased process because transistors adaptable to shortwave and ultra-shortwave reception, which were popular among West German listeners, only entered the market at the end of the 1950s. Accordingly, between 1956 and 1959, West German portable radios that integrated more than just medium wave reception used both transistors and valves.

By 1963, portable sets generated the highest revenue in West German radio sales.[7] While the advent of the transistor had led to a boom in pocket radios, many of these were cheap imports. Because of their low price and inferior sound quality, they were used as a kind of "third" set for use during times when neither a home receiver nor a *Kofferradio* was at hand. While these were popular among teenagers, the "suitcase" design maintained its dominant position. With the full replacement of valves by transistors, the circuits for a fixed power supply were omitted and the receivers were expressly marketed as "universal" sets and natural companions for everyday life, appropriate for use indoors, outdoors, and in automobiles. "Being modern people, we quite simply need a good travel receiver," proclaimed a Grundig advertisement.[8] The producer Graetz illustrated its range of uses in a series of images (figure 4.2). Shaving in the morning, gardening, and traveling by car or railway were all situations manufacturers promoted as ideal for using a portable radio. The advertising of portable devices thus clearly broached the issue of secondary listening. In the 1930s, users of stationary sets had already started combining listening to the radio with other activities (Pater and Schmidt 2007; Douglas 2004). Hence, as studies undertaken by broadcasting corporations showed in the early 1950s, it was common for men to shave while the morning news was being broadcast in an adjoining room – most sets were located in the living room or the kitchen – and for housewives to lighten their domestic chores by

Figure 4.2 - Advertisement showing the multiple use options of the portable radio, Graetz advertisement, 1963

listening to the radio (Meyer 2001, pp. 116-118; Eberhard 1962, pp. 71-75). The portable simplified and supported this practice of relieving and diversifying routines by secondary listening, as it could be taken along to any activity and any listening space.

According to surveys done at the time by a leading opinion research institute, 16 percent of West German households owned a portable radio in 1962. In 1966, this was the case for a third, and in 1971, for more than half of households. By 1971, the distribution of the stationary set had dropped slightly to 78 percent.[9] With a portable radio at hand, users carried their favorite music to ever more places and changed the soundscapes they entered. This involved negotiations as to where radio-borne sounds were deemed appropriate and where they were considered to be a nuisance. In the mid-1950s, the increasing tendency to listen in natural settings – which were perceived to be as yet devoid of technology's influence – became an issue of public discussion. "Don't deaden and drown the voices of nature with a loudspeaker, but for once also listen carefully to the bird twitter in the morning, the swoosh of the trees, the ripple of the waves!"[10] so the technical journal *Funkschau* warned its readers, calling for prudent use of the portable radio. Later, the increasing use of portable radios in urban spaces entered public debate. During the 1960s and 1970s, some swimming pools and public transportation companies banned listening to music on their premises or vehicles. In the long run, however, radios became part of the urban soundscape, with leisure venues such as public outdoor pools becoming natural places for listening to loud music. "Elvis Presley snivels from the left, Willi Schneider sobs from the right, and Heintje squeaks in the highest tones: the soundscape of the portable radio at the swimming pool,"[11] wrote one West German consumer magazine, jokingly describing the sound mixture of bits and pieces of past and current hit parades.

Yet indoor listening remained significant. Market surveys from the early 1970s suggested that the use of portable radios in the home still predominated by a small margin, with the kitchen, bedroom, and bathroom being the favorite listening spots.[12] Furthermore, portable devices were also increasingly found in the workplace. In addition to such "stationary" applications, they were taken along, for instance, in the car, to the pool, on holidays, when making excursions, and to parties. With such mobile applications, the users of portables made themselves as comfortable outdoors as indoors. Even when on the move, users pursued valued, previously domestically restricted routines, and they "domesticated" formerly non-domestic spaces by adding their own personal "sound souvenirs."

During travels and holidays, the mobile sounds created a sense of belonging in a foreign and potentially uncontrollable outside world and reassured mobile listeners of their autonomy and identity anytime, anywhere. When the average West German could afford to go abroad on an annual holiday – in 1961, nearly every second city dweller did so (Pagenstecher 2003, p. 125) – shortwave reception had

been reintroduced in portable radios. Producers explicitly marketed these models as "holiday receivers" or even as a "bridge to the homeland."[13] With shortwave reception at hand, vacationers could tune into West Germany's world broadcast services. In addition, several broadcasting corporations offered special holiday programs such as Ponte Radio, a weekly Bavarian broadcast aimed at West German tourists south of the national border. As going abroad was new to most tourists, and many of them were reluctant to become involved with a foreign language and unknown customs (Pagenstecher 2003, p. 130), a shortwave receiver was a fundamental means of domesticating the holiday resort. The "sound souvenirs" delivered by national broadcasts enabled tourists to stay in touch virtually with a familiar, nationally based soundscape and their native language, while immersing themselves in a foreign culture.

Teenagers as Pioneers of a Mobile Lifestyle

Up until the mid-1950s, West German teenagers listed sports and reading, not listening to music, as their most popular leisure activities (Blücher 1956, p. 32). This would soon change completely. At the end of the 1950s, music gradually turned into a dominant part of teenagers' leisure activities and identity construction. Portable audio devices – or *objets nomades*, as Jacques Attali calls portable audio gear for teenagers (Attali 2001, p. 199) – acquired a special meaning for teenagers, and radio producers actively supported this by supplying models for a specific teenager market. Because of the lack of rock and pop music in West German radio broadcasts, teenagers tuned into different stations: teenagers of the 1950s listened to the networks of the American and British Forces, which targeted military personnel stationed in West Germany, while a decade later, Radio Luxemburg's German shortwave broadcasts became very popular (Siegfried 2006; Weber 2008).

In 1960, 13 percent of West German females between the ages of twelve and sixteen and 37 percent of males between seventeen and twenty owned a portable radio (Scharmann 1965, p. 261n). The 1962 study "Teenagers as Consumers" stated that teenagers frequently owned two radios due to the cheap pocket radios that were popular "for camping, on hikes, or when visiting the public swimming pool" (Heinig 1962, p. 71). Teenagers could not only afford a portable radio more easily than a stationary set, they also genuinely valued the transportability, whereas adults tended to consider portable radios as inferior to the high-end stationary equipment. The urge for mobility was clearly stated in an article published by the teenager magazine *Twen* in 1961. The article was entirely devoted to the advantages of portable radios. "Young people want to be mobile. Thus, also the things and artifacts which they use day-to-day should be as transportable as possible.... One wants to take one's music along – to a friend, to a party, on a journey, or just to the adjoining room."[14] *Twen* praised the spatial flexibility of portable radios, and

it even assured its readers that stationary audio technology would be less valuable.

Teenagers clearly "mobilized" music consumption more extensively than adults. Portable record players and radios were used at public hangouts such as local playgrounds and parks. By listening to youth-specific music or broadcasts, teenagers – notably young males – purposefully claimed parts of the public sphere (Marßolek 2001; Siegfried 2006). Portable radios were taken to friends' places. At home, teenagers not only gained freedom and independence from parental audio equipment, but also evaded the control of their parents by installing their radios beyond an audible radius, in the attic for instance (Baacke 1968, pp. 187n).

Teenagers were also the first to listen to a radio while walking on the street as pedestrians, thereby challenging the prevailing norms of public behavior. Such youth-specific, very visible, and partly subversive mobile listening practices were constantly exposed to adult criticism. "In particular, young people value the continuous reception out of the little suitcase – not always to the delight and pleasure of older companions,"[15] the leading West German consumer journal *Test* asserted about the ongoing inter-generational tensions over loud and truly mobile radio use. For teenagers, however, listening to music was not confined to stationary inside or outside locations. To them, music consumption was a ubiquitous, all-encompassing lifestyle.

Personalizing Mobile Listening: How Walkmans Normalized Public Headphone Use

At the end of the 1970s, market research and sociological studies showed that more than 60 percent of the West German households owned a radio cassette recorder which customarily integrated both a player and a recorder function.[16] Once available as a combination unit in the traditional suitcase design at the end of the 1960s, the radio cassette recorder literally took over the many places where the portable radio had once been used and became standard equipment for semi-mobile secondary listening. When a range of prerecorded music cassettes became available in the early 1970s, cassette recorders enabled users to have their favorite pop and rock stars at hand anytime. Adults took the radio cassette recorder along to their holiday houses or while spending leisure time with others.[17] Radio cassette recorders were also found, quite stationary, on the kitchen shelf or in the hobby room, where they ran on a fixed electricity supply rather than on batteries.

For young users, once again, the radio cassette recorder gained a specific meaning as their "first basic electro-acoustic equipment," often acquired as a gift from their parents.[18] Young users experimented extensively with the recording function of the combination unit. They assembled personal compilations of their favorite songs while they were being broadcast on the hit parade (see Bas Jansen's contribution to this volume). Manufacturers encouraged this. The West German mail-

order company Quelle advertised its cheap radio cassette recorder as a tool "for the young hit hunter," and Grundig emphasized that a self-compiled hit parade was easily produced and saved money because it did not involve any costs beyond the price of the unrecorded cassette tape.[19]

Radio cassette recorder users mainly continued the mobile listening practices users had established during the portable radio's period of expansion. While in principle mobile headphone listening had been possible with earlier portable audio devices – nearly every model had the necessary jack and one earpiece for silent listening – it only became normal to walk around while listening privately to music with the advent of the Walkman. When Sony's engineers combined a small pocket recorder with stereo headphones to create the first Walkman model *TPS-L2* in 1979, they mixed two different listening cultures: the stereo headphone listening of the concentrated, isolated listener and the mobile listening of the secondary listener. Previously, the two-sided headphone design had been a privilege reserved for stationary listening contexts in which subtle acoustic details mattered, such as the strenuous listening done with the early detector radios of the 1920s or the devoted listening to hi-fi tunes that emerged with the advent of stereo transmission and recording in the 1960s and 1970s (Sterne 2003, p 87n; Gauß 1998).

The Walkman met with a wave of enthusiasm among music fans (du Gay et al. 1997). In West Germany, both teenagers and members of a new social stratum of young urban professionals, who would later come to be known as "yuppies," were seen with their Walkmans while shopping, strolling, biking, skating, or commuting. By using the term "Walkman feeling," early Walkman users tried to describe the novel, quasi-cinematic experience that the "mobilization" of the isolated acoustic headphone sphere helped to create.[20] Due to the stereo headphone, the user's perception of the space being crossed was reduced to a visual impression which was blended into the self-chosen, private auditory sphere.

The distinctive feature of the Walkman design was its restriction to a wearable, play-only unit for headphone listening, used either alone or – as most early models incorporated a double headphone jack – with a friend. Compared to the available range of portable audio portables devices that included multiple functions and never abandoned the recording function or the speaker, Sony's mono-functional wearable seemed to be a "technical devolution" (Hosokawa 1987, p. 14n). The West German consumer electronics industry therefore seriously doubted its marketability. However, in just a few years, this reduction to headphone listening would prove to be pivotal for the Walkman's success.

At the same time, headphone listening also became the key issue in the public dispute that followed the Walkman's introduction. To many West German contemporaries, this seemingly permanent "wiring" of headphones to pedestrians appeared quite strange. They occasionally even compared it to a medical transfu-

sion,[21] and most often interpreted it as a sign of social escapism. They discussed the Walkman within the larger incipient social trend towards single households, individualized lifestyles, and the diversification of electronic, leisure-time devices at a time when West German consumers were increasingly exploring the commercially available codes, icons, and sensations of post-modern consumer society (Schulze 1992; Rödder 2004). By the same token, critics interpreted the spread of video games and the introduction of private broadcasting channels as endangering family life and traditional values. The consumption of such new electronic media was seen as a sign of decreasing civic and family involvement and of increasing individualized and consumption-based leisure patterns.

What made the Walkman extraordinary, though, was that individualized consumption was publicly displayed. Since teenagers were considered to express a culture of despair and a lack of social involvement, adults simply considered the Walkman as additional proof of such socially disengaged, resigned behavior. An audio journal defined it as "a technology for a generation which has nothing more to say," and the leading West German news magazine *Der Spiegel* pictured teenagers eating and shopping with their friends while each listened to a personal Walkman.[22] In West Germany, Walkmans indeed remained a technology for teenagers. In 1984, 30 percent of twelve- to fifteen-year-olds owned a Walkman, while 39 percent had a cassette recorder, and 36 percent a record player. The same year, the proportion of Walkman owners shrank to 5 percent in the twenty-five- to twenty-nine-year-old segment of the population (Schönhammer 1988, p. 64; Bonfadelli et al. 1986, p. 64).

In the second half of the 1980s, however, mobile headphone listening also entered the West German world of adults. The diversity of Walkman models available – from the high-tech designs with hi-fi features to specific models for joggers to the cheap low-end offers – ensured that everybody could find suitable equipment. From 1985 onwards, adults embraced the just-introduced portable CD players without hesitation. While not appropriate for pedestrians or joggers, its laser technology promised to guarantee hi-fi sound quality. Moreover, it was expensive enough to qualify as a status symbol for the traveling businessman. As the upper-class and male-oriented consumer magazine *DM* stated, the "traveler of the world" carried a disc player along to listen to his favorite music both "on tour as well as back home with the best sound quality, without crackling and hissing, with a full range of tone from the deepest to the highest note, piano and fortissimo, like in the original concert."[23] The magazine even went on to describe the portable CD player as the perfect tool to carve out a private auditory sphere while in transit, which ensured one's own "comfortable listening climate" wherever needed. Since the male mobile music listener would not be disturbed by work or family duties, mobile situations were actually defined as ideal for music listening – a convenience that would erode with the introduction of the mobile phone in the 1990s. In such

transit situations, mobile music served the same purpose as the car radio: to put travelers and commuters in the mood for the transition between two different realms such as work and home.

As with previous portable audio devices, users of Walkmans and portable CD players employed these technologies both indoors and outdoors, making them into a significant element of urban culture. Shopping pedestrians, urban commuters, cooking housewives, people trying to sleep, and students doing their homework all listened to the Walkman. Others used the device as a language learning kit or listened to relaxing or instructive audio books, a practice which had already been promoted with the cassette recorder to exploit scant time. Even in medical contexts, the Walkman proved useful. Dentists used Walkmans to calm their patients down, and tinnitus patients could drown out the annoying ringing in their ears by playing background music. As in the case of the portable radio, consumers employed their Walkmans in many more situations than the walking and jogging the producers had foreseen.

Once teenagers' use of the Walkman had been studied more closely, it became apparent that young Walkman users did not show less physical activity or social involvement than others. Rather, they used the Walkman as an emotional and perceptional prothesis, like many adult users. "I ... have my own world somehow, I see it differently and hear it differently and feel stronger," one 16-year-old female student related about her emotional experiences with the Walkman, which she took along on her unescorted daily walk to school (Weber 1992, p. 33). Others used the Walkman to relax or to reanimate themselves. Sony's market research found that the Walkman served as a "blankie" (Stelzer 1988, p. 73): the intimate auditory experience provided mental and emotional support. Other teenagers reported that the music enhanced the kinesthetic experience of motion and speed, for instance, when biking. Exactly because users carried their music around with them, any situation could become unique. In addition, some teenagers shared their music by admitting a closed friend, via a second headphone or shared earpieces, into their intimate soundscape. By and large, these accounts resemble practices and experiences later users reported, while female Walkman listeners also emphasized that mobile headphone use prevented public harassment (Bull 2000).

By the end of the twentieth century, personalized mobile headphone listening had become an accepted way of creating a private soundscape; it was a sign of relaxation and well-being rather than one of escapism. Sound sockets have become standard in trains and airplanes so that travelers can tune into relaxing music. Owners of Walkmans and portable CD players value the wearable audio equipment as an emotional and perceptional prosthesis or simply as a tool to accompany daily routes and routines with self-chosen background music. After all, people also use headphones intentionally to block out unwanted soundscapes, which is now seen as a reasonable way to handle mobile lifestyles and compensate for ur-

ban density and noise. The iPod continues this function of mobile headset music, while also simplifying the hit hunters' creation of individual sound albums through its digital format.

Sound Souvenirs: Rewind and Forward, Fostering Group and Individual Identity

Over the last fifty years, listening to self-chosen music has become an integral part of daily domestic and non-domestic life in most societies. This phenomenon has entered nearly all social spaces – the social sphere of childhood, all spaces in the home, and for some, work as well as public spaces, such as urban streets, parks, and subways. Portable radio cassette recorders and Walkmans have become a distinctive element of urban culture around the globe: the former as a means to enhance the urban soundscape, the latter as a means of controlling which sounds one hears and which one ignores (see also Bull 2000).

Portable audio device users are not limited to any one specific spatial realm in regards to their experiences of emotional pleasure or reassurance. By listening to mobile "sound souvenirs," any given spot can be domesticated through a self-selected sound track. Users thus have partially regained control over the spaces they cross, either by making the unknown territory known through familiar songs, or by turning routine activities and commuting into exciting, potentially unique experiences through an accompanying selection of music. In the first practice, users create similarity between the new territory and home by taking sound souvenirs from a familiar to an unfamiliar situation. They go back in time to be able to cope with the present – the "rewind" mode of using sound souvenirs. The second practice, however, can be called the "forward" mode of taking sound souvenirs along. By making the routine unique or the familiar unfamiliar with the help of a self-created sound track, this practice generates future "sound souvenirs," as one will later remember listening to a certain song while doing things like camping at a specific beach or traveling to particular places.

In today's "mobile network society" (Castells et al. 2006), carrying around portable electronics that reassure individuals beyond their domestic retreats has become increasingly important. The mobility of everyday life has increased during the second half of the twentieth century. In West Germany, commuting between home and workplace has become normal since the 1960s, and at the beginning of the twenty-first century, the average German teenager and adult are on the move for more than two hours each day, whether for shopping, leisure, or commuting (Ott and Gerlinger 1992, p. 79; Kramer 2005, p. 195).

Portable electronics have thus become intertwined with both the increased spatial mobility and the growing individualization of society. They have helped to foster and maintain a sense of emotional and cultural identity, which appears to have

drifted from a group to a more individual basis. With the portable radio, German tourists were able to link themselves to home broadcasts to foster their national, or at least, their language-based cultural identity. Teenagers carved out territories in public space by tuning into loud, youth-specific radio stations or by listening to rock and pop stars. With their selectively chosen "sound souvenirs," they created and upheld group identities revolving around music styles and songs. At the same time, however, when used in the home, portable audio devices served to bypass family structures that had existed when all family members had used a stationary set communally. And finally, the portable audio devices of the late twentieth century afforded only a distinctly personalized use in which headphones impeded the environment's participation in the user's mobile experience.

Notes

1. This became even more important when the traditional stationary consumer electronics market began to stagnate around 1980. See International Resource Development Inc. (ed.), *Personal Portable Consumer Electronics Markets* (Norwalk, Connecticut, Report no. 587, Jan. 1984).

2. For another comparison between producers' ideas and users' practices, see chapter 1 by Karin Bijsterveld and Annelies Jacobs in this volume. They discuss an opposite situation in which producers have many more ideas than users in the case of the reel-to-reel tape recorder.

3. All translations from German quotes into English are my own.

4. Slogan from an ad for a Grundig portable audio device, *Funkschau*, no. 12, 1951, p. 237.

5. *Funktechnik*, 1957, no. 15: 504n. ("Zahlen sprechen für sich").

6. See the ads in *Funkschau*, no. 4, 1950, on the back cover; *Funkschau*, 1951, no. 12: 237; *Funktechnik*, 1950, no. 7: 223.

7. *Funktechnik*, 1963, no. 1: 3, 169 ("Reiseempfänger sind Hauptumsatzträger").

8. Advertising brochure "Grundig Reisesuper. Musik Kennt Keine Jahreszeit. Frühjahr 1962": 2 in Archives Deutsches Museum, file FS 002253.

9. *Jahrbuch der öffentlichen Meinung*, 4 1 (965/67): 275 and 5 (1968/73): 400.

10. *Funkschau*, 1954, no. 7: 123

11. *DM*, 1970, no. 7: 51 ("Draußen auf Empfang").

12. See market studies reported in *DM*, 1975, no. 11: 55n ("Musik an jedem Ort: Kofferradios"); *Test*, 1974, no. 5: 252-58 ("Preis und Leistung im Einklang"), and Kursawe 2004, p. 320.

13. Advertising brochure "Grundig," circa 1960. In: Archives Deutsches Museum, file FS 002253.

14. *Twen*, 1961, no. 2: 30-33, here 30 ("Ein Handliches Thema mit 14 Variationen").

15. *Test*, 1970, no. 4: 166-72 ("Laufend auf Empfang") 166.

16. In 1978, 62 percent had radio recorders, 63 percent had a record player, statistics provided by

the "Gesellschaft für Konsumforschung." See: *Funkschau*, no. 20, 1978: 5 ("Eine Mark auf jede Leerkassette?"). Eighty-two percent of the radio recorder owners used it daily or at least several times a week, and 90 percent had at least once taped a cassette.

17. See, for instance, a consumer test report picturing a group of male adults, accompanied by a radio recorder at an evening get-together, *Test*, no. 6, 1975: 320 ("Schwächen im Kassetten-teil. Test: Radiorecorder I").

18. *Test*, No. 12, 1980: 21-27 ("Billige Kombis für junge Hörer").

19. *Quelle Katalog* 1977/78: 763; *Grundig Revue*, Grundig Programm Frühjahr/Sommer 1972: 37, in Archives Deutsches Museum, file FS 002253.

20. See, for instance, a journalist on his first Walkman usage in Peter Glaser, "10 Jahre Walkman: Rock Around the Block," *Tempo* (Juni 1988).

21. As did, for instance, a schoolteacher who talked of a "transfusion." See: Wolfram Flößner, "Homo Walkman," *Schulpraxis* (1981): 1-5.

22. *Stereoplay*, no. 2, 1981: 13; *Der Spiegel*, June 8, 1981, 210-213 ("High und fidel"). From a technical point of view, Sony engineers also considered the public use of headphones as potentially problematic and included a so-called "Talkline" button which, once pushed, lowered the volume. A built-in microphone then transmitted the sound of the environment.

23. *DM*, 1991, no. 12: 58-61 ("'Walk, Don't Run': tragbare Cd-Player"), 58.

Chapter Five

The Auditory Nostalgia of iPod Culture

Michael Bull

I have always believed that certain songs play as a musical timeline for
your life. So, now that it's easy to listen to anything and everything that
I want, I'll have a song for just about every happening in my life. (Fali,
iPod user)

When I was a child, I used to watch a kids' show called "the music ma-
chine" and I always dreamed of having something like that. A device
that plays any song there is. The iPod comes pretty close to the fulfill-
ment of this childhood fantasy. (Jane, iPod user)

Introduction

For the first time in history, the majority of Westerners possess the technology to
create their own private mobile auditory world wherever they go.[1] Apple iPods,
alternative brand MP3 players, or mobile phones whose music listening options
enable these people to construct highly individualized soundscapes. The iPod is
symbolic of a culture in which many increasingly use communication technolo-
gies to control and manage their daily experiences.

In this chapter I focus on one strategy of control: the transcendence of time and
place through the evocation of various forms of auditory nostalgia. IPod users of-
ten report being in dream reveries while on the move – turned inward from the
world – and living in an interiorized and pleasurable world of their own making,
away from the historical contingency of the world, and into the certainty of their
own past, real or imagined, enclosed safely within their own private auditory
soundscape. Nostalgia bathes these experiences in a warm, personalized glow.

In the following pages I analyze user accounts of such nostalgic reveries. For a
book project, over one thousand iPod users filled out a questionnaire on the Inter-

net in 2004.[2] The respondents answered requests posted in the *New York Times*, *BBC News Online*, *The Guardian Online*, *Wired News*, and *MacWorld*. These requests were then syndicated and replicated in a wide variety of newspapers and magazines worldwide. From February to April 2004, I received 4,136 requests for the iPod questionnaire.

Respondents came mainly from the U.S., U.K., Canada, Australia, and Switzerland, but also included people from France, Italy, Spain, Denmark, Finland, and Norway. Apple gives no regional figures for sales, so it was impossible to tell whether the respondents mirrored national use or were a reflection of the use of the specific Internet sites on which the requests were posted. Equally, the questionnaire was written in English, thus discounting iPod users with no capacity for written English. The majority of respondents came from social classes I (professional) and II (intermediate) with a distinct bias towards working in new media, advertising, and the creative sectors of the economy. Studies of Internet research have often found no differences between Internet samples and others gained by more traditional methods (Smith and Leigh 1997). The median age of respondents was thirty-four. Fifty-three percent of respondents were male; the age differences between male and female users were insignificant.

The questionnaire asked about general iPod use in relation to the use of other communication technologies, such as the mobile phone, television, radio, automobiles, and public transport. Respondents were invited to describe use over a period of a week and to include data on what was listened to. Twenty percent of respondents were then asked follow-up questions in response to their initial answers. In addition to the Internet sample, a small sample of U.K. users was interviewed personally.

In analyzing the respondents' accounts, I reclaim the value of individualized forms of auditory nostalgia as opposed to the culturally fabricated ones contained in the critique of nostalgia formulated in social and cultural studies (Huyssen 2003). IPod users represent a different moment of culture to those found in José van Dijck's contribution (see chapter 7). While her chapter charts the interrelationship between personal and collective memories of popular music among Dutch radio listeners, the iPod users in this chapter tend to consciously turn away from collective forms of listening embodied in radio use.

This is not to deny that Ipod users too are part of the cultural Zeitgeist, but a part of this Zeitgeist is represented by what I refer to as a hyper-post-Fordist moment of consumer culture, in which subjects seek out "individualized" moments of consumption with all the theoretical ambiguity that this involves. In a hyper-post-Fordist culture, subjects construct what they imagine to be their own individualized schedules of daily life – their own daily soundtrack of media messages, their own soundscape as they move through shopping centers, their own workout sound track as they modulate the movement of their bodies in the gym. Within the

enveloping acoustics of the iPod, its users move through space in their auditory bubble, on the street, in their automobiles, on public transport. In tune with their body, their world becomes one with their "sound tracked" movements, moving to the rhythm of their music rather than to the rhythm of the street. In tune with their thoughts, their chosen music enables them to focus on their feelings, desires, and auditory memories. The nature and status of these individualized auditory nostalgias is the subject of the present chapter.

A Brief Narrative of Mechanical Reproduction and Auditory Nostalgia

Nostalgia is a dominant mode of address in contemporary urban experience. It helps to locate the subject in the world, it gives a semblance of coherence, and it warms up the space of movement in a mobile world in which users increasingly deflect away from the spaces and time traversed.

Nostalgia and mechanical reproduction go together: experience is reproduced (the dead come back to life), and that which is forgotten is bathed in a light of recollection. Mediated nostalgia – nostalgia generated through the record player, the photograph, or the iPod – reverses the irreversibility of time in the mind of the subject. The history of mechanical reproduction is thus a history of the increased ability of people to create patterns of instant recall in which they conjure up real or imagined memories of home, place, and identity. Early research into the use of the gramophone record displays much of the geography of memory, nostalgia, and longing that resonates through contemporary iPod use. The Edison Survey of American record listeners, undertaken in 1921, found that for many Americans – the country of immigrants – listening to gramophone music transported them back or linked them to their absent homes and families, providing them with a "script of central themes of [their] lives.... The process of phonographic remembering included a growing sense of mastery over powerful memories of the past as the listener summoned forth the music that stimulated the emotions linked to memory" (Kenny 1999, pp. 8-10).

The phonograph, placed in the center of the family home, enabled or sparked these memories through the playing of short two-minute records, of a Caruso, or of a Central European folk song. Families or parents would listen collectively to the sounds of music that reminded them of their homes far away, or the people they had left behind. In this sense, the music may not have had a specific link other than it represented the sounds of Bohemia or Italy, representing a stratified cultural dream pool for these groups of people – even as it was consumed in the domestic spaces of the home. Early descriptions of nostalgia invoke a "shared," even though often imaginary, sensory experience. Radio continued in the collectivized auditory nostalgia of twentieth-century Western society.

Radio historian Susan J. Douglas has noted the shift from the collectivized

memories associated with early radio to the more recent post-Fordist segmental-ization of the audience through radio formatting (Douglas 2004). Industry spokesmen insist that, especially in large markets, there's more variety than ever, since the listener can choose from a host of carefully crafted and narrowly defined formats. But within the format of a particular station, variety is kept outside the door. In promotional ads, listeners are assured that they won't ever have to hear, for example, heavy metal, rap, or anything unexpected on their station. Audience research indicates that many Americans want this kind of safe, gated-in listening. It goes with our increasingly insular, gated communities and lives (Douglas 2004, p. 348). The segmented nature of contemporary radio listening evoked by Dou-glas's largely nostalgic reverie of Fordist radio reception is superseded in the pres-ent account by the individualized scheduling of music in the most recent of mobile auditory technologies, the iPod.

Practicing Auditory Nostalgia

Nostalgia can be triggered by a sense of smell, touch, a sound, or an image. Swiss soldiers stationed in France in the eighteenth century were the first clinically de-fined victims of "nostalgia." Supposedly, bouts of nostalgia among the soldiers were triggered by the Alpine melodies of Switzerland: "the sounds of a certain rus-tic cantilena that accompanied shepherds in their driving of the herds to pasture immediately provoked an epidemic of nostalgia amongst the soldiers" (Boym 2001, p. 4). These troops were treated with leeches or, alternatively, and probably preferably, a swift return home.

Auditory memory for these soldiers was represented by the sounds of home. Their memory of the sounds of the village was frequently communal, as was their plight of fighting in a war far from home. Their traditional sense of life's slow rhythm was in contrast to the experience of the speed of bullets and of the swift na-ture of battle that they unfortunately found themselves in. The memory of home invoked by the soldiers – one of slowness and community – was epitomized by the ringing of the village bell. Historian Alain Corbin argued that in nineteenth-centu-ry rural France, people's sense of presence was a largely auditory one with the sound of the bell invoking stronger memories than the image of the village. Bells were "invested with an intense emotional power," symbolizing a strong sense of community (Corbin 1998, p. 80). The Swiss soldiers' memories were similarly rooted to a particular geographical and sonic space.

In contrast to the sound of the bell in the eighteenth and nineteenth centuries, in contemporary culture, the technology of the iPod provides an auditory mnemonic for contemporary nostalgic. Paradoxically, my first example is of a Swiss national. Jerome has lived and worked in the U.S. for the last seven years since meeting Claire, his American wife. Jerome is thirty-seven and works in Indianapolis as a

senior partner in a law firm. Jerome's life has been highly mobile, having lived not just in Switzerland, but also in France, Australia, and now the U.S. Like many urban dwellers, Jerome's life has been one of chosen displacement, movement, and transitory abodes. Movement is also inscribed into his working day by his sixty-minute solitary drive to work each day.

Jerome has a music collection of over five thousand CDs and LPs. At the time of the interview, he had downloaded 9,800 tunes onto his iPod, divided into twenty-five different genres and multiple playlists. Jerome, like many users, is tethered to his iPod, which he describes as his regular companion to the activities of his day: "There hasn't been a day since I bought my iPod in 2003 that I haven't used this little device." Jerome uses music "as a kind of diary," and considers his iPod as a "time machine." It enables him to operationalize his nostalgic reveries at will:

> The iPod is pretty much the diary or soundtrack to my life. There is a song for every situation in my life. Even if I might have forgotten about a certain time, person, or place, a song can trigger these memories again in no time.

Memory recall itself is contingent on the music played. Jerome might consciously recall a memory by choosing a specific tune or playlist, or, alternatively, rely on the iPod randomly choosing something from his whole collection. Memories are evoked most predictably from his "all time favorites list" of 113 "5 Star" songs. Nostalgia is most commonly evoked by Jerome while listening to his iPod on his way to and from work rather than while listening at home with his family:

> Driving in the countryside of Indiana does not quite take as much concentration as driving through the rush hour traffic in London. I usually set my car on "cruise control," and just keep an eye on the traffic in front of me (which is not too heavy here in Indiana). The songs transform me to all kind of places in my life.... And that is what I love about the "shuffle" feature. Whenever a "childhood" song comes on, I "feel" like I am back in my parent's house. Then a track from an Australian band might bring me back to the two years I have spent in Sydney. I sometimes don't even remember that I have passed certain "points" on my drive from or to work. This thing is a wonderful "time machine" and is better than any diary.

Driving becomes primarily an auditory experience with the shuffle feature of the iPod picking music at random. The unpredictability of the randomness of choice is prefaced by the certainty of what is contained in the iPod's memory. The unpredictability contained within the random mode of the iPod differs significantly for example from that of a favorite radio program. The iPod has supplanted the radio and the CD player as the auditory companion of the driver as Jerome explains: "I

don't want to have to listen to a song I don't like." The iPod "drives me wherever I
go." Jerome is "gated in" by his music preferences, experiencing the pleasures of
random access to his music while simultaneously isolating himself from tradition-
al auditory technologies which are perceived of as either limiting or unpredictable.
The iPod permits him to successfully micromanage his mode of nostalgia:

> Sometimes I am in a certain mood (home sick to Switzerland, melancholy –
> thinking about my childhood or certain events in my life etc.) in which case I
> choose a specific play list that has all the songs that relate to this specific situa-
> tion. Sometimes I just want to hear all my favourite tracks and I only play "Five
> Star" songs.

Jerome is precise about the way in which certain songs make up his "auditory
diary":

> I have a lot of music that I use as kind of a "diary." As an example, when I grew up
> in the Seventies in Switzerland, I was a huge "Smokie" fan. In fact, my very first
> record that I bought was "Bright Lights and Back Alleys" from Smokie. I saved
> all my money for months just to get me that album. So, I have music on my iPod,
> that reminds me of a very specific part of my life (Smokie = Childhood, Status
> Quo = my teenage years, Jesus and Mary Chain = my first love, Wham! = the very
> first time I went to London and absolutely loved it there, REO Speedwagon = the
> very first time I went to Indianapolis and met my wife…). I left Switzerland seven
> years ago and moved to the USA. Hence, I have some "Swiss Folk" music on my
> iPod, which I usually wouldn't listen to, but whenever I get homesick, it is the
> perfect soundtrack to my mood. This is where play lists come in…. this feature is
> simply great!

Nostalgia might then be represented by a "mood," the music played representing
some notion of home, very much in the manner of the eighteenth-century Swiss
soldiers. For Jerome, the soundtrack to his mood is Swiss music that he otherwise
would not listen to. Other music appears to represent either generalized times of
life or more specific situations. These specific occasions are linked to the songs on
his "Five Star" list of perennial favorites, which all hold a specific and "very deep
meaning" for him, meanings which he habitually conjures up while listening in his
car. Although Jerome also listens to a lot of music at home, stating humorously,
"my wife sometimes jokes that I spend more time with my iPod then I do with her,"
nostalgic reverie appears to take place primarily in his automobile as a solitary
exercise.

 The act of listening becomes a journey through the iconic moments and periods
in Jerome's life, a private and domestic narrative of specific childhood experi-

ences, such as his mother singing along to Abba, and reminiscing on the senti-
ments of lost love. The music – Abba – might have actually been played at the time,
or it might merely remind Jerome of his feelings at that time. He vividly recalls the
power of being transported out of his time and place by specific songs:

> A song can transport me to any time and place in my life in a matter of seconds. It
> plays "Wake me up, before you Go Go" by Wham! and I am immediately walk-
> ing down Oxford Street in my mind. It plays "For a few dollars more" by Smok-
> ie, and I am back in my room at my parent's home, looking out of my window
> over the city of Zürich. It plays "Unbelievable" by EMF, and I am back with my
> best friends in "Serfaus" on our annual ski vacation that we used to have during
> the nineties. It plays "Happy when it Rains" by Jesus and Mary Chain, and I am
> immediately back in the "Swiss Army," the time that I hated the most, but which
> also brings back some of my most treasured memories, because my girlfriend was
> waiting for me at the train station every time I got back home for the weekend.

Sound is a powerful aphrodisiac when it comes to evoking memory. Memories are
largely mediated memories in iPod culture, a mediated life through which to filter
one's personal narrative. This coupling of the personal to the commodity is a hall-
mark of iPod culture with users in potentially constant touch with their narrative
past. Musical pasts also become reconfigured and rediscovered in iPod culture.
Musical identity is inscribed onto a portable memory bank giving the user instant
access to its contents.

George, a forty-nine-year-old teacher with two teenage daughters living in the
north of England (both of whom have iPods bought by George), keeps musically
up to date by downloading his daughters' music. He also uses his iPod to excavate
his own musical past. George grew up in a poor, rundown Liverpool neighbor-
hood in a house that had no garden and only an outside toilet. He describes how
the Harry Belafonte song "Oh Island in the Sun" became firmly entrenched in his
media reveries as a child, as he dreamed of an elsewhere that would take him away
from the bleak, cold environment in which he lived. The Belafonte song evokes an
idyllic blue sky, blue seas, and white sands, ironically displaying the mediated
power of orientalism even on a young child. As an adult, he recalls the shock of vis-
iting the Bahamas and hearing a group of musicians playing "Oh, island in the
sun." Paradoxically, he remembers being taken back to his childhood to the
cramped and damp Liverpool house of his youth by the sounds of the song. The
successful retrieval of time, of a past brought to a vivid present through the con-
struction of a complete and personalized archive, as hinted by George's descrip-
tion of his auditory search into the past, taps into a consumer's dream of omnipo-
tence. In the fragments of one's musical collection, one can find a past which is
"out there," ready to be found or completed.[3]

Sarah, a thirty-year-old freelance writer who travels regularly between New York and London, shows that the retrieval of one's musical past need not be the preserve of the middle-aged:

> It's reacquainted me with my old "back catalogue" of music that I only have on vinyl or tapes, and had therefore not listened to in years. Now with file sharing online or borrowing from friends, I feel like I've got a lot of "old friends" back. That is, music that really means a lot to me in a nostalgic way, I guess, that I had-n't got around to re-purchasing, and maybe wouldn't have. It's like having all your books with you wherever you go, or better still, a library of your own cura-tion at your fingertips.

In addition, her account illustrates how the gathering in of one's musical past is frequently a social exercise involving friends, family, or acquaintances, even while the practice of nostalgia is commonly a solitary exercise for iPod users. The virtu-ality of the process of collecting music breaks down the considerable physical bar-riers to potential retrieval associated with music stored on tapes or vinyl. (See chapter 3, Jonathan Sterne's contribution to this volume, for an understanding of the contingent nature of digital storage that goes unrecognized in users' accounts.)

Auditory mnemonics work directly as users literally reimagine their experi-ences through songs or through associations:

> My favourites are normally my favourites because they remind me of a specific time or feeling. Some of those favourites are Tori Amos's song "Winter" because it reminds me of words my dad would say to me before he passed away. (Heather)

Yet auditory mnemonics also cultivate generalized memoryscapes for users in which the sensory landscape is transformed through evoking a mood or memory of the listener:

> Sometimes if the music has a particular memory associated with it, the world sometimes takes on the characteristics of the time and place the memory evokes. Listening to an old Beatles track, for example, brings back memories of my fa-ther listening to that music when I was a kid, and the world can sometimes feel like it was still in the late 70s/early 80s, even though that isn't the time of the recordings themselves. (Brian)

The geographer Ben Anderson has noted that auditory memory is often involun-tary, being a practice of intuition that "embodies a form of sensual mimetic re-membering" (Anderson 2004, p. 8). A piece of music might remind the listener of

warm weather or of feeling good without him or her being able to formally identi-
fy why this is the case. Anderson cites an example of a subject who, on hearing The
Beatles' song "In My Life," thinks of her dead father even though he disliked Bea-
tles music (Anderson 2004, p. 10). In this case, emotions and feelings are invoked
by the song rather than by the musical identification that the father had with the
music, unlike Brian's description of his father listening to a Beatles song.

 Nostalgia is both individualized and, at the same time, commoditized in iPod
culture. Individualized forms of mediated nostalgia inhabit the same life world as
those prefabricated forms of nostalgia provided by the culture industry. Such
"sweet ready mades reflect the culture industry's attempt to tame the longing for
the subjects desire for non-commodified time" (Boyn 2001, p. xvii). Technology
acts both as a threat and an enabling medium, offering the iPod user the facility to
either embrace or transcend the culture industry's cultural directive to consume to
the manner born.

Nostalgia Contested

Nostalgia is a contested and culturally loaded concept often equated with simulat-
ed forms of sentimentality: a view of the past through rose-tinted glasses, the
cracks polished over. Many consider nostalgia the product of individual fancy and
collective ideology, representing a trivialization of experience invariably associat-
ed with popular culture. Nostalgia is frequently treated as a structural and con-
temporary disease of the present, as a set of ersatz experiences promoted by the
culture industry's intent of stealing not just the present, but also the past from con-
sumers. From this perspective, contemporary consumer culture is thought to be
awash with simulated forms of nostalgia in which "the past has become part of the
present in ways simply unimaginable in earlier centuries" (Huyssen 2003, p. 1;
Kenny 1999; Seremetakis 1996).

 If consumer culture attempts to commoditize all experience, or to colonize as
much of the daily lives of consumers as possible, then the production of mobile
technologies like the iPod would appear to signify this "colonization" of our life
world on an even more pervasive level, as users move seamlessly through daily life
to the mediated accompaniment of the sounds of the culture industry. What better
than to sell mobile technologies to consumers that enable them to tap into the
dreams of commodity culture virtually anywhere and any time?

 Yet this "one-dimensional" view of the relationship between the consumer and
commodity culture obscures the way in which individuals reappropriate the prod-
ucts of the culture industry in daily life. The individual creation of specific audito-
ry memories used in a nostalgic fashion is not necessarily reducible to the fabricat-
ed constructions of the culture industry. To be sure, all subjects might be prey to
these fabrications, yet the present analysis demonstrates the significance of the in-

dividual appropriation of meanings by users. This is not to suggest that everything invokes forms of auditory nostalgia. Nostalgia is merely one structural possibility of use enabled by the capacity and portability of MP3 technology offering round-the-clock connectivity to one's past. The culture of nostalgia embodied in the personalized auditory recall of iPod users represents a significant "practice of everyday life" that, despite the workings of the culture industry, permits potential creativity within the everyday, routinized consumption process. From this position, nostalgia and the workings of memory are not merely the product of a culture striving to sell people memories at all cost, but also a utopian moment in daily life whereby consumers attempt to transcend the present through individualized modes of recall.

Philosopher Theodor Adorno, in typical dystopian fashion, believed that the commoditization of experience created structural social amnesia, as the media stretch out into an ever-expanded present (Adorno 1999). Instantly coupled with information overload, we rarely remember the news programs of only two days ago: the rhythm of daily life has become increasingly structured and partitioned by media production and consumption (Lefebvre 2004 [1992]). Yet, in tune with this media overload, which is thought to assault our sensibilities in a welter of social forgetting, comes parallel modes of technologically facilitated forms of personal retrieval. Mobile technologies such as iPods not only become digitalized urban sherpas for many users, they become personalized repositories for a subject's narrative. In the chilly, anonymous, and disenchanted urban spaces moved through come the urge to centralize oneself, to place oneself. As iPod users negotiate their way through their auditory mnemonic, we need not deny the powerful influence of the media on both the desire for a nostalgic life and the contents contained therein. IPod users' personally narrated nostalgia remains channeled through the commodities of the culture industry. IPod users work, often self-consciously, within the commodification of experience to eke out the value of their own time and experience.

Nostalgia is invariably a pleasurable experience for users of iPods. This pleasure lies in the very creativity of the exercise in which nostalgia becomes an urban form of the aesthetic, a successful aestheticization of experience. In this scenario, the isolated user is accompanied through their day by the warm glow of their memories and their associated moods. Daily life becomes infused with the warmth of a narrative presence. IPod users, in effect, are never alone. The "imaginary" realm of the users' presence negates the sensual determinacy of the immediate, the tactile and visual world through which they move. This very negation of the "present" in its determinacy has been considered to be potentially liberating in the writings of Friedrich Nietzsche (1967), Ernst Bloch (1986), Walter Benjamin (1996-2003a [1927-1934]), and Theodor Adorno (1998), where they identify the transcendent nature of the imaginary, the going beyond that which "really is," as

possessing progressive elements. These acts of "going beyond" encompass the utopian sensibility of living a life as it should be lived within a privatized and personalized world of nostalgic reverie.

Notes

1. One half of Australians possess an MP3 player or its equivalent, such as an iPod or mobile phone with listening capabilities, while the figures in China and South Korea are 70 percent. The iPod takes its place in the history of auditory mobile technologies. The personal stereo was the technological predecessor to the iPod insomuch as it permitted users to take their personally chosen music on the move with them. Personal stereos differ from iPods insofar as their contents are restricted and static. Users often resorted to switching their machines off if the music didn't fit in with the cognitive desire of the user (Bull 2000). IPod users frequently reorder their music on the move, or give themselves over to the randomness of listening. In doing so, they might be described as fine tuning the relationship between cognition and music – they become "listening selves."
2. See Bull (2008).

Chapter Six

Performance and Nostalgia on the Oldies Circuit[1]

Timothy D. Taylor

Introduction

In 1869, members of the Methodist Episcopal Church built a town on the coast of New Jersey (regionally known as "the Jersey shore"). The town was populated mainly by Methodists, as it is to this day. Every August, for one week, thousands of people from out of town would descend on this tiny shore village for a "camp meeting," a week of sermons, prayer, hymn singing, and fellowship. To accommodate them all, in 1894 the church fathers built a large auditorium called, appropriately enough, the Great Auditorium. This enormous wooden structure seats about six thousand people and today, when not used for religious purposes, it is rented out to various acts from local singing groups to internationally famous musicians such as Ray Charles. This venue also serves as a node in the "oldies circuit," the frequently disparaged pasture for superannuated popular musicians from the 1950s and 1960s. Every summer, several concerts of doo-wop and other oldies groups occur in the Great Auditorium. Doo-wop is a popular music that is fairly simple harmonically and melodically, frequently employing vocables – hence the name. It was a music made mostly by teenagers for teenagers that thematized their concerns, especially love and sex. Audiences are large, mostly white, and middle-aged and older.

Seeking to escape the sweltering summers of New York City, my wife and I bought a little house in this town. Sixty miles from New York City, two blocks from the beach, it was the perfect escape, despite the religious nature of the town. (We actually were asked by our real estate agent what our religion was, and my response – not my wife's – was entered on a form, along with the name and address of my childhood pastor, my wife's religion having been assumed to be the same, though it is not.) And we attended some of these concerts. Seeing them over the few years that we summered there, it became clear that they were all organized and

presented the same way. A local radio DJ was the host at every show we saw.[2] He served not only as the host but as a localizing influence: the acts might not have been from New Jersey (though some were), but it didn't matter because there was a local person prominently displayed, mediating. Every show we saw featured three doo-wop acts, ranging from the extremely well known, such as the Coasters (The Billy Guy Coasters, not the group that has ownership of the name[3]), the Marvelettes, the Tokens, and the Del Vikings to groups not quite as well known, such as the Duprees. The backup band was always the same with the exception of the Tokens, in which case the grandson of the lead singer, Jay Siegel, took over.[4] Before the show, at intermission, and afterwards, the musicians would be outside the auditorium selling recordings and offering to autograph them. The recordings were never the ones that had made the groups famous, but were recent recordings, usually of these bands on tour, performing pretty much the same show their audiences were seeing.

Doo-wop and Nostalgia

The extraordinary affection with which crowds greeted these performances and with which fans continue to have toward this music are a result of a complicated mixture of nostalgia for times past and a lost youth. Additionally, the music has also come to signify a moment in American history when many people felt that racial integration could be peacefully achieved in sharp contrast to the kind of hard-edged racial dynamics frequently articulated in today's hip hop music.

Doo-wop was a music associated with teenagers and produced mainly, though not exclusively, by African Americans; some Jewish and Italian Americans also had success. It was music about love and passion and other teenage concerns, mainly from their young and idealistic perspectives.[5] Songs about love and other teenage themes united blacks and whites around this music. Song lyrics, from the two most popular doo-wop songs ever, The Penguins' "Earth Angel" and the Five Satins' "In the Still of the Night," both from 1954, for example, are all about young love and the thrill of sex.

Earth angel,
Earth angel
Will you be mine
My darling dear
Love you all the time
I'm just a fool,
A fool in love, with you

In the still of the night
I held you
Held you tight
'Cause I love
Love you so
Promise I'll never
Let you go
In the still of the night

It would be difficult to overestimate the effect of songs such as these on young peo-
ple of the era. One woman, who was thirteen years old at the beginnings of doo-
wop in 1954, told me that this music was like nothing that she and her friends had
heard before: as opposed to the rigid duple meter of so many pop songs, it rocked
and swayed (since much of it was in more capacious compound meters such as
12/8). And it was much more passionate and sexy than any music she knew. These
sentiments occur also in Donald Katz's remarkable book *Home Fires*, a story of a
Long Island, New York family from the end of World War II to the present. The
oldest child in the family, Susan, discovered rock 'n' roll and doo-wop in the mid-
1950s as an early teenager:

> [Alan] Freed, the WINS disc jockey whose near-hysterical delivery penetrated
> the walls of 221 Lincoln [the family home], had been calling the driving music he
> played "rock 'n' roll" since 1950. Susan would sit next to the radio every night,
> neatly jotting in a notebook the titles and performers of all the songs he played.
> This cataloging process helped Susan choose 78- and 45-rpm records to add to
> her collection, but she also took notes because she wanted to understand and re-
> member everything she could about music that could change her mood and
> make her entire body tingle. A few of her school friends seemed to "feel" the pure
> emotion of the music too, and Susan wanted to talk to them about it, to be close
> to those who'd had the same experience. (Katz 1992, p. 91)[6]

Susan found her way to a concert hosted by Freed in nearby Brooklyn: twenty
bands, including the Cleftones, the G-Clefs, the Platters, the Moonglows, and the
Drifters appeared.

> Susan and [her younger sister] Lorraine felt the show leave the stage and flow like
> lava into the audience. The music encircled the girls ... as young people danced in
> the aisles beside them. The show was a purity of sensation that resonated inside
> them, pulsing, expansive, full of joy. For Lorraine, the enthralling spectacle was
> enhanced by the presence of black people.... They were all around her....
> [N]ever had she seen such passion and overpowering emotion. She watched

black girls sway to and fro and tried to move like they did…. By the end of the show in Brooklyn on that memorable evening, the aisles were completely clogged. Everyone was dancing, singing, surging toward the stage. Lorraine was only ten years old, and Susan had just turned thirteen, but inside the Brooklyn Paramount they were truly sisters, bridging the chronological divide that separated them in the suburbs. The rocking, exuberant crowd in the theater was integrated in every way by the music, by how it made them feel. (Katz 1992, pp. 93-96)

But with the rise of rock and roll, especially after the British Invasion of 1964, the rebel-individual, a more "adult" positionality than that articulated by doo-wop, became valorized. Doo-wop quickly became relegated to the sidelines of popular music, no longer listened to by anyone but the most serious fans (see Melnick 1997).

Doo-wop's rapid eclipse helped make it a collector's music very quickly. Jeffrey Melnick argues that Anthony J. Gribin and Matthew M. Schiff's encyclopedic *Doo-Wop: The Forgotten Third of Rock 'n Roll* "reminds us that doo-wop was transformed into a collector's artifact more quickly, more decisively, and more zealously than perhaps any other subgenre of American music," and notes that "by the early 1960s, doo-wop had become the property of collectors and anthologizers" (Melnick 1997, p. 137). And, indeed, Gribin and Schiff's "songography" is an astonishing 450-page list of musicians and their recordings, a formidable monument to doo-wop "collectordom" (Gribin and Schiff 1992). A *New York Times* story about one of the many doo-wop revivals, this one in the early 1990s, says "the doo-wop world exists in a string of specialty record shops, private record collections, small club dates and gatherings of devotees sprinkled through the blue-collar byways of the New York region" (Gottlieb 1993, p. 25).

Doo-wop's quick exit from the scene and its conversion from a living, meaningful music for youths in the 1950s to a powerful sign of that youth and feelings associated with it means that, today, the music serves as a potent trigger for a structure of feeling of nostalgia, taking listeners back to what they invariably describe on websites, in published interviews, and informal conversation as simpler or more innocent times, which is frequently euphemistic for times when there was less tension about race. Let me make it clear here that I am referring to nostalgia not as a psychological condition or a pathology (see Michael Bull's contribution to this volume), but as a Raymond Williamsesque structure of feeling that emerged in European modernity. Nostalgia as a structure of feeling has changed considerably over time, proliferating and, as many have written, taking on great importance in late modernity. In today's consumer culture, nostalgia can be associated with or provoked through commodities, and the complex kinds of relationships that people can have to them, in a number of ways.

Williams's conception of "structure of feeling" is useful in this context because it removes "feeling" from the realm of the individual and the psychological and places it instead in the realm of the cultural, historical, and material. And it is valuable in more immediate terms because it allies feeling with experience. Williams first introduced the concept in *The Long Revolution*, and presented it again in *Marxism and Literature*, where it has perhaps been the most influential and the most attacked. Yet I believe it continues to be a useful concept, for it helps to theorize some of the most palpable but least concrete aspects of life, as Williams writes:

> It is as firm and definite as "structure" suggests, yet it operates in the most delicate and least tangible parts of our activity. In one sense, this structure of feeling is the culture of a period: it is the particular living result of all the elements in the general organization. And it is in this respect that the arts of a period, taking these to include characteristic approaches and tones in argument, are of major importance. For here, if anywhere, this characteristic is likely to be expressed; often not consciously, but by the fact that here, in the only examples we have of recorded communication that outlives its bearers, the actual living sense, the deep community that makes the communication possible, is naturally drawn upon. (Williams 1961, pp. 64-65)

Structures of feeling, Williams writes in *Marxism and Literature*, are an attempt to understand what is "actually being lived, and not only what is thought is being lived" (Williams 1977, p. 131). The concept is meant to refer to those "experiences to which fixed forms do not speak at all, which indeed they do not recognize" (Williams 1977, p. 129). It is, in effect, a theory of practice, of what people actually do. Williams's theory allied a particular structure of feeling to a generation, a point that he amplified in an interview: "The way in which I have tended to apply the term in analysis is to the generation that is doing the new cultural work ... when it is beginning to articulate its structure of feeling" (Williams 1981, p. 157). Williams did not theorize a way in which the particular structure of feeling of a generation could carry over into another, and, indeed, he felt that particular structures of feeling were linked to particular generations and classes.

But doo-wop is a complex case, for the generation that made this music was the U.S. baby boomer generation, or just before it, a group that was extremely influential in reshaping American culture according to its own tastes and desires, as many have written. Doo-wop is a musical genre that was so powerful for a particular generation but was swept away by another, only to live on in the oldies circuit and fund-raising events for public broadcasting stations. In a consumer culture awash with increasingly ephemeral commodities, saturated by media and advertising, nostalgia has become an increasingly noticeable structure of feeling as a way of finding stability, a "frame for meaning" (Stewart 1988, p. 227). Jean Baudrillard

writes that "When the real is no longer what it used to be, nostalgia assumes its full meaning.... There is an escalation of the true, of the lived experience...." (Baudrillard 1988, p.171). This is what I am calling nostalgia as a structure of feeling in this context.

Perhaps the most interesting aspect of live doo-wop performances is that nostalgia is triggered not by a recording or any tangible commodity, but by the performances themselves, as experiences of live music. Since the recordings sold at shows are self-produced and not available through commercial distribution channels, there is no sales data, but it is not the opportunity to purchase recordings that draws people to the shows – it is the experience of the shows themselves that invokes this structure of feeling. In addition to the visceral pleasure of the music, nostalgia seems to be the main reason for the fans' attraction to the music, the reason they attend live concerts. Some doo-wop groups solicit fan feedback on their websites, and many write in to describe the memories the music evokes, such as the fans of a group called the Planotones, a doo-wop revival group (a group formed after doo-wop's heyday that sings in this style) headed by Kenny Vance.

Play it ["Looking for an Echo"] every night. It's relaxing and takes me back a few years when life was less violent. I know my husband would have loved the music too. He passed away in 1994. We really enjoyed the oldies. I met him in 1963 after being in the Air Force. I always think of him and the times we had. Keep bringing that doowop sound to all of us.

Kenny Vance and the Planotones do real justice to the old songs we once cherished so deeply. I found in their music a heart warming trip back to when I was a teenager. Kenny and company have captured a sound long forgotten and brought it back to linger like the sweet taste of an old fashioned sundae from the neighborhood ice cream parlor now extinct. Yes, the era is gone, but the music is forever in our hearts.

I am from New Jersey, and used to "hit" in the subways in West Orange and Newark. When you sang "Diamonds and Pearls" last night, I was in ecstasy! That was our "signature song" when we'd harmonize, and I was singing (in harmony) last night at the top of my lungs. I knew every word, and I think most of the people around me thought I was from a foreign planet![7]

[Y]ou transform the mood to another place and take us all back to the times of this great music – whether we were there to hear it firsthand or not!

Two fans in particular wrote movingly of the period:

> The music brought back so many wonderful memories of high school and all my friends and the great times we had listening and dancing to "doo wop." We really lived in the best of times!!

> You have brought us back to a better time – a sweeter time, a more gentle time, a time of raw emotions but emerging hope. You have redefined romance, the innocence of that first kiss, the hours spent daydreaming, the thrill and risk of a "Ladies' Choice."[8]

Many things stand out from these comments. The nostalgia thread is clear though complex: nostalgia for a lost innocent youth, before the responsibilities of adulthood took over; nostalgia for a more innocent time. And there is even the acknowledgement that perhaps some people aren't old enough to have nostalgia for times when they weren't yet around, showing how this structure of feeling has influenced those outside its immediate demographic and social group.

Doo-wop and Race in the 1950s

While the lyrics of doo-wop music articulated themes on the minds of 1950s teenagers, the music – made by Jewish, Italian, African American, and racially mixed groups – appealed to blacks and whites alike, demonstrating a vision of racial harmony at odds with what many African Americans were actually experiencing. This vision grew out of the postwar optimism that resulted from the end of the Great Depression and victory in World War II, giving many Americans cause for hope. Hope became a prominent ideology, even for members of marginalized or oppressed groups. It is difficult to recapture, or perhaps even understand, this attitude toward race relations today following the upheavals of the Civil Rights era in the 1950s and 1960s, but the many contemporary publications and subsequent scholarly works all point to a moment when it was thought that racial differences could be overcome.

Anthropologist Sherry B. Ortner, in a study of her high school class in late 1950s Newark, New Jersey, writes about the dominance of the integrationist ideology in the north during this period, before the rise of Black Nationalism and identity politics. "[T]he prevailing liberal view of the fifties," she writes, "was that there was a lot of racism, but that white people of good will and Black people of good will could overcome this ... and would bring others around to this position" (Ortner 2003, p. 71).

The white alums that Ortner interviewed spoke of the race relations of the period. One person, when asked if she was friendly with any African American stu-

dents, replied "Oh yeah, I was. I think it was a very gentle time." Another male student, who had been an athlete, had a good deal of contact with African American students through sports. When asked about race, he replied that "We were teammates. There were no conflicts.... There was never anything about the color line. There was never any incident when I was in high school that dealt with the color line." Another athlete echoed this, saying that there were "no problems with the Blacks at all" (Ortner 2003, p. 74).

This ideology of optimism about race relations and the promise of integration, left traces in the popular media of the day, such as film and television, and were registered in the popular culture of music like doo-wop. This was a unique cultural moment in American history, when there was perhaps more crossover by African American musicians to white audiences than at any other point in American history. Brian Ward notes that "between 1957 and 1964, recordings by black artists accounted for 204 of the 730 Top Ten hits on the *Billboard* best-seller chart..." (Ward 1998, pp. 123-124). And of course, there was the rise of the teenager as a separate market group, to which Melnick claims doo-wop responded and helped create (Melnick 1997, p. 138).

Ward writes that African Americans in this era viewed the success of black popular music among whites "as a portent of, maybe even a vehicle for, eagerly anticipated changes in the broader pattern of American race relations" (Ward 1998, p. 128). In 1956 the Platters said that rock and roll was "doing a lot for race relations. It's giving the kids a chance to meet rock and roll artists, and this is helping them find out that so many of the stories that they hear are not true." Many years later, one of the members of the group said:

> Because of our music, white kids ventured into black areas. They had a sense of fair play long before the civil rights movement. We were invited into a lot of homes by kids whose fathers looked at us like we were going to steal the goddamned refrigerator.

Another member of the group said something similar, having played gigs on the South Carolina shore in the 1950s. "It was at the beach that racial segregation began to break down, white kids could listen to R&B behind their folks' backs." And Herbie Cox of the Cleftones in the late 1950s said that "disk-jockeys and record distributors were doing more for integration than *Brown versus the Topeka Board of Education*."[9]

A member of a doo-wop revival group says that "We respect these artists, because they deserve it and because they did not get respect in the 50s. Outside, it's like a war, but there is no color line when it comes to doo-wop" (Gonzalez 1995, p. 4). Fan posts occasionally mention race or the "simpler times" of the 1950s.

Yourself and the Planotones took me to a time and place that was so simpler than todays world.

They [the Planotones] seemed to be having a good time, we were loving them, and my husband and I were loving each other. They reminded us that there was indeed an era of purity and simplicity … before race riots and Vietnam and random teenage shootings.

Always thought this music did more for race relations way, way before any civil rights movements.[10]

For many fans, the nostalgia doo-wop seems to evoke is not just nostalgia for lost youth, but a nostalgia for a moment when the dominant ideology about race was integration, not the kind of multicultural separatism that prevails today in the U.S.

Performance and Nostalgia

It is clear that doo-wop on the oldies circuit isn't like any other kind of concert. For the most part, the doo-wop acts don't include original members or include only some of them.[11] Yet, at the same time, these bands are not billed or advertised as tribute acts – groups that emulate defunct groups. Nor are they seen as cover bands that offer commentary, ironic or not, on the tributed groups (see Oakes 2004).

The interest of most fans is in the evocation of memories. Nostalgia seems to be so dominant that they don't really care how it is evoked, or whether the group is original or contains original members. One person from this period and a native of the greater New York City region, told me that people go to the oldies concerts because they want to relive the moment when this music was new and they experienced this music first as recordings. The concerts are loose "reenactments" that only have to be somewhat faithful to the past. Indeed, these concerts are only faithful in a couple of ways. The original race of the musicians carries over when original members of groups are no longer in the group. In most groups, the singers wear identical costumes, and, of course, the melodies and lyrics are the same. The CDs sold at shows aren't that important, this person thinks. The complicated staging and choreography of events in an act help concertgoers re-live or experience vicariously times past.

John Michael Runowicz, who was both a backup musician for a doo-wop group in oldies concerts and who conducted an ethnography of the doo wop/ oldies scene, writes:

[W]ithin the oldies concert frame, the audience may be hearing and seeing more than the performance in front of them. They may also be hearing and seeing the

memories the concert evokes. For them the echoes of the past and the reverber-
ance [sic] of their youth are part of the oldies sonic gestalt where mistakes or sub-
par performances are forgiven or not even noticed…. The most typical response
I have received from oldies members is how the music "takes them back…."
(Runowicz 2006, p. 256)

Runowicz's comment about "mistakes or sub-par performances" is apt, as I ob-
served the same thing. Nobody much cares about that, or the bad sound systems
or poor sound mixing, nor about the question of whether or not the groups on-
stage had some, or any, original members.

With doo-wop, it is clear that authenticity in terms of original group member-
ship scarcely matters. It is only the authenticity of the emotionality that matters,
an emotionality that provides audiences a way of traveling back in time.[12] What
struck me about the live concerts I saw was simply how hard the musicians
worked. Most popular musicians work hard, of course, and many of them take
pains to show audiences just how hard they are working, coming out into the au-
dience to work the crowd, sweating, straining. But at oldies concerts, doo-wop
musicians, especially those who are not original members of a given group, such as
the Billy Guy Coasters,[13] seem to go further, as if to authenticate themselves for au-
diences who largely are unaware that they are not watching a group made up of
original members. The hard work of some of these musicians somehow makes
them more real, more believable, and their display of emotionality more affecting.
It is this hard work that emphasizes emotionality and helps underline the fact that
people at these concerts are going for the experience. It is the immediacy of experi-
ence – experience that can trigger nostalgia – that matters the most.

Everything about the performances is ramped up compared to the original
recordings, as though the musicians have to out-perform their recorded forebears,
or blast away at the accretion of years. Everything is always as loud as possible,
everything is faster than the original recordings, and in some cases harmonies are
added above the original vocal melody line, which complicates them but also,
again, raises the energy level by adding a higher vocal part. Additionally, the back-
ing instrumentalists are more prominent and more rock-oriented than on the orig-
inals. The overall effect is a more intense and driving performance which adds to
the intensity of the live concert experience.

Musicians, whether or not they were part of an original group, always speak of
how much they love to perform this music. Shirley Alston Reeves of the Shirelles
says that "I still get a thrill each time I sing these songs. You know, people will
always love music that takes them to a special place. I'm proud to have been part
of something that has been meaningful to someone" ("Shirelles Still Smooth as
Honey" 1997). She also said:

I've never gotten tired of the songs. I've never gotten on stage and said, "If I have to sing these one more time, I'm going to scream." It's because of the reaction of the crowd. They're singing, too. And I can see their faces. A lot of performers like to look over the crowd's faces, but I want to see them.

I see tears and I see couples holding hands. It's very intense. Or they'll be dancing in the aisles to songs that brought them together in high school. It's wonderful, especially in the world today when there's so much bitterness. In our songs, there's no color, no barriers. Just good memories and loving thought (Morse 1992, p. 37).

Another singer, who quit performing to raise a family but has since returned to the stage, says that "To walk out onstage now and to watch people's faces is just absolutely wonderful. I can see their smiles. They are going back in their hearts and their memories to that first kiss. It's really special" (Williams 2008).

The power of this music to provoke nostalgia is such that it crosses class lines which is rare in the U.S. The original makers of, and audiences for, this music were largely working class, and many of the fans of doo-wop today come from this group. The community where I lived in the summertime was overwhelmingly working or lower-middle class (for just one example, the local video store, now defunct, had a warning written on an English film saying "Warning! British accents"). Runowicz says that the audience for doo-wop concerts on the oldies circuit is mainly people in their 60s and 70s, both genders, mostly white, many Jewish and Italian, a point also made in a *New York Times* article on the music (Runowicz 2006, p. 180; Gottlieb 1993, p. 25). At the same time, it is clear that the doo-wop/oldies audience is broader than just the working and lower-middle classes, or the greater New York City region; the phenomenal success of the doo-wop broadcasts aired by the public broadcasting stations – not known for its working and lower middle class audience – speaks to a wider appeal of this music.[14] Middle-class people who might not have been part of the audience for doo-wop at the time are part of the audiences for it now.

In a sense, then, these doo-wop performances are more than just performances. They are curated commodities that provide access to a "golden age" (McCracken 1988) for most fans. But while a performance is a commodity, it isn't a tangible object, and its objectification in the form of a recording carries relatively little meaning. These performances are, in fact, a peculiar anomaly in the world of late capitalism. They are not, as so many concerts today are, simply renditions of songs already familiar from a musicians' recent album or previous hits. And they are not tribute acts, which are often viewed ironically, as much as fans might like the originals (see Oakes 2004).

Instead, oldies concerts are, in a way, sacred performances. They are a way for listeners to transport themselves back to a time when conditions were thought to

be better, or at least, there was still the possibility of hope for a better world. The idea that these groups are real or contain all of their members must not be broached, for that might compromise the return to the golden age. Grant Mc-Cracken writes that, "When displaced meaning is recovered … it must not be exposed to the possibility of disproof" (McCracken 1988, pp. 109-110).

McCracken also writes of the dangers that can accrue once one owns an object that permits travel to the golden age, since, as we all know, pleasure in the ownership of commodities usually wanes. Collecting is one solution to this problem, he argues, and we have already seen the extent to which doo-wop is a collector's music.[15] But most fans aren't collectors. For them, the concert is the thing. The concert, with its live nature, its presence, its ephemerality, is the commodity that provides access to this golden age. And perhaps part of the appeal of these performances is precisely their existence as performances. They are still commodities in the sense that tickets have been sold for them, but they are not commodities-as-goods that can trigger nostalgia, as some recordings do. Perhaps this is part of the appeal too – oldies concerts are, as I have said, largely outside the realm of commercial music. The musicians appear to audiences as "merchants" in Marx's sense, selling their CDs themselves, even though the concerts surely generate surplus capital for capitalists.[16] That the music is scarcely advertised and has very little presence in mainstream American culture (save for its use on Public Broadcasting Service which is hardly mainstream), helps it play an important role in nostalgia, for it is largely untainted by commercial culture, however commercial the music might have been when it was new.

The musicians seem to know this. Each group asks the audience to remember its hits and works hard to get audiences to participate by clapping along with the beat and singing along. If everybody seems to know the song, the musicians divide the audience up by gender, with men and women alternating singing.

Conclusion

In a consumer culture saturated by media messages, music can insinuate itself into one's memory and come to signify memories or experiences that one never actually had. In particular, doo-wop has become a signifier of youth and innocence, which comes up again and again in online discussions of the music: innocence for lost youth, for simpler times, optimism over race relations, the intensity of young love. This was, as many have noted, music by youths for each other. Some fans of this music are too young to remember it when it was new, but it has taken on the signifiers of youth and innocence – including race – that can provoke a nostalgia for an unexperienced past. In this way, these live doo-wop performances serve as a kind of technology of nostalgia, or a prosthetic memory. The oldies circuit performances of doo-wop are meaningful for those who attend them because of the

intensity of the live performances and the intensity of the nostalgic structure of feeling; they remind those listeners who remember of, and instruct those who cannot remember in, the passions of youth and the promise of racial harmony.

Notes

1. Thanks are due to Kariann Goldschmitt for research assistance and to "Sound Souvenirs" workshop participants who offered many helpful suggestions. I would also like to thank Sherry B. Ortner, who remembers this music when it was new and in its more recent incarnations "down the shore."

2. John Michael Runowicz says this is normal (Runowicz 2006, p 173).

3. See http://www.thecoasters.com for an explanation of which Coasters is the original one. This is a contentious issue among some musicians and fans as discussed below.

4. This is the common format for such shows according to Runowicz, who says that doo-wop shows use the "package" or "revue" format of the Alan Freed Apollo Theatre during the 1950s (Runowicz 2006, p 66).

5. See also the film: DOO WOP: VOCAL GROUP GREATS LIVE (2006).

6. Brian Ward writes of a 1954 *Billboard* report that estimated the audience at one of Freed's shows in Cleveland as one-third white (Ward 1998, p. 139).

7. http://www.planotones.com/pl8.htm, retrieved 5 August 2007.

8. http://www.planotones.com/pl8.htm, retrieved 5 August 2007.

9. *Down Beat*, 30 May 1956, p. 14. Platters singer quoted in "The Platters' Glory Days," *Goldmine*, 21 February 1992, 11; C. Johnson quoted in "Under the Boardwalk," *New Musical Express*, 29 August 1987, p. 13; Herbie Cox quoted in Phillip Groia, *They All Sang on the Corner*, 2nd ed. (New York: Phillie Dee, 1983), p. 128. All quotations appear in Ward 1998, p. 128.

10. http://thecyberranch.com/oldiesforum.

11. There is a good deal of consternation about this among hardcore fans. See Adler 2007; "Oh Yes, They're Great Pretenders" 2006. See also Runowicz 2006, chapter 5. Serious fans' concern for the performers' authenticity is something that needs to addressed, but the space limitations do not permit it.

12. "Authenticity of emotionality" was introduced in Taylor 2007.

13. Billy Guy was an original member of the Coasters, but he didn't have control of the name.

14. Airing doo-wop oldies concerts during pledge drives has garnered more for the Public Broadcasting Service than any other program (Gallo 2000).

15. See Taylor 2001, chapter 4.

16. "A singer who sings like a bird is an unproductive worker. If she sells her song for money, she is to that extent a wage-laborer or a merchant. But if the same singer is engaged by an entrepreneur, who makes her sing to make money, then she becomes a productive worker, since she *produces* capital directly" (Marx 1990, p. 1044; emphasis in original).

Chapter Seven

Remembering Songs through Telling Stories: Pop Music as a Resource for Memory

José van Dijck

Introduction

"You can check out any time you like, but you can never leave…" The knife-sharp guitar solo following Don Henley's last words rack up a series of emotions and memories in my brain. Ever since my definite return from California, where I lived from 1987 to 1991, the song is intensely colored by experiences: staying at a desolate hotel in the desert, driving a pick-up truck up north on Highway 101, playing a frisbee at Pacific Beach. The song is also inevitably associated with the old tape recorder in my apartment's living room, a red ghetto blaster from which many awkward traveling tapes originated. The memories triggered by this song are so personal, and yet, they feel like a huge cliché. "Hotel California" must have featured in the top five of almost every golden oldies hit list in the past decade. It's unlikely that there are many people who are now in their forties who have no memories at all upon hearing this song; younger generations have heard the song and the stories connected to it from their parents or through radio DJs. The song persists in both my personal and a collective memory. You can try to forget it, but you can never escape it…

In this chapter, I propose to study the interrelation between personal and collective memories of popular music, as these memories are constructed through stories *of* and *about* recorded music. Pop songs are often considered vehicles for reminiscence; they glue particular experiences to memory. While these memories may have happened in reality, actual references can never be verified. Memories tend to alter each time we recollect them (Van Dijck 2007). As all memories do, musical memories reflect as well as construct experience. Recollective experiences are often articulated in personal stories (Nelson 2003; Wang and Brockmeier

2002). The question I raise in this *Sound Souvenir* contribution is: how do we construct personal and collective musical memory through stories? What function do narratives have in the construction of musical memory?

To analyze the intertwining of personal and collective memories of recorded music, I will turn to a readily available online set of narrative responses generated through a national radio event, the *Dutch Top 2000*. Since 1999, a public radio station in the Netherlands (Radio 2) has organized a yearly, widely acclaimed, five-day broadcast of the 2000 most popular songs of all times – a list compiled entirely by public radio listeners who send in their five favorite pop songs.[1] During the event, the station solicits personal comments, both aesthetic evaluations and memories attached to songs. Besides having disc jockeys read these comments aloud during a live broadcast, they are also posted in their entirety on an interactive website. In addition, the station opens up a chatbox for exchanging comments. The result is an extensive database of comments and stories, constituting an intriguing window on how recorded music serves as a vehicle or resource for memory.

Recorded Pop Music and Autobiographical Memory

Recorded pop songs are often signifiers of individually lived experiences; they are also items of culture that we select and collect to store in our minds or in our private "jukeboxes" to be recalled at a later moment in time. We can't possibly retain all the music we hear in our lifetime, so there must be a mechanism accounting for why certain melodies get stuck in our long-term memory while others do not. In order to last, a song needs somehow to catch our attention, to stand out from other experiences or perceptions. American ethnomusicologist Thomas Turino (1999, p. 224) has tackled the intriguing problem of musical memory by approaching music as a system of signs. He uses Peirce's notion of indexicality to explain how music is not *about* feelings but rather involves signs *of* feeling and experience. Musical signs, he says, are sonic events that create effects and affects in a perceiver the way a falling tree creates waves through the air. Rational effects or conscious responses are responses that involve reasoning – the interpretation or appreciation of music. The affect of music lies not in the sounds or words per se, but in the emotions, feelings, and experiences attached to hearing a particular song. Musical signs thus carry strong personal connotations, betraying an emotional investment. At the same time, however, members of a social group share indices proportional to common or communal experiences (Frith 1987). Musical signs thus integrate affective and identity-forming meanings in a direct manner, and it is through the recollection of songs that we may come to see the nature of this integration.

We may gain valuable insights in the connection between personal and collec-

tive memory by applying narrative analysis to stories relating how people feel affected by recorded popular music. Many respondents to the *Top 2000* create stories around certain songs to help them communicate a particular feeling, mood, or to express their affective ties to them. Through these stories, we learn how people came to invest emotionally in a song, how the song came to mean something to them in the first place, and how they retained that attached meaning – a meaning they like to share with a large anonymous audience. The following comment was posted in response to the U2 song "With Or Without You":

> My father died suddenly in November 1986. That night we all stayed awake. I isolated myself from my family by putting on the headphones and listening to this song. The intense sorrow I felt that night was expressed in Bono's intense screams. I will never forget this experience, and each time I hear this song I get tears in my eyes. (Jelle van Netten)

Memories tied up with extreme pleasure or intense sorrow, like the one above, are likely to linger in our minds, due the brain's tendency to store sound perceptions along with their affects and somatosensory impact (Bower and Forgas 2000). The (explicit) narratives created out of these memories are deemed worthy of sharing because they resonate with both universal and intimate experiences.

The comment above implicitly suggests that a memory aroused upon hearing a song is an exact repeat of an original listening experience stored in one's memory. The idea of a record reiterating the same content each time it is played is subconsciously transposed to the experience attached to hearing music. People's expectation that they will feel the same response each time a record is played stems from a craving to relive the past-as-it-was – as if the past were also a record. Many of us want our memory of an original listening experience to be untainted by time, age, or life's emotional toll. And yet, it is improbable that repeated listening over a life time would leave an "original" emotion (if there ever was such thing) intact. Instead, the "original listening experience" may be substituted by a fixed pattern of associations, a pattern that is likely to become more brightly and intensely colored over the years.[2] A memory changes each time it is recalled, and its content is determined more by the present than by the past. As Geoffrey O'Brien eloquently puts it in his musical memoir: "The age of recording is necessarily an age of nostalgia – when was the past so hauntingly accessible? – but its bitterest insight is the incapacity of even the most perfectly captured sound to restore the moment of its first inscribing. That world is no longer there" (2004, p. 16).

As much as people believe their "original" experiences remain intact, cognitive research confirms that musical remembrance alters with age. An American clinical study shows a significant difference between how older and younger people remember recorded music. Whereas young adults connect recorded music with

memories of specific autobiographical events, seniors use familiar songs as stimuli to summon more general memories and moods from the past.[3] Recorded music infused with feelings elicits stronger, even if less specific, autobiographical memories later on in life. Since the narratives posted to the *Top 2000* website do not systematically disclose the respondents' ages, I cannot confirm or disprove researchers' empirical observations. In general, though, respondents who give clues to their age as being over forty-five tend to refer more to nostalgic moods triggered by specific songs than respondents who identify themselves as being young adults. However, this might just as well be attributed to the fact that a majority of songs featured in this collective ranking were popular in the era when baby boomers came of age.

Recorded pop music may also construct a cognitive framework through which (collectively) constructed meanings are transposed onto individual memory, resulting in an intricate mixture of recall and imagination, of recollections intermingled with extrapolations and myth. One listener, in response to The Beatles' song "Penny Lane," comments on the oddity of certain music invoking an historical time frame she never lived through:

> This song elicits the ultimate Sunday-afternoon feeling, a feeling I associate with cigarette smoke, croquettes [the Dutch variant of the hamburger], and amateur soccer games. This feeling marks my life between the ages of five and fifteen. A nostalgic longing of sorts, although I have to admit I was not even conceived when this record became a hit song…. (M. Klink)

The respondent transposes the general mood of an era onto her childhood, even though these periods are distinctly apart. It is not unthinkable that she has projected a general impression of a decade, generation, or Zeitgeist onto this particular song (Kotarba 2002). Recall and projections thus curl into one story even when the respondent realizes that remembrance cannot possibly be rooted in actually lived experience. Mixing memory with desire or projection is a common phenomenon acknowledged by cognitive scientists and neurobiologists (Damasio 2003, pp. 93-96).

Turino has theorized about this unmistakable intertwining of personal and collective memory (1999). Narratives about music often braid private reminiscences in with those of others or connect them to larger legacies. Certain songs become "our songs," as they are attached to the experience of various collectives, be it a family or peer group. Verbal narratives appear to be important in the transmission of both musical preferences and the feelings associated with them, to the extent that it becomes difficult to tell "lived" memories from the stories told by parents or siblings (Misztal 2003, p. 84). This does not mean, of course, that children uncritically adopt their parents' memories, nor, for that matter, their musical taste.

Young people construct their own favored repertoire by relating to peers as well as to older generations either positively or negatively. Musical memories become the input – resources to adapt to or resist – used when building one's own repertoire. A few assorted comments posted to the *Top 2000* website may illustrate this. One respondent, reacting to the Doors' hit song "Riders on the Storm," writes:

> One of the things my father passed on to me was his musical taste. His absolute favorite was Jim Morrison, and as a child I would sing along with every Doors' song. Remarkably, my father thought "Riders on the Storm" was one of the worst Doors' songs, but I think it's one of their best. (Joanna)

What we see here is an inter-generational transfer of personal and collective heritage, not only by sharing music, but also by sharing stories. Many comments posted on the website testify to this cultural process of sharing memories connected to songs. Like photographs, recorded songs relate to personal memories, and it should come as no surprise that older people are eager to pass on their stories along with their preference for certain recorded music.

Stories appear as a distinct aid in remembering the mental associations attached to a particular kind of music. These stories, like the memories themselves, are likely to change with age, and as much as we like to capture the "original affection" triggered by music, we want the story to freeze that feeling for future recollection. Yet stories, like records, are mere resources in the process of reminiscence, a process that often involves imagination as much as retention. In other words, our personal musical repertoire is a *living* memory that stimulates narrative engagement from the first time we hear a song to each time we replay it at later stages in life. It is this vivid process of narrative recall that gives meaning to an album and assigns personal and cultural value to a song.

Recorded Music and "Technostalgia"

Technologies and objects of recorded music are an intrinsic part of the act of reminiscence. Even though their materiality alters with time, generating resentment, their aging may partially account for our very attachment to these objects. Personal memory evolves through our interactions with these apparatuses (record players, CD players, radios, etc.) and material things (records, cassettes, digital files), as both are agents in the process of remembering. Media technologies and objects are often deployed as metaphors, expressing a cultural desire for personal memory to function *like* an archive or *like* a storage facility for lived experience. When it comes to music, it is easy to see where this metaphorical notion originated. The record's presumed ability to register – to record and hold – a particular mood, experience, or emotional response can be traced back to the record's historically as-

cribed function as a material-mechanical inscription of a single musical perform-
ance. It is almost a truism to expect technologies and objects to replay the pre-
sumed original sound of a song, notwithstanding our awareness that objects and
apparatuses, like bodies, wear out, age, and thus change over time.[4] The "thing-
ness" of recorded music is unstable, and yet this knowledge does not prevent a pe-
culiar yearning for the recreation of audio quality as it was first perceived, evi-
denced for instance by the recent "vinyl nostalgia" accompanying the surge in CD
sales (Katz 2004; Rothenbuhler and Peters 1997). People who use recorded music
as a vehicle for memories often yearn for more than mere retro appeal: they want
these apparatuses to reenact their cherished, often magic experience of listening.

It may be illustrative to filter this kind of technostalgia from the comments
posted on the *Top 2000* website, espousing the integrality of technology to peo-
ple's reminiscing. Many respondents recall the sound equipment through which
they first heard a particular song, emphasizing how it defined their listening expe-
rience. Writing in reaction to The Beatles's song "The Long and Winding Road," a
woman writes:

> The first time I heard this song I almost snuggled into my transistor radio. This
> was the most beautiful thing I had ever heard. When I got The Beatles' album, I
> remember pushing the little Lenco-speakers against my ear (they were sort of the
> precursor of the walkman). Whenever this record is played again, I get on my
> knees, direct my ears downward, pushing them toward the speakers on the floor.
> I still want to live in this song.... (Karin de Groot)

In this comment, the experience of listening seems inextricably intertwined with
the primitive equipment that first enabled its broadcast – and that memory has be-
come partial to its reenactment in contemporary stereo systems. Needless to say,
the reenactment never brings back the equipment and the context of the original
sound – a fact that the respondent is very aware of – but certainly brings about the
intended affect.

In other instances of reminiscence, the role of technology should be understood
indexically rather than metaphorically, adhering to Thomas Turino's Peircian ap-
paratus, as it stands for taking control over one's sonic space. Memories of an orig-
inal listening experience often include allusions to a newly acquired freedom to lis-
ten to songs, alone or with friends, outside the living room, where the soundscape
was usually controlled by the musical taste of one's parents. Many are still commit-
ted to the sounds mounting from the radio (especially transistors and car radios), a
medium that first confronted the baby boom generation with pop music. In con-
trast to personal stereos (record players or tape recorders), radio sound is
ephemeral yet material in its texture. Listening to music on the radio often allows
for a momentary "insider" sensation that the listener is part of something larger. It

creates relationships between the self and others that contribute to an individual's sociality (Tacchi 1998; Rothenbuhler 1996). Narratives that testify to the liberating role of music technology abound on the website postings to the *Top 2000*. Read, for example, this reaction to the Herman Hermits' song "No Milk Today":

> Because this was the first song to wake me up to the phenomenon of pop music in the years 1966-1970, it reminds me of how magical it felt to just listen to my small transistor radio, often secretively, because I needed to hide it from my parents. When I listen to this song now, I turn up the sound as much as I can, preferably when I am driving my car and listening to old tapes. (Maarten Storm)

For this respondent, hi-fi equipment was (and remains) a technology that endowed him with the liberty to create his own sonic space. There are many responses similar to this one, all attesting to the importance of stereos in forming an autonomous sense of self and the mental-physical room to develop one's personal musical taste. Some respondents explicitly relate how their attempts to capture favorite songs played on the radio resulted in tapes of very bad quality. And yet they still treasure their amateur recordings, not in spite of, but *because of* their obvious technical shortcomings.

Audio artifacts and technologies apparently invoke a cultural nostalgia typical for a specific time and age. The ability of digital recording techniques to meticulously recapture a worn-out recording and reproduce its exact poor auditory quality, may offer only partial solace to a cultural yearning. Joseph Auer (2000) has suggested that every new medium in a way authenticates the old, meaning that each time a new audio technology emerges on the scene, the older ones becomes treasured as the "authentic" means of reproduction or as part of the "original" listening experience. In the digital era, scratches, ticks, or noise can be removed from tapes to make old recordings sound pristine, but they can also be added to make a pristine recording sound old. Sound technologies thus figure in a dialogue between generations of users. Think, for instance, of a young musician's sampling of original pop songs into digital sound experiences, or the creative use of old telephone sounds as ring tones on teenagers' cell phones.[5] The dialogue with outdated technologies, frequently used in contemporary pop songs, symbolizes recorded music's ineffable historicity. Paradoxically, sound technologies are concurrently agents of change *and of preservation*. With the new digital technologies, sonic experiences of the past can be preserved and reconstructed in the future.

Incontrovertibly, the materiality of recorded music influences the process of remembering. "Recorded music" has become a rather generic container for vinyl albums, cassette tapes, CDs, and MP3 files stored in computers or on hard disks. But the status of each item varies and that variation affects their function in memory formation. Music listened to from live radio, records, cassette

tapes, or MP3 players each have a different emotion attached to them. Prerecorded CDs or records are more valuable as objects to keep and collect, whereas MP3s or cassette tapes have a different function: they are more like a back-up. As music theorist Mark Katz (2004, p. 171) has shown in his study on sound capturing, which includes a survey among young downloaders of recorded music, a large majority of respondents still buys prerecorded CDs, often after having listened to them in rerecorded form or after having shared them in whatever mechanical or digital form: "The tangibility of the CD is part of its charm. A collection is meant to be displayed, and has a visual impact that confers a degree of expertise on its owner." In semiotic terms, the indexical function of the musical sign is bound up with its auditory materiality: hearing a familiar song on the radio constitutes a different memory experience than playing that very song from one's own collection, perhaps even more so when these recordings are played from MP3 formats. As one respondent to the *Top 2000* puts it:

> It is so strange: I keep most songs [featured in the *Top 2000*] on CDs and I have the entire list of songs stored in MP3 format on the hard disk of my PC, so I can listen to these songs any day any time. And yet, I only swing and sing along with my favorite songs when I hear them on the radio, during this yearly end-of-the-year broadcast…. (Jaap Timmer)

Materiality and technology often become integral to memory, something that is unlikely to change with the advent of digital equipment. As long as listening to music remains a mediated experience, memory will be enabled and constructed through its material constituents.

Shared Listening and Exchange

Memories attached to songs are hardly individual responses per se. Recorded music gets perceived and evaluated through collective frameworks for listening and appreciation. Individual memories almost invariably arise in the context of social practices, such as music exchange and communal listening, and cultural forms like popular radio programs, live concerts, and so on. These social practices and cultural forms create a context for reminiscence and become vehicles for collective identity construction. Sociologist Tia DeNora (2000) observes in her ethnographic study of how young adults use audio equipment in everyday life that recorded music helps individuals evolve into social agents. Since the introduction of sound recording in the last decade of the nineteenth century, sonic experiences have been assigned meaning as collective memories through performative rites, like shared listening and exchanging music. Listening to recorded music has always been a social activity: listening with peers or sharing musical evaluations with friends helps

individuals to shape their taste while concurrently constructing a group identity (Frith 1996).

It is therefore understandable that the sociability of listening to pop music becomes an inherent part of people's memories. For instance, one respondent adds the following general comment to the *Top 2000* chatbox:

> It was 1976, and with a number of friends I organized disco events for the local soccer club. These events always turned into choose-your-favorite-pop-song tournaments. The *Top 2000* reminds me of those days. (Henk Vink)

If you read through the *Top 2000* comments, almost one in every ten relates how groups of people, varying from three-generation families at home to labor crews and office personnel, stay tuned to the five-day, non-stop event and listen *as a group*. One woman entrusts to the chatbox how listening to the *Top 2000* during a house remodeling project facilitates previously deadlocked communication between grandfather, parents, and children. The radio event engenders collectivity at the same time and by the same means as it generates collective memories. The actual sharing of music and singing along with a group hence becomes part of the emotion triggered by a song.

Even if some sound technologies by nature of their hardware promote listening to music as a solo activity, they can still be deployed towards social activities. Ever since the emergence of the Walkman in the 1970s, personal stereos have been associated with the construction of individual sonic space. As Michael Bull (2000, p. 40) argues, personal stereos can function as a form of "auditory mnemonic" in which users attempt to reconstruct a sense of narrative within urban spaces that have in themselves no narrative sense to them. And while it is true that the Walkman, just as its most recent reincarnations – the MP3 player and Discman – are designed with individual urban listeners in mind, these recording technologies can also be put to social use and serve as collective listening instruments. Read the posting of an eighteen-year-old respondent to the *Top 2000* website, who commends the 1961 song "Non, Je ne regrette rien" performed by Edith Piaff:

> Last summer, half a dozen of my classmates [and I] drove to France to celebrate our high school graduation. We played a lot of oldies, and as both cars had their own iPods attached to the stereo system, we sang along as loud as we could with our self-compiled repertoire. Now we've all gone off to different colleges, but next month we'll have a reunion, and I'm sure we'll bring our iPods along, so we can bring back some cherished memories. (Willem van Oostrum)

The iPod plugged into the car's stereo system, allowing these students to sing along with its recordings, is inscribed in the narrative recollection of a generation of

young adults. They consciously create their own sonic memories, using the newest devices to recreate golden oldies. Rather than being a mere vehicle for individual listening and storage of favorite songs, the MP3 player thus figures as agent in the conscious process of building up a collective memory. MP3 files lend themselves particularly well to multiple and effortless exchange, although such digital mate-riality, in recent years, has become the center of a controversy over stealing and freely downloading recorded music. As Jonathan Sterne (2006b) argues, however, the new material quality of recorded music obviously deserves to be examined in its own right as it generates new cultural practices involving mixing and sharing.

To sum up, cultural practices such as communal listening and swapping record-ed music appear crucial in understanding how and why we construct shared mem-ories through narrative experiences. Musical memories are shaped through social practices and cultural forms as much as through individual emotions. New digital technologies allow music fans to customize their favorite collections of songs and use them as a symbolic resources in the construction of identity and community. Let us now turn to the particular role of the *Top 2000* itself as a media event that actively tries to instill a sense of collectivity in its listeners. In what sense do the *Top 2000* stories of individual memories contribute to a sense of collective memory and communal cultural heritage?

The Top 2000 as Collective Cultural Memory

The postings to the Dutch *Top 2000* website nicely illustrate how "mediated memories" are shaped precisely at the intersections of personal and collective memory. Stories about songs and the memories connected to them constitute channels for shaping individuality while concurrently defining the larger collec-tivity we (want to) belong to – ensuring autobiographical as well as historical con-tinuity. Recorded music becomes part of our collective memory at the same time and by the same means as it gets settled into our personal memories. Theorized from a semiotic-cultural perspective, personal emotions and affects attached to songs are articulated in explicit memory narratives that people like to exchange – reminiscences of lived experience expressed through musical preferences. These stories are not only about emotions triggered by music, but directly bespeak musi-cal memory as it relates to personal and group identity often handed down from generation to generation. Through shared musical and narrative experiences, people construct collective reservoirs of recorded music that become our cultural heritage.

Building a national heritage of favorite popular music is obviously the purport-ed goal of the *Top 2000* and an important contribution to its success. The eminent value of creating collective musical repertoires, as American historian William Kenney (1999, p. xix) points out, has proved vital to the "ongoing process of indi-

vidual and group recognition in which images of the past and present could be mixed in an apparently timeless suspension that often seemed to defy the relentless corrosion of historical change." But as important as creating a cultural heritage may be as a key to understanding the *Top 2000*'s popularity, its success as a national event – more than half the population of the Netherlands tunes into the event every year – can hardly be explained by the nation's craving for a collective repertoire. The significance of this event as a platform for exchanging personal stories of musical reminiscence cannot be overstated as a crucial function in the formation of collective memory. It is in the public spaces between individuals and communities that memory gets shaped and negotiated. The process of narrating, discussing, and negotiating personal musical reminiscences and collective musical heritage is far more important than the ultimate ranking of songs.

In 2006, after realizing that listeners were interested specifically in storytelling, the Dutch *Top 2000*'s organizers decided to launch a separate "storytelling platform" as part of the annual event. Listeners had become used to sending in their spontaneous comments, as illustrated by the comments above. But to allow space for more "literary" contributions, the radio station called for short stories relating a specific musical memory or experience. In the months leading up to the last week of December, listeners were invited to send in personal short stories (750 words maximum) based on a specific song featured in the ranking. The response from listeners was overwhelming: over a thousand listeners sent in their stories. A jury selected the ten best stories, and during a special celebratory radio event in January, the winning stories were read out loud by professional speakers, embellished with suitable background sounds, which was followed – of course – by the song. All of the stories were given to the Dutch National Archive, which has created a special website to make the collective heritage of these musical stories permanently accessible to everyone interested. The collection will grow as people add more stories each year. Storytelling has now become an integral part of the musical event.

The cultural historian Paul Grainge (2000) proposed a relevant distinction between nostalgia as a commercial *mode* and a collective *mood*. In the case of the *Top 2000*, nostalgia emanates from a collectively experienced mood, in contrast to a conception of nostalgia as a consumable stylistic mode espoused by commercial outlets, such as the Top 40 or oldies stations. The *Top 2000* thrives on the inseparable exchange of songs *and* stories. Through a combination of the annual radio event, website, and television broadcast, this multimedia platform offers space for consensus building a national heritage of pop songs, while simultaneously serving as a podium for collective nostalgia and communal reminiscences. The extensive archive of responses generated by the Dutch *Top 2000* constitutes a valuable source of data on personal musical memory and cultural heritage formation. It opens up new perspectives on the importance of public space for sharing personal stories and constructing a collective musical kinship, which in turn feeds

our individual creativity and identity. The *Top 2000* encourages both individual memories and collective recollecting. Indeed, it is vital to keep alive a vibrant heritage of old and new music shared through stories, because it provides individuals with cultural resources to understand their pasts and guarantee a shared interest in a communal future, both of which are essential forces in people's long-term commitment to music. This musical heritage of pop music, constructed through songs and stories, may become the epitome of cultural memory: you can check out any time you like, but you can never leave...

Notes

1. Started as a one-time millennium event in 1999, the Dutch national public radio station, Radio 2, invited listeners to send in their personal all-time top five songs, resulting in a collective *Top 2000*. See http://top2000.radio2.nl/2005/site/page/homepage. The response to this one-time event was so overwhelming that the station decided to repeat it the next year, and the tradition has continued ever since. In December 2004 and 2005, the national Top 2000 was selected by well over one million Dutch citizens who sent in their personal top five songs. The number of people involved in such an event is unprecedented in the history of mediated events in the Netherlands. In that year, almost 6.5 million people listened to the radio broadcast, 5 million people watched the accompanying daily television shows and the website registered 9.2 million page views in just five days. Cast against a population of 16 million, the event engaged more than half of all Dutch people over twelve years old. The comments used in this article are derived from the 2004 database. The database is no longer publicly available, but has been archived by Radio 2. The comments used in this article were originally in Dutch; all translations are my own, and I have identified the respondents in the same way they identified themselves on the (public) website. I would like to thank Kees Toering, station manager and initiator of the *Top 2000*, for making all statistics and archives available.

2. A few cognitive psychological studies have shown how older adults' memory grows more positive over the years; older adults are more motivated than younger adults to remember their past in emotionally satisfying ways, and older adults' positive bias in reconstructive memory reflects their motivation to regulate emotional experience (see Mather 2004; Kennedy, Mather, and Carstensen 1994).

3. Clinical psychologists Schulkind, Hennis, and Rubin (1999) tested how various age groups remember through music. For their experiment, the researchers tested two groups of adults: younger adults between eighteen and twenty-one years old and older adults between sixty-five and seventy years old. They made them listen to a series of songs that were popular between 1935 and 1994, but only appeared on the hits lists during a defined period (in contrast to evergreens). The subjects were asked whether each song reminded them of a general period or a specific event from their lives.

4. On the material temporality of recording, see Sterne's discussion on "triple temporality" in *The Audible Past* (2003), pp. 287-333. For a historical discussion on the relation between materiality and functionality of audio technologies, see Morton (2000).

5. In the early stages of digitization, Alan Goodwin (1988) already argued for a new postmodern theory of musical creativity, based upon the new digital cultural practice of sampling. However, the politics and aesthetics of sampling are beyond the boundaries of this article's thesis.

Part III
Technostalgia

Chapter Eight

Tuning in Nostalgic Wavelengths: Transistor Memories Set to Music[1]

Andreas Fickers

> Take me back, take me way, way back
> On Hynford Street
> When you could feel the silence at half past eleven
> On long summer nights
> As the wireless played Radio Luxembourg....
>> (Van Morrison, "On Hynford Street")

> ...Whatever happened to Tuesday and so slow
> Going down the old mine with a transistor radio
> Standing in the sunlight laughing
> Hiding behind a rainbow's wall
> Slipping and sliding all along the waterfall
> With you, my brown eyed girl
> You my brown eyed girl....
>> (Van Morrison, "Brown Eyed Girl")

Introduction

Hundreds of songs pay tribute to the radio. But only a few songwriters have produced such intimate and melancholic sound souvenirs of their personal memories of the radio as the Irish bard Van Morrison. Already in his 1960s hits "Caravan" and "Brown Eyed Girl," the transistor radio was celebrated as a catalyst and mediator of strong personal feelings and emotions, mainly through its function of putting revolutionary sounds into the air. In several of his later songs, the radio became an object of technostalgic contemplation.[2]

This chapter examines the meaning of and nostalgic yearning for transistor ra-

dios in the lyrics of popular songs. Popular music provides a treasure of lyrics that deal explicitly with the transistor radio as a cultural phenomenon – a neglected topic in scholarly work on the history of radio so far (Schiffer 1991; Fickers 1998; Weber 2008). From Chuck Berry's "Oh Baby Doll" to Buck Owens' "Made in Japan," the Beach Boys' "Magic Transistor Radio" to Kraftwerk's "Transistor," a broad range of popular music genres reflects the transistor radio's deep cultural impact in youth culture and popular entertainment. In analyzing both contemporary lyrical reflections and nostalgic echoes of the transistor radio in popular music, this chapter provides an unorthodox take on the rich and fascinating sound souvenirs of a technology that blazed the trail of mobile electronic devices.

Popular Music Songs As Communicative Memories

The "memory boom" of the 1990s has produced an astonishing quantity of scholarly literature on both the *functioning of memory* on the neurological, psychological, philosophical, and autobiographical level as well as on the *role of memory* in the politics of history and remembrance. Scholars such as the Egyptologist Jan Assman (1999) and the social psychologist Harald Welzer (2002) have developed a new vocabulary for distinguishing among different forms of collective memory. Important for this study is the distinction made between "communicative memory" and "cultural memory." While "communicative memory" means "living memory" (Frank 2000, p. 545), the generational memory shared and discussed by contemporaries, "cultural memory" is characterized by highly ritualized and structured forms of memorial practices. The agency of cultural memory goes beyond a group actively remembering the past, and includes monuments, rites, and traditions. As Otto Gerhard Oexle (2001) has pointed out, these two forms of collective memory can mingle with each other – commemorative events being a perfect example of when this is the case (see Ruth Benschop's chapter 12 in this volume). The "memory culture" or "politics of remembrance" of a collective, as in a nation, is therefore the complex result of an interplay between different, sometimes overlapping, contexts of memorial practices and various official or unofficial "carriers" of memory in a society at a specific time.

What is the analytical potential or relevance of this theoretical differentiation between communicative and cultural memory when looking at the transistor memories reflected in popular music tunes? First, the performance of popular songs can be studied as a communicative practice actively co-constructing and re-constructing the cultural meaning of the transistor radio. The songs, in their sonic and lyrical dimensions, both reflect and construct an ongoing process of intellectual appropriation and symbolic encryption of the transistor as a technological and cultural phenomenon. Second, transistor songs often relate personal experiences with the radio and can thus – in contrast to cultural memory practices cen-

tering on the collection and exhibition of transistor radio sets in private or public spaces (Meter 2005) – be analyzed as practices transferring autobiographical and generational memories of the transistor radio to new generations. While sources like advertisements and radio sets as material artifacts allow for studying the potential usages and symbolic meanings of the transistor radio as configured by the radio industry (Fickers 2007), popular songs dealing with the transistor radio offer the possibility of tracing the symbolic and experiential meanings of the transistor.

To trace these cultural meanings, I have analyzed one hundred songs that refer explicitly to "transistor," "transistor radio," or "portable radio" (or its German, French, and Dutch cognates) either in the title or the lyrics of a song.[3] These songs were drawn from four online databases featuring song lyrics in four languages (German, French, Dutch, and English) in order to guarantee a broad spectrum of divergent national and cultural popular music traditions.[4] Accordingly, the popular music genres represented vary substantially: They range from classical rock and roll and rockabilly to various forms of rock (alternative, hard, punk, electro, folk, progressive, art, funk) and pop music (electro, new wave, rock), including country, folk, and blues, as well as German "Schlager" and French "chansons" and – last but not least – quite a few hip-hop songs. The time frame of the selected songs covers half a century, taking Chuck Berry's 1957 "Oh Baby Doll" as the earliest song and Korn's 2005 heavy metal performance of "Twisted Transistor" as the most recent historical reference.

Shifting Meanings and Memories of the Transistor

By studying references to the transistor in the selected corpus of songs, we can discern several recurring motifs emphasizing spatial, emotional, or social memories of the transistor. Yet in addition to the many songs expressing specific social practices or cultural meanings of "the transistor," a distinctive number of songs demonstrate a rather playful use of this notion as a rhetorical figure or poetic ornament. Not surprisingly, such lyrical or poetical use is especially noticeable in genres like rap or hip-hop. In the songs of Company Flow, De La Soul, El-P, and Gang Starr, the word "transistor" functions as an acoustic component of the poetic construction. A typical example of this is Gang Starr's "Beyond Comprehension" (1991):

Transmitting lyrics like teletype,
reacting to beat in a whisper,
and like a transistor,
I'm sounding dope when I'm crisper

Other examples would be the song include Michelle Shocked's "Don't Mess around with My Little Sister" (2004), where we hear "She may blow your mind like an old transistor, but I'm telling you, Mister, don't mess around with my little sister," or the line from the Wanderer's song "Sold Your Soul for Fame" (1981), "Turn off your old transistor, you've had your chance now, Mister."

Moreover, while some of the songs refer to the original meaning of the term transistor as the physical semiconductor and electronic component, most of the songs' lyrics use "transistor" as a synonym for "radio," in the sense of an electronic consumer device and entertainment medium. From an etymological point of view, it is interesting to notice the bandwidth of meanings attributed to the term. Invented by the American physicist John R. Pierce, one of the triumvirate of transistor inventors at Bell Laboratories, the term "transistor" signified a fusion of two technical terms, "varistor" and "transconductance" in solid state physics, a neologism that won an internal ballot over several competing alternatives such as "semiconductor triode," "solid triode," "crystal triode," and "iotatron."[5]

Only a handful of songs refer to the transistor as an electronic component or physical semiconductor. The songs that do, however, are intriguing. In her 1979 song "Intellectually," Amanda Lear uses the transistor as synonym for the binary logic of male reasoning that functions like a computer: "Intellectually, you are superior, but internally, you're a transistor, your ticking brain – which could explain, the why's and when's I ask in vain, is a computerized calculator." In a love declaration to "machines" ("Machines," 1980), the pop band Sailor confessed "I really dig the groovy shape of your transistors, I only wish you hadn't so many resistors." In a similar rhetoric but set to a melodramatic tune, "Starship" ("Transatlantic," 1987) rhymed "Transistor, tube, and microchip won't bring me closer to your lips." And last but not least, in the song "Transistor" (1997) by the funk metal band 311, a girl is described as "a transistor, lightning resistor, conducting to the mother star, that's what you are".

While the transistor has proved to be what William Shockley – one of its inventors – has called the "nerve cell" of the information age (Riordan and Hoddeson 1997, p. 8), the term rapidly changed into a much more complex signifier. As convincingly demonstrated by Brian Schiffer, the term transistor soon became loaded with a double meaning, embodying both a techno-scientific and a cultural dimension. As "a sign of modernity," the transistor simultaneously epitomized the high-tech image of miniaturization and the symbolic capital of a cultural revolution.

> During the fifties, miniaturization and miniature products would begin to acquire a high-tech image as a result of the missile race and the advent of the transistor. Ever so slowly, the pocket radio would become a more desirable product as a sign of modernity.... The shirt-pocket radio or, simply *the transistor* (as it

was called then) became a metaphor for freedom and independence.... The tiny transistor radio had become the symbol of a generation. (Schiffer 1991, pp. 169, 181)

It is interesting to note that, in contrast to the radio advertisements informing Schiffer's study, songs about transistors serving as historical evidence for this chapter rarely stand for "modernity" or "freedom and independence." The mediated memories of the transistor refer to the contexts, practices, or routines of listening – either in the home (domestic memories) or outside (ambient memories) – rather than signifying a Zeitgeist at a more abstract level. These findings perfectly match with Jérôme Bourdon's study of television memories based on the life stories of TV viewers. In his article "Some sense of time. Remembering television," Bourdon asserts that remembering television is by no means synonymous with remembering television viewing: "What is remembered is not programs but interaction with tv" (Bourdon 2003, p. 12). The same goes for transistor memories, which mainly refer to the close relationship between the listeners and their radio as mediator between private life and public sphere.

The Transistor Radio As Consoling Link to the World

Surprisingly, most transistor memories are not those referring to the specificities of the transistor radio generally listed in popular or scholarly works: outdoor mobility, ambient use, or the portability of the set. Instead, the transistor radio is remembered as a consoling object, linking the often melancholic and isolated listener with the outer world. In her chanson "La musique" (1978), a love song by the French singer Barbara dedicated to an old friend now in prison, the transistor radio figures as the only possibility of communication between two lovers: "Maybe, on your transistor, my voice can reach you. This is the only possibility I have to send you my song." In a similar rhetoric, her compatriot Gilbert Becaud crooned in 1974: "Your transistor is the only bridge between you and me. Through its waves I easily find my way to you." In her melancholic story about the "longhaired boy from around the corner" (1976), the well-known German Schlager singer Ingrid Peters even makes the transistor radio into the only friend of a poor lonely boy.

It is striking that most examples of these melancholic and consoling references to the transistor originate from the musical genres of the "Schlager" and the "chanson," well known for their sentimental ballads with simple, catchy melodies or light pop tunes. The two lyric-driven genres, which typically center on feelings, love, and relationships, seem predestined to voice melancholic references to the transistor radio. But in a more general sense, radio serves in a lot of popular songs as a metaphor for communication across physical or geographical boundaries (think, for example, of the highly political song "Radio Free Moscow" (1984) by

the American prog rock formation Jethro Tull), as a godlike medium, filling the ether with voice and music (very strongly articulated in the song "Radio is God" by the Austrian pop group Opus), or as a symbol of perfect interpersonal communication (in the sense of "being on the same wavelength"). The idea of radio as dialogue – so brilliantly analyzed by John Durham Peters in his book *Speaking into the Air* (1999, p. 206-225) – recurs as a leitmotiv in the countless pop songs dedicated to this media technology. The Talking Heads song title "Radio Head" (1987) serves as a representative demonstration of the equation of radio with human conversation and subtle interchange of ideas:

> Baby your mind is a radio
> Got a receiver inside my head
> Baby I'm tuned to your wavelength
> Let me tell you what is says:
>
> Transmitter!
> Oh! Picking up something good
>
> Hey, radio head!
> The sound of a brand new world
>
> So look at my fingers vibrate
> From their tip down to their toes
> Now I'm receiving your signal
> We're gonna leave the land of noise
> …

The term "wavelength" is another example of the transition of a technical term closely linked to radio technology into the cultural sphere. Numerous songwriters use this metaphor, Van Morrison being the most prominent among them because of his use of the term as the title for one of his albums in 1978. The title song "Wavelength" invokes fond memories of his adolescence in Belfast, listening to the Voice of America. The transition of technical terms like "wavelength," "interference," or "fine-tuning" into everyday language and their mutation into metaphors of social interactions denote the deep rootedness of radio as a cultural practice.

The Transistor as Mobile Companion

The symbolic capital of radio as an intimate companion and link to the world was even upgraded when linked to another key metaphor of modernity: mobility

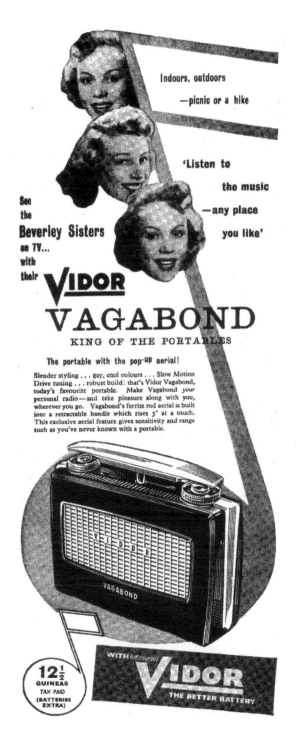

Figure 8.1 "Listen to the music any place you like." Both the ad's text and the set's name "Vagabond" underline its portability and mobility as a crucial characteristic of the transistor radio.

(Borscheid 2004). One of the advantages of the transistor radio, as compared to earlier mobile devices, was its energy and cost saving. While mobility – either through battery-powered or detector sets – constituted an original feature of radio since its earliest amateur days, the domestication and the power enhancement of radio went hand in hand with the electrification of households. From the late 1920s onwards, all high performing sets were equipped with growing numbers of electron tubes, making wired electricity supply not a necessary but a strongly recommended condition of use. In a certain sense, wireless became cabled and the in-house mobility of the set was restricted to the length of the cord. While this process of domestication has been widely studied (Douglas 1999; Hilmes 1997; Lenk 1997), the transistor radio heralded the renaissance of cordless radio. Just like in the pioneering days of detector radios, the transistor triggered a new enthusiasm for mobile radio reception, fueled by the general verve for miniaturization and high-tech toys (Schiffer 1991). One important social epiphenomenon of this resumed liberty of mobile radio usage was the nascence of a new intimacy of listening. An article in the German radio technology journal *Funkschau* suggested in 1960 that "The cordless set permits more intense and intimate listening again – for example at the breakfast table, in your homely hobby room, or when the housewife carries it to her handicraft corner."[6] figure 8.1]

Various songs reminisce about personal listening habits or auditory experiences in domestic spaces. In their song "Do You Remember Rock 'n' Roll radio?" (1980), the legendary American punk-rock band The Ramones asked "Do you remember lying in bed, with your covers pulled over your head? Radio playin' so no one can see...." Another nostalgic tribute to nocturnal experiences with the transistor radio comes from the Canadian hardcore punk formation S.N.F.U. (Society's No Fucking Use). Lyrically known for their love of gross-out humor, violence, tabloid-esque pop culture commentary, and satire,[7] the song "Cheap Transistor Radio" from the 2004 album *In the Meantime and in Between Time* is both a nostalgic reminiscence of their youth in the 1970s where the "possibilities seemed endless" and a slightly wistful pronouncement to "continue that line of thinking":

> A cheap transistor radio underneath my pillow
> I fell asleep to the hits
> And I woke up with the batteries dead
> But it was worth it cuz it's free
> Much like it felt in the 70's
> Cheap! Tran! Sistor! Radio!
> Possibilities seemed endless
> As to what was and what could be
> I think it is very important

To continue that line of thinking
Come on tell me
Dou you agree? Or do you disagree?
Come on tell me, honestly
Cheap! Tran! Sistor! Radio! Yeah!
Cheap! Tran! Sistor! Radio!
Underneath my pillow [5x]

In addition to these domestic memories of the transistor, another group of inti-
mate transistor memories is centered around ambient experiences with the tran-
sistor as a mobile communication technology. Thanks to the portability of the
medium, the transistor became a constant companion, creating a permanent son-
ic environment. In most songs describing the feelings of liberty and freedom, the
spatial experience (mobility) is linked with a temporal quality. In the songs "Mag-
ic Transistor Radio" (Beach Boys, 1973), "Bad Sneakers" (Steely Dan, 1975), "Ta
Ta Wayo Wayo" (The Cars, 1977), "Portable Radio" (Hall & Oates, 1978), "So
ein Sommersonnentag [Such a Sunny Summer Day]" (Severine, 1982), specific
forms of public and communal listening (at the beach for example), made possible
by the mobility of the transistor radio, create the main point of memorial rever-
ence.

The hitherto unknown all-availability or disposability of a medium like the
transistor radio, which inaugurated the era of postmodern media usages, not only
provoked criticism among intellectuals and cultural critics of the 1960s (Fickers
1998, pp. 81-90), but also generated, at least in the case of the British comedian
Benny Hill, humoristic and ironic reactions. In his "Transistor Radio" song,
which topped the U.K. charts for six weeks in 1961, Hill (his real name was Alfred
Hawthorn Hill) caricatured the addiction of his girlfriend to her new transistor
radio:

My baby's got a new transistor radio, she takes it everywhere we go.
She takes it when we go out a-walkin,' even to a movie show....
I'd like to take her transistor radio and throw it in the deep blue sea,
I'm so jealous of her transistor radio 'cause it takes her mind off me.

Instead of being jealous, Buck Owens, who started his career as a country singer
under the band name of Buck Owens and his Buckaroos, fell in love with the
"beautiful girl made in Japan." In his declaration of love "Made in Japan" (1972),
Owens wallowed in sweet memories of his romantic relationship with a Japanese
transistor radio. In Owens' fantasy, the "object of desire" (Forty 1986) turned in-
to a subject of interpersonal relationship:

My transistor comes from far away,
and when it's night over here over there it's a breaking day.
I remember all the good times I had walkin' in the sand
with the beautiful girl that I met in Japan....
As we walked by the river and she softly took hold of my hand,
that's when I fell deep in love with the girl made in Japan.

Both "Transistor Radio" by Benny Hill and Buck Owens' "Made in Japan" relate the intimate relationship listeners established with their transistor radios – a relationship that functioned as an emotional prosthesis. Because of this closeness, both in a physical and psychological dimension, the transistor can evoke strong feelings of technostalgia, a longing for a technology that stands for a treasured past. The technostalgic transistor memories, couched in the various song lyrics and emotionally amplified by the music, are a perfect example of a communicative memorial practice negotiating past and present, private and public, individual and collective experiences with a media technology.

The Transistor Radio As Ambassador of Popular Music and Icon of Juvenile Lifestyle

Virtually all scholarly works on the 1960s as the crucial decade of cultural modernization and youth rebellion acknowledge the transistor radio for being a teen status symbol and credit it as a mediator of "Americanization" and modern lifestyle. Although historical research on the transistor as a cultural phenomenon is rather scarce, no one contests the importance of the transistor as an agent of intercultural transfer and a crucial electronic consumer good in the emerging popular music subcultures of the postwar years (Sassoon 2006; Siegfried 2006). Numerous songs acknowledge the transistor radio as a central actor in emerging teen music subcultures and as a nodal point of leisure time activities. In a song by the French rock and roll legend Johnny Halliday (nicknamed "the French Elvis"), the title of which, "La croisière des souvenirs [The Cruise of Memories]" (1977), already indicates the nostalgic temper of the tune, Halliday sings about the good old times when transistor radios, cigarettes, and other items associated with teen (sub)culture juvenile accessories created a feeling of freedom and independence. In a similar but somewhat romanticized mood, the Greek Schlager star Vicky Leandros, famous for her melodramatic ballads and sloppy love songs, sings about the transistor ("Die Souvenirs von damals [Old Memories]," 1998) triggering memories of her first love letters written at the delicate age of 15.

Two of the earliest transistor songs discovered, Chuck Berry's "Oh Baby Doll" (1957) and Freddy (Boom Boom) Cannon's "She's My Transistor Sister" (1961), can be interpreted as contemporary sketches of a juvenile lifestyle, dominated by

rock and roll music, dancing, and sex appeal. Chuck Berry remembers the moments of unexpected freedom because of a teacher leaving the classroom: "When the teacher was gone, that's when we'd have a ball. We use to dance and play all up and down the hall. We had a portable radio...." Cannon's song "She's My Transistor Sister" is a real love poem dedicated to the irresistible transistor radio:

> She's my transistor sister, with a radio on her arm
> No one can resist her, 'cause she's loaded with her musical charm
> It's Presley, Darin, and US Bonds, and its Fats and Connie and Orbison
> She's my transistor sister, playing her radio
> Yeah, now early in the morning till late at night
> She's in tune with the local DJ's, sings all the words to the latest hits
> Right along with the records they play
> Whoa, oh, transistor sister, transistor sister, transistor sister
> Playing her radio, whoa, oh
>
> - - - instrumental interlude - - -
>
> She's my transistor sister, boy; you've got to love her a lot
> The guys just can't resist her, with a fifteen thousand watt
> If you got it right, you get no static; the time and weather is automatic
> My transistor sister, playing her radio;
> yeah, now early in the morning till late at night
> She's in tune with the local DJ's, sings all the words to the latest hits
> Right along with the records they play
>
> Whoa, oh, transistor sister, transistor sister, transistor sister
> Playing her radio
> Whoa, transistor sister
> Playing her radio, whoa, oh
>
> Transistor sister
> Playing her radio

Evidence for the fact that the transistor set was a highly appreciated consumer good for teenagers is given by a number of songs that refer to the unforgettable moments of buying or receiving a transistor set, for example as a Christmas or birthday gift. In "Tiny Blue Transistor Radio" (1964), country singer Bill Anderson enthusiastically recalls the day he got his first transistor radio "for my birthday just a year ago." The song was successfully covered by his female colleague Conny Smith one year later. While the American singer and parodist Allan Sher-

man was happy to list the Japanese transistor radio at the top of his gift pack in his
1964 parody of the Christmas consumption cult number "The Twelve Days of
Christmas" (1964), Buck Owens still needed to put it on his wish list for Santa
Claus in 1968 in "One of Everything You Got" (1968)! Sherman's parody of the
popular Christmas standard (whose origins as a song go back to the thirteenth
century) is interesting because it refers to an old and well-known Christian folk
carol. His ironic adaptation of the song catapults a capitalist status symbol – the
transistor radio – into a theological frame of reference. Both the verse structure of
the lyrics and the melodic composition based on the cyclic repetition of the open-
ing theme reinforce the status of the transistor radio as the first and most impor-
tant gift! The transistor is further accentuated by the fact that all the other gifts
represent useless gadgets rather than precious presents.

Note: "S" is Sherman, "C" is the chorus, and "B" is both

S: On the first day of Christmas my true love gave to me
A: A Japanese transistor radio
C: On the second day of Christmas my true love gave to me
S: Green polka dot pajamas
C: And a Japanese transistor radio
S: *It's a Nakashuma*
C: On the third day of Christmas my true love gave to me
S: A calendar book with the name of my insurance man
C: Green polka dot pajamas and a Japanese transistor radio
S: *It's the Mark 4 model - that's the one that's discontinued*
C: On the fourth day of Christmas my true love gave to me
S: A simulated alligator wallet
C: A calendar book with the name of my insurance man, green polka dot
 pajamas and a Japanese transistor radio
S: *And it comes with a leatherette case with holes in it so you can listen right
 through the case*
C: On the fifth day of Christmas my true love gave to me
S: A statue of a lady with a clock where her stomach ought to be
C: A simulated alligator wallet, a calendar book with the name of my
 insurance man, green polka dot pajamas and a Japanese transistor radio
S: *And it has a wire with a thing on one end that you can stick in your ear and
 a thing on the other end you can't stick anywhere because it's bent....*

Although there is still some academic speculation about the original meaning of
the "partridge in a pear tree" as the first "gift" in the original song, a certain con-
sensus reigns among scholars that the "partridge" was often used as an emblem

for evil and the "pear tree" as a symbol of female fertility (Brice 1967; Grant 1995).[8] In a somewhat adventurous and speculative interpretation of Sherman's parodist adaptation, one could identify the transistor radio as an emblem of modern consumer society, as symbol of an ambivalent object of desire, embodying both the temptation and danger of rock-and-roll music with its strong sexual and racial connotations.

The Transistor Radio as Public Nuisance and Noise Maker

Despite being the object of love poems and the most wanted Christmas gift, the transistor radio also had its enemies. While praised as a triumph of modern technology by some, it was criticized or condemned as a public nuisance by others. Not all contemporaries of the transistor were pleased with the effects of this mobile radio in public spaces; some experienced it as a source of noise and acoustic pollution of the environment. The earliest example of this category of critical social or political memories of the transistor that could be detected is a song by the Dutch songwriter Jules de Corte, who, in around 1962, wrote a song called "Draagbare radios [Portable radios]," where he criticizes the negative social and cultural impacts of this "new wonder of our times":

> The new wonder of our time, portable radios,
> Spread over cities and the countryside,
> Cause some troubles.
> Portable radios in the bus and in the train,
> Why do they have to make such a noise?
> Oh my god, maybe I'm too conservative,
> But it causes me so much trouble.
> From here to here, here to there,
> Portable radios peeping like a mouse,
> Brutal and noisy – I would prefer to stay at home if I only could.
> Portable radios all along the road,
> What will it be in the future?
> Boys and girls, what a gadget!
> Soon the whole world will be flooded by transistor radios.
> Portable radios on the beach and on the fields,
> … no, no, this is one miniature too much.
> [Translation AF]

In a similar critical tone, the French chansonniers Dalida ("Baisse un peu la radio [Turn Your Radio Down]," 1966) and Pierre Perret ("Il y a cinquante gosses dans l'escalier [50 Guys on the Stairs]," 1981) complain about the domestic noise pro-

duction produced by transistor radios, and George Harrison's "Devil's Radio" (1987) sharply condemns the radio as a gossip dissemination machine. All lyrics agree on their critique of the transistor radio as an irritating noise factor, disturbing the peaceful (at least acoustically) social environment.

Conclusion

Technostalgia seems to be hip. When I googled the term, more than 14,500 entries popped up, most of them referring to blogs where amateur collectors of truck accessories, early computer games, or adult fans of model railways act out their nostalgic passion for yesterday's technologies. Asked why they had named their first album "Technostalgia" (2001), T-Minus front man Troy Thompson replied, "The emotional aspect of music to me is almost supreme, and a common emotion I feel from making music is nostalgia. The album was created using technology that wasn't around for normal Joes like me 5 or 10 years ago. Put the words technology and nostalgia together and you get technostalgia. I like the irony."[9] While the term "technostalgia" implicates the bittersweet longing for a past which can, in a mediated way, be reexperienced or relived by the use of these old technologies, a lot of transistor songs are expressions of a musing reflection or contemplation of the past. In this sense, they could be characterized as techno-melancholic hymns to the transistor radio, paying a sonic and lyrical tribute to the memory of the transistor.

The aim of this essay was to retrace echoes of the transistor radio, spreading on a frequency that innervates a resonating body of individual and collective memories, and to analyze these sonic references to the transistor as a cultural phenomenon. The transistor memories set to music can be described as communicative memories, referring to the transistor as a technical artifact, a sonic medium, and a cultural status symbol. In contrast to classic memorial practices, for example, the staging of the transistor as a technical artifact in a museum of technology or industrial design, songs bear witness to the transistor's living memory. The broad range of musical genres and the variety of symbolic connotations reflect an ongoing process of "intellectual appropriation" (Hard and Jamison 2005) of the transistor, as a communication technology and social medium. The songs reflect a process of lyrical and sonic digestion of actual or remembered interactions with the transistor radio, and thereby demonstrate the continuous (re)construction of the cultural meaning of a technical artifact invented sixty years ago.

This cultural analysis of these songs reveals a multitude of lyrical and musical references to the transistor that point to the spatial, temporal, and social conditions of its use and highlight its various literal and symbolic meanings. The palette of triggered memories is as diverse as the narrative and melodic structures of the songs. Moments of intimate relationship between the transistor and its users are equally portrayed as feelings of melancholy or joy and happiness; social or politi-

cal functions are discussed as well as everyday experiences. While some songs touch on a theme in passing, others deal with it explicitly. Yet despite this variety, the technostalgic and technomelancholic memories seem specifically connected to the transistor radio's closeness to the listener's body.

The many facets of the transistor as an object of mediated memories demonstrate the rich cultural heritage of this audio technology and stress the innovative potential of popular music songs as articulations of technostalgia. And, as the Beach Boys tell us in their mysterious fairy tale of the "Magic Transistor Radio" (1973), the whirling magic sound of the transistor radio will one day trigger old memories of the transistor and blur the boundaries between past and present…

What is that sound – is it possible?

Could it be the pied piper himself

Coming out of the magic transistor radio?

Or was it just the wind whistling by the castle window?

No one knows if the mysterious piper of night

Was the one who came back to visit the princes and the princesses again.

But if you have a transistor radio and the lights are all out some night

Don't be very surprised if it turns to light green

And the whirling magic sound of the pied piper comes to visit you

Notes

1. I would like to thank all participants of the Sound Souvenirs workshop for their helpful comments during the discussion of my paper. Special thanks to Heike Weber and Karin Bijsterveld for their fruitful advice.

2. See/hear for example "Real Real Gone," "In the Days before Rock'n' Roll," See Me Through, Part 1," all on the 1990 album *Enlightenment*, or "On Hynford Street" on the 1991 album *Hymns to the Silence*.

3. For the search on different online song lyric databases, the following English as well as French, Dutch, and German key words have been used: transistor, transistor radio, portable radio, radio portable, *Kofferradio*, *tragbares Radio*, *Taschenempfänger*, *draagbare radio*, *zakradio*.

4. See www.lyrics007.com, www.discogs.com, www3.lyrix.at, and www.paroles.net, all retrieved on 10 April 2008.

5. For a digital copy of the technical memorandum originating from Bell Laboratories on the subject of "Terminology for Semiconductor Triodes" dating 18 May 1948, see http://users.arczip.com/rmcgarra2/namememo.gif, retrieved on 10 April 2008.

6. See N.N., "Beim Transistor sind wir erst am Anfang," *Funkschau* 7 (1960): 151.

7. See http://en.wikipedia.org/wiki/Snfu, retrieved on 10 April 2008.

8. For a detailed discussion of the etymological and musicological history of this carol see http://www.hymnsandcarolsofchristmas.com/Hymns_and_Carols/Notes_On_Carols/ twelve_days_of_christmas.htm, retrieved on 10 April 2008.

9. See the transcription of the interview at the T-minus website, http://www.tminusband.net/ reviews_general.htm. The interview was originally published at Stanley Holditch's weblog, presented as "Birmingham's alternative online source." See http://blog.fleabomb.com/ (retrieved on 10 April 2008).

Chapter Nine

Pulled out of Thin Air? The Revival of the Theremin

Hans-Joachim Braun

Introduction

The theremin, one of the earliest electronic musical instruments, seems to be all over the place lately. In the United States and Europe, it has recently been featured at many concerts, performances, and happenings, apparently to create a sense of awe and wonder in the audience. The more spectacular, astonishing, or perplexing the sound, the better the performance seems to be. The New York Theremin Society organized a concert featuring an ensemble of ten thereminists at Disney Hall in Los Angeles on 26 May 2007. The award-winning theremin-documentary maker Steve M. Martin was "thrilled" to arrange the historic event. A concert featuring so many thereminists had happened only once before, seventy-five years earlier, at Carnegie Hall. "If you're in the area," one ad read, "don't miss this chance to see a once-in-a lifetime event!"[1]

The performance organized by the New York Theremin Society is not the only one pointing to a revival of the Theremin. The Internet platform *thereminworld* contains information about theremin events worldwide and fosters "world thereminization" with considerable success. The annual Ether Music Festival, sponsored by Moog Music, has also attracted a lot of attention. Electronic music enthusiasts have begun to organize an increasing number of theremin workshops, not only in Russia, the U.S., Britain, the Netherlands, and Germany, but also in Mexico, Japan, Korea, and Australia.

Recent interest in uncovering old film scores and rare recordings featuring the theremin similarly expresses this renewed interest in the instrument. In early 2008, a Philadelphia cinema showed the classic Soviet film AEOLITA, QUEEN OF MARS, which was accompanied by a live performance of Gene Coleman's score for theremin and music ensemble. At about the same time, Naxos released the first complete recording of Dimitry Shostakovich's late-1920s score for the film ODNA

(ALONE), the earliest film to feature a theremin. "Komsomol – Patron of Electrifi-
cation" (1932), a symphonic suite by Gavril Popov, was recently performed at the
Avery Fischer Hall in New York, and Bernard Hermann's score for the movie POR-
TRAIT OF JENNY (1948) was found after having been lost for decades. Both compo-
sitions prescribe the use of the theremin. In 2006, fans rediscovered recordings by
Clara Rockmore and Lucie Bigelow-Rosen, two early theremin virtuosi.[2]

Why has the theremin, which created a sensation in the early years following its
appearance but has remained in a niche existence ever since, experienced such re-
markable revival? How can we explain this recent example of technostalgia? Is
there reason to believe that the apparent revival of the instrument, which has re-
mained virtually unknown for decades, will lead to a much wider audience for its
music? This article takes up these issues both in an empirical and a theoretical
manner.

Betwixt and Between

The original theremin, designed in 1920, produces its sound through two high-
frequency generators whose oscillations overlap. A speaker makes the filtered and
amplified sounds audible. One of the generators has a rod antenna, known as a
pitch antenna. The player activates the instrument by changing the distance be-
tween his or her hand and the antenna, which alters the differential frequency and
hence the pitch. The other antenna controls the volume range (Stoll 2006, p. 17).

As to its tonal possibilities, the theremin is – to apply Victor Turner's and
Arnold van Gennep's notion of liminality – "betwixt and between" the old and the
new (Turner 1987; Van Gennep 1909). Some early theremin virtuosi regarded the
timbre of the violin and the human voice as their ideal. They came close to it but
could not attain it completely. When trying to do something new, they found it
hard to make the theremin "stand on its own feet" and express its aesthetic poten-
tial to the fullest. Outside the world of cinema sound effects and "program mu-
sic,"[3] few composers and musicians wholeheartedly accepted the instrument.
This confined the theremin to a niche existence in the musical world for most of
the twentieth century.

Evidently, the possibilities of the theremin did not match the aesthetic and so-
cial expectations of the 1920s or the decades since. Several reasons have been giv-
en for its lack of popularity. Most obviously, the instrument is extremely difficult
to play because of the lack of direct physical contact between the musician and the
instrument. Moreover, the possibilities of the theremin in terms of timbre are lim-
ited. Just listen to a CD with a predominantly nineteenth century repertoire.[4] To
someone not acquainted with the theremin, the sounds may be fascinating at first,
but with continued listening the charm gradually wanes. After a while, the timbre
of the instrument and the absence of breathing by the player can become enervat-

ing to the listener. This makes it difficult for the theremin player to compete with conventional musical instruments. So, for example, why use the theremin for the still popular late-nineteenth-century romantic repertoire, which was written for the human voice or traditional instruments like the violin, when the violin and the voice can be used?

The difficulties of playing the theremin result from the fact that the instrument is played "in space" – without using a fingerboard, keys, or frets. For a theremin player it is therefore useful, though not strictly necessary, to have perfect pitch. A player is constantly moving his or her hands, listening to the resulting changes in the sounds, and adjusting the precise position of his or her hand to attain the desired pitch or volume. This requires continuous aural feedback. Moreover, precise control over one's hand motions is indispensable. This makes it spectacular to watch, but hard to do and explains why accomplished theremin players are rare.

Mastering the technique of performing pieces from the standard instrument repertoire requires the dedication and effort of an unusually sensitive and talented performer (Rockmore 1987, p. 3). Horizontal movements influence the strength of the electromagnetic field of the pitch antenna. The movements of one hand should therefore not affect those of the other. In addition, every venue and performer's body influences the electromagnetic field differently, which means that the instrument has to be tuned anew at every new venue by the theremin player him- or herself. And since there is no established playing technique or notation system, almost all well-known thereminists have developed their own particular techniques for directing their hands toward the pitch antenna or altering loudness (Rockmore 1987, pp. 6-17).

As the theremin reacts to every movement in its immediate surroundings, players not only have to stand completely still, but also have to refrain from nervous breathing or any other signs of stage fright. Even the slightest uncontrolled bodily movement influences the intonation and the stability of the tones. An attentive audience can therefore deduce the player's mood or even character from the sound of the theremin (Eyck 2007, p. 10). This may also be true of players of "conventional" musical instruments, but to a lesser extent – the theremin registers the players' body very precisely. This makes it a near equivalent of a medical diagnostic instrument, which is an intimidating or even frightening idea to many players.

Given the limited possibilities of the theremin in terms of timbre, and the many difficulties musicians have to overcome in playing the instrument, it is understandable that it did not become a musical instrument for the masses. At the same time, these conditions make it rather surprising that the theremin ever found a niche in musical culture in the first place or has undergone a revival in interest in the last decade. How, then, can both its early limited success and recent revival be explained? This will be the subject of the next section.

A Confined Popularity

In 1920, Lev Termen, a Russian physicist and expert in building sensors and sur-veillance technology, invented the thereminvox – the full name of the theremin. Initially, the theremin met with considerable enthusiasm. Even Vladimir Lenin fostered interest in the new instrument because it underscored his gospel of electrification and served as a symbol of Soviet scientific ingenuity. In the late 1920s and 1930s, it was a big sensation and success at concerts in Western European and North American cities. Composers like Henry Cowell, Edgard Varèse, Percy Grainger, and Bohuslav Martinů embraced the theremin and wrote for it. Percy Grainger for instance composed "Free Music #1" (1936) for four theremins, aiming to liberate music from the tempered system of Western tonality. As he claimed in his "Statement of Free Music,"

> It seems to me absurd to live in an age of flying and yet not be able to execute tonal glitches and curves – just as absurd as it would be to have to paint a portrait in little squares.... Too long has music been subject to the limitations of the human hand, and subject to the interpretations of a middleman: the performer. That is why I write my music for theremins – the most perfect of tonal instruments I know. (Kavina 1999)

Granger was not alone in his view. Numerous early-twentieth-century composers and critics asserted that music should be freed from the constraints of the traditional tonal system by using new musical resources in general and electricity in particular. Grainger even employed an unusual graphic notation for "Free Music #1," in which he notated the left and the right hand separately.

Eminent virtuosi like Clara Rockmore and Lucie Bigelow-Rosen held the audience spellbound. One reviewer wrote "Miss Rockmore's séance-like management of this slightly supernatural instrument is quite amazing. Of course, the purpose of remaining still [while playing it] is not theatrical or hypnotic at all, but strictly musical" (Rockmore 1987, p. 3). In 1927, the Paris Opera had to call the police to maintain order among the crowds that thronged to a theremin demonstration. At one theremin concert in 1932, Clara Rockmore performed the "Terpsitone" on an experimental dance platform. The platform had been equipped with thereminvox-like antennae, enabling the dancer to play a melody while dancing, thereby achieving an astonishing synchronization of sound and motion.

Lucie Bigelow-Rosen's performance in Munich in 1936 received similar praise. Even the Nazi newspaper, *Völkischer Beobachter*, revelled in Bigelow-Rosen's wonderful performance on the exotic instrument. The author was lyrical about her skill at playing the instrument:. "As if she had come out of a picture by Gains-borough, so she stood there in front of her mysterious instrument...." The pro-

gram included Bach chorals, Debussy's "Clair de Lune," Ravel's "Pavane," and Brahms' "Lullaby Song." Bigelow-Rosen's performances in Germany were not without problems, however, because she was married to the Jewish lawyer and banker, Walter Rosen. Had it not been for the 1936 Olympic Games in Berlin, the Reich Music Chamber would not have allowed her theremin performances to take place. After all, the theremin was considered a "Jewish instrument," because it was the Jewish firm of M.J. Goldberg and Sons in Berlin who looked after the interests of Lev Termen and his inventions in Germany. Jörg Mager, whose electronic Sphärophon was a rival of Termen's Aetherophone, never tired of denouncing the theremin. In addition, there was a widespread reservation about electronic instruments. Some commentators argued that electronic instruments were artificial and "unnatural" as opposed to the "natural" sound of conventional musical instruments (Donhauser 2007, p. 225). These views proceeded from an obvious conservatism combined with a wish to preserve middle-class musical culture and defend it against attacks by a technology-inspired civilization. Yet critics of the theremin also feared that the new instrument might replace conventional orchestra instruments and make musicians redundant. In contrast, early twentieth-century proponents of electro-acoustic music regarded this redundancy as a positive development and imagined a technologized world without orchestra members and performers who might misinterpret compositions (Braun 2002).

Another kind of critique of electronic instruments was fuelled by a deep distrust of the virtuosity the players of such instruments displayed and by worries about the unsuitability of the instruments for amateurs. During the 1920s, composers like Paul Hindemith advocated a new kind of music – "*Gebrauchsmusik*"[5] – to be performed by amateurs at home. The idea was that composers of "art music" should write simple chamber music for conventional musical instruments, music that anyone was capable of playing. Given the difficulties of playing them, electro-acoustic musical instruments did not suit this purpose, even though Hindemith highly welcomed contemporary electro-acoustic instruments for art music. Moreover, composers, musicologists, and music critics were highly suspicious of the virtuosity and "show element" associated with electro-acoustic music. According to the music critic Walter Gronostay, such virtuosity was simply out of place. Virtuoso players did not understand the proper meaning of music, showed a tendency toward musical superficiality, and thus had more negative than positive effects on their audiences (Donhauser 2007, p. 225).

Finally, musicologists like Otto Kappelmayer criticized the aesthetic deficiencies of early electrical instruments. Although the new electro-acoustic instruments conveyed the charm of the new and the unusual, it was not clear why one should replace a "normal" piano by an electric one. What really mattered was the most adequate way to express emotions (Donhauser 2007, p. 225). For this, electro-

acoustic musical instruments were deficient. Technical progress did not self-evidently equal aesthetic progress, an argument that would be frequently repeated with the development of electronic and computer music from the 1950s onwards (Braun 2002).

A Niche Existence

Nevertheless, the Theremin happened to be well suited for sound effects. Composers of film music such as Miklós Rósza, Bernard Hermann, Max Steiner, and Howard Shore made good use of it. The theremin was used in the film scores of Alfred Hitchcock's SPELLBOUND (1945), Billy Wilder's THE LOST WEEKEND (1945), and Robert Wise's THE DAY THE EARTH STOOD STILL (1951). In Hollywood, the employment of the theremin continued in 1994, when Howard Shore wrote a soundtrack which included a theremin for the Walt Disney film ED WOOD, with Lydia Kavina playing. Two years later, Danny Elfman mixed an Ondes Martenot with theremin samples for MARS ATTACKS (Glinsky 2000, p. 341).

Pop groups such as the Beach Boys and Led Zeppelin also used the theremin, or modifications of it, with splendid results. In 1965, Lothar and the Hand People employed a Moog theremin – Lothar being the pet name for the groups' theremin – in a psychedelic mix of Moog synthesizers and tape decks. In jazz, Yousseff Yancy from Brussels augmented his trumpet playing with a theremin in 1968, and multimedia artist Eric Ross often used theremins with a MIDI controller.

It would be an exaggeration, however, to claim that the theremin achieved widespread application and recognition in film and pop music. As far as art music is concerned, composers like Jorge Antunes, Olga Neuwirth, and Kyosho Furukawa have made serious attempts to write for the instrument. In general, however, the use of the theremin in art music has been limited (Stoll 2006, p. 18).

The Revival

Still, the interest in the theremin and its inventor reawakened in Russia, the country of its origin, after Perestroika. In 1992, the Moscow Conservatory established the Theremin Centre, an electronic music studio which featured the theremin. In 1992, Steve M. Martin's prize-winning documentary came out which significantly increased interest in Termen's inventions and his instrument. The centenary of Lev Termen's birth in 1996 was celebrated with Theremin festivals and conferences in major Russian cities. In the late 1990s, Zoya Dugina-Ranevskaya, one of Termen's pupils, started regular classroom lessons for the theremin, using a model with a left-hand controller for articulation and pedals for volume control. In Russia and elsewhere, the popularity of the theremin gradually started to grow, first among professional musicians and later amateurs, often to produce sound effects.

This initial resurgence in interest was aided considerably by the availability of instructions for building simple theremins on the Internet.

Carefully produced recordings of artistic merit have always helped to enhance interest in a particular instrument or musical genre. In this respect, Lydia Kavina and Barbara Buchholz have been particularly significant. In 1999, Kavina issued the CD *Music from the Ether: Original Works for Theremin*. In addition to pieces written by well-known early twentieth-century composers including Bohuslav Martinů, Percy Grainger, and Joseph Schillinger, she included orchestral works by the late twentieth-century composers Jorge Antunes and Vladimir Komarov as well as two pieces of her own. Many musical works for the theremin combine it with other musical instruments and the human voice. Lydia Kavina's "Suite for Theremin and Piano" exhibits several possibilities with the theremin, such as its wide-ranging pitch, dynamics, and glissando effects. In 1994, Kavina wrote "In the Whims of the Wind for Theremin, coloratura soprano, and piano." This work confronts the singer's voice with the theremin, and shows what it can do beyond what a voice can, such as attain higher and lower registers more easily.

The CD *touch! don't touch – music for theremin* came out in 2006 (Stoll 2006). Its producers were Lydia Kavina and Barbara Buchholz, a German instrumentalist, performer, and composer, who had training on the flute, guitar, and bass, especially for jazz. A singer as well, Buchholz studied the theremin with Kavina in Moscow. The CD was sponsored by the Art Foundation of Northrine Westphalia, the German Music Council, and the broadcasting station *Deutschlandfunk* as an attempt to bring the instrument to the attention of contemporary composers. As the CD's title suggests, *touch! don't touch* is about electronically produced sounds coming together with sounds created with acoustic instruments. In one piece, "The Son of the Daughter of Dracula versus the Incredible Frankenstein Monster (from Outer Space)" written for two theremins, violin, violoncello, piano and percussion, the composer Moritz Eggert, produces a wide range of glissandi and psychedelic trembling together with the thunder of tympani, tremoli in the strings, and haunted-house samples. Linking his compositional concept to the way the theremin was often used in the 1920s and 1930s, Eggert plays with the many possibilities of the theremin and additional sonic options (Stoll 2006, p. 24).

In 2004, two years before issuing *touch! don't touch*, Barbara Buchholz produced the CD *Russia with Love* (Buchholz 2004). It contains avant-garde music, popular songs, and jazz-inspired tunes that easily cross the borders between art and popular music. Buchholz plays a theremin which combines the thereminvox of the 1920s with present-day technology. Activating a sampler through MIDI, it is possible to generate loops and samples by hand movements.

Closely related to such initiatives is the work of Alvin Lucier, an American composer of experimental music and sound installations which explore acoustic phenomena and auditory perceptions. Lucier's performances are in between scientific

demonstrations and artistic presentations. His performances often have the feel of a well-prepared and vivid physics lesson rather than a concert, even though Lucier, an artist, aims at the artistic (Brech 2006, p. 154). His 1965 composition "Music for Solo Performer" is particularly relevant in this respect. In this piece, EEC electrodes attached to the performer's scalp detect bursts of alpha waves generated as soon as he or she gets into a meditative brain state. Only these alpha waves – waves between 8 and 12 hertz that are not audible without the help of electron-ics – are allowed to pass through, while higher frequency beta waves are filtered out. The amplified alpha waves result in an electrical signal that is used to activate percussion instruments distributed around the performance space. The alpha waves have a dynamic of their own and are only established when the performer has succeeded in achieving utter concentration (De la Motte-Haber 1999, p. 306). This is hard to attain since tension is detrimental to the rise of alpha waves. What's more, the performing artist needs to adopt both the role of observer of his own mind state (yet without imparting any meaning to this) *and* that of the audience (De la Motte-Haber 1999, p. 238).

Finally, "Thereminskie ostrava [Theremin Island] for two theremins, piano and percussion" is worth mentioning. In this piece, the composer, Nicolaus Richter de Vroe, is concerned with gestures and *mise-en-scene* rather than with music and sound. For the proper interpretation of the piece, the theremin players had to learn the technique of imitating the composer's signs with their hands. In "Thereminskie ostrava," the emphasis is clearly on the performative (Stoll 2006, pp. 20-21).

Understanding the Revival

The performative aspect of the theremin might be one of the reasons why, in spite of its drawbacks, the instrument is growing in popularity again. In Europe, the "performative turn," a transformation from a predominantly textual to a predominantly performative culture, has had two connected stages. In nineteenth-century arts and culture, the mind (and thus texts and words) was privileged over the body, whereas this textual orientation gradually came to be replaced by a more theatrical one in the early twentieth century. Exhibitions and fairs, festivals and sports events, dance, striptease, and even the theater of the department store gained increasing significance, signalling the beginning of a genuine "theatrical-ization" of public life.

From the 1960s onwards, the performative element in the arts has witnessed the rise of action art, happenings, and experimental theater. In performances, the transitory, fleeting dimension became essential – the terms "fluxus" denoted the transitory nature of these events (Bachmann-Medick 2007, p. 121). Such performance art, in which the body, gestures, mimicking, and visual elements were

key features, also contributed to new developments in music. Performance artists such as Joan La Barbera and Meredith Monk added the stunning virtuosity of their voices, while others – Laurie Anderson, Diamanda Galas, David Moss – applied electronics in ingenious ways, enlarging, duplicating, distorting, or dismembering their words or songs without de-materializing their voices (Fischer-Lichte 2004, p. 221). In performances like these, the auditory realm is experienced as a liminal space, a space of constant transformation, just as with the theremin. In addition to the rise of performance art, the media brought the ever-increasing visualization of information (Fischer-Lichte 2004, p. 108). Moreover, now that the Internet functions as a stage, some sociologists even speak about a "stage society [*Inszenierungsgesellschaft*]" (Williams and Jurga 1998).

Closely linked to this performative turn is the remystification of Western culture – the opposite of the "demystification of the world" identified by Max Weber in the early twentieth century. The appropriation of religious practices from non-Western cultures, such as the "New Age" movement, contributed to this shift. Authors like Antonin Artaud criticize the logocentrism, rationalism, and individualism the Renaissance brought us. According to Artaud, the theater should bring the human being in close contact again with his or her prelogical, prerational, and preindividual origins. Theater performances should thus be ritual, liminal experiences. They should bring forth a state of trance in the audience that affects the subconscious and diminishes the forces of control. To achieve this, the theater needs a transformation into a "magic ritual" which creates a "*rite de passages*" for the audience. Its aim is to heal people who have been made ill by Western civilization (Artaud 1987, 1998; Fischer-Lichte 2004, p. 339-40).

We come across such a form of remystification in Tom Waits' remarks about Lydia Kavina playing the theremin in *Alice*. Waits composed the music for *Alice*, a musical directed by Robert Wilson at the Thalia Theater in Hamburg in the early 1990s. This is what Waits had to say about Kavina's performance:

> She was really amazing. You would imagine someone like that would have some really sophisticated instrument, but she brought this thing that looked like a hot-plate with a car aerial coming out of it. She opened it up, and inside, all the connections between the circuits were established with cut-up little pieces of beer can wrapped up around the wires. All the paint was worn off, but when she played it, it was like Jascha Heifetz. They're doing experiments with the theremin now. The sound waves you experience when you play it have therapeutic value.

> Interviewer: "How so?"

I don't know, just the fact that you don't touch it – that you play the air and you're in contact with the waves – somehow does something to you on a more genetic level and can heal the sick. Raise the dead. Apparently.[6]

Tom Waits' statements in the interview were obviously tongue in cheek, but it seems clear that the mystification the theremin allows for is essential to the instrument's recent surge in appreciation. The theremin's tender, vulnerable timbre and its likeness to singing make it similar to the minimalist and meditative music that became popular in the 1960s and continue to be so today, exemplified by the work of Pauline Oliveros (Danuser 1997, p. 8).

Widely described as séance-like, the performances by Clara Rockmore – the world's best known thereminist and the "high priestess" of the instrument – came close to being secular rites. According to Arnold van Gennep and Victor Turner, rituals are not merely performed, but also have the power to bring about transgression. The second phase of these rituals, the liminal phase, creates a transition between the old and the new. As such, the theremin seems to be the liminal musical instrument *par excellence*. This is due in part to its physical properties which cause high frequency oscillations to overlap. The sound that is heard consists of the amplified intermediate oscillations. But it is the fleeting, volatile, undetermined nature of the theremin sound and its ability to create very small shifts in frequency and thus nuances in intonation which qualify it for the title of the most liminal musical instrument.

It is not only the performative turn in Western culture and the closely linked remystification that explain the revival of the theremin; the rise of the "new virtuosity" also plays its part in it. From the 1950s onwards, virtuosity experienced a remarkable reappreciation in avant-garde music. This virtuosity was productive rather than reproductive, and it can be compared – although its impact was smaller – to the virtuosity of composer-performers like Niccolo Paganini and Franz Liszt in the first half of the nineteenth century. In the second half of the twentieth century, the amazing virtuosity of composer-performers such as the pianist David Tudor, the oboist Heinz Holliger, and the trombonist Vinko Globokar paralleled the musical feats of the great thereminists using conventional musical instruments.

The virtuosity of recent theremin players has been helped considerably by the rise of new forms of performance control. In the second half of the 1980s, building on the work of computer music pioneer Max Mathews and others, Robert Boie, an engineer at the Bell Telephone Laboratories, developed the prototype of the "Radio Baton" which was soon followed by the "Radio Drum." These handheld batons emit radio frequencies from their tips which are detected by a sensor plate. Whereas the conventional theremin only detects proximity as such, these devices register spatial proximity in three dimensions (Manning 2004, p. 379). Andrey

Smirnov, founder and director of the Theremin Center for Electro-Acoustic Music at the Moscow State Conservatory, and others have made several modifications to the original theremin. The most recent is Smirnov's digital theremin sensor which uses an Arduino interface to communicate data from the theremin sensors to software such as Pure Data and SuperCollider.[7] These innovations have enhanced the much-needed control in playing the theremin.

Why are today's theremin players so thrilled by this instrument? Why are they willing to take up the enormous challenge of playing it well and develop the necessary skills and ears to do so? Many young musicians are fascinated by the sonic experiments of the 1920s and 1930s and the rise of electronic and computer music from the 1950s onwards. But the theremin has also become a symbol of "emotional technology." For some of these thereminists, their aesthetic ideal is not so much rooted in the avant-garde of the 1920s, but in nineteenth-century romanticism. Their love of the theremin is not so much an expression of technostalgia per se, but of nostalgia for a particular sound – a sound that provides a counterpoint to the electronic music of the 1950s and early 1960s, which many people find inaccessible. Quite often the old dichotomy between "dead technology" and "living humanity" reappears. As Barbara Buchholz, one of today's best-known theremin players, puts it:

> The poetic way of playing the theremin conveys a sensual approach to electronics. It is an instrument of our time; after the digital 1990s it meets the need of combining the high technological level of electronic music with a living human form of expression.(Buchholz 2004)

The Russian theremin virtuoso Lydia Kavina even thinks that "to play the theremin you have to be a bit crazy. What is nice and special about the theremin sound is its insecurity, its humanity, the trembling. This weakness makes it strong" (Buchholz 2004). In another statement, both artists Barbara Buchholz and Lydia Kavina explain that

> When playing the theremin there is no mechanical memory, no connection between a note and a hand or finger position. There is no form of visual or tactile orientation when playing. The player's only source of orientation is her ear; she plays – in this sense it is like singing – only intonations that are imagined by listening inwardly. The sound ideas and interpretations of various theremin performers are as different as the voices of different singers. This is what makes the electronic sound of the theremin so alive, so spontaneous – and as vulnerable as the human psyche itself. (Stoll 2006, pp. 18n)

It may be for this reason that contemporary forms of theremin music most favored by listeners are ambient and slow, meditative music. Like the synthesizer, its use is not restricted to either art music or popular music. In fact, the role of the theremin in music is another proof of the often-voiced opinion that this division is highly artificial and has been obsolete for quite some time. If we look at the categories with which the theremin pieces were identified in the "Spellbound" broadcast by the American radio station, Cygnus Radio, we see a wide range: ambient, avant-garde, classical, electronic, jazz, neo-classical, and rock.[8] Yet the ambient music is what seems to stir a tender chord in today's audiences.

Conclusion

Has the theremin been pulled out of thin air? Is its recent revival merely a flash in the pan? The current possibilities of MIDI and sampling have certainly increased the attractiveness of the theremin, and the fact that playing this instrument is now taught at different places in the world has advanced the prospects of its dissemination. That playing the theremin is theatrical and still invokes a magical feeling in the audience are great assets in our modern culture. The revival of the theremin is a sound souvenir of both the historical avant-garde and of mysticism and romanticism, but it is also the result of two recent developments in arts and music, the performative turn and the new virtuosity.

But are we experiencing a breakthrough? Will the theremin achieve a popularity which equals electrified musical instruments, such as the electric guitar, the electric bass, or the e-piano? This will most probably not be the case. After all, the possibilities offered by today's synthesizers far exceed those of the theremin. And the electronic instruments just mentioned are much easier to play well. However, given the shift toward the performative and the reappreciation of virtuosity, mysticism, and romanticism, we may expect that the theremin will find a serious afterlife in live performances that combine the theremin with other musical instruments, and in the creation of sound effects. The theremin will continue to be a challenge and a fascination to players and audiences alike.

Notes

1. LA Disney Hall to Hold Historic 10-Theremin Concert - May 26th (2006),
 http://www.thereminworld.com/news.asp?cat=8, retrieved 24 July 2007.
2. http://www.thereminworld.com/news.asp?cmd=t&p=2, retrieved 18 February 2008.
 http://www.thereminworld.com/news.asp?cat, retrieved 18 February 2008.
 http://www.thereminworld.com/news.asp?cmd=t&p=3, retrieved 18 February 2008.

3. Program music is "Music that … attempts to express or depict one or more nonmusical ideas, images, or events" (Randel 2003: 680).
4. See for instance the works by Saint-Saens and Tchaikowsky on Clara Rockmore's CD *The Art of the Theremin* (Santa Monica: Delos CD 1014, 1987).
5. *Gebrauchsmusik* is music intended, by virtue of its simplicity, of technique and style, primarily for the performance by a talented amateur rather than a virtuoso.
6. Tom Waits, *The Onion AV Club Interview*, http://act-sf.org/nev_bri_oni_int.pdf, retrieved 11 September 2007.
7. http://www.clubtransmediale/xxxxx_workshop, retrieved 16 February 2008.
8. http://www.thereminworld.com/news.asp?cmd=t&p=2, retrieved 18 February 2008.

Chapter Ten

Technostalgia: How Old Gear Lives on in New Music

Trevor Pinch and David Reinecke

Introduction

For many musicians and collectors, the musical instruments of the past live on in the studio, on the stage, and for those rare enough instruments, in the vault.[1] Paradoxically, many of the finest guitars end up on the wall of collectors' homes never to be played again. Vintage synthesizers, such as the Moog Minimoog, have acquired such a legendary status that they are unaffordable to most working musicians. Even old instruments and pieces of equipment that are not particularly rare, such as the Fender Deluxe tube amp favored by rock musicians for its classic rock sound, present particular problems for gigging because of their weight and fragility. Indeed old and valuable instruments are actually for many musicians a pain: they are fragile, insurance policies may circumscribe use, and they are an inviting target to be filched.

Age has become a fetish in the world of guitars where large amounts of money are paid for a specially "reliced" guitar. As one company, Relic Guitars, which offers this service claims, "The idea behind relicing a guitar is to artificially replicate the natural wear that occurs over the many years that the instrument has been played. This procedure involves aging the hardware, and creating authentic looking wear marks on the neck and body of the guitar."[2] This is little different (other than the shock of deliberately scratching up anything as beautiful as a guitar) from the specially manufactured patched and faded jeans and denim jackets currently in fashion. There clearly is value to be found both in manufacturing age and age itself.

Teasing out this value to be found in what we call vintage gear, the whole coterie of old instruments, amplifiers, and recording equipment, and how their use is bound up in current identities, practices, and technologies found among musicians is our goal in this paper. In exploring the relation between the past and present, embodied through music equipment, we can better understand what we mean

by "technostalgia" in relation to vintage gear. Nostalgia is commonly understood as a desired return to an ideal past in response to a troubled present (Davis 1979). On the contrary, we hope to show that "technostalgia" is more than a return to an ideal past, but rather an attempt to mediate between past and present to achieve a particular sound and feel (Hennion 1997).

How then in practice do musicians deal with this bewildering range of choices of sounds, instruments, and equipment which they face in a digital age? How do they blend the new and the old? How do they learn about what if anything to value in old gear? What is it in old instruments they particular value? And, most importantly, how do they achieve their ideal sounds? To answer these questions we have been carrying out a small ethnographic investigation (including in-depth interviews) among a select number of rock and electronic musicians. We hung out with these musicians, visited their studios, and watched them perform. These musicians range from hobbyist musicians to professional musicians. We selected our subjects from our two local scenes (Ithaca, where Trevor is based, and Philadelphia, where David is based) and supplemented this with other contacts.[3] All the musicians we chose to interview are known especially to value old instruments and equipment. All have access to and knowledge of digital equipment as well. The gear we cover here includes guitar amplifiers, synthesizers, the Wurlitzer electric piano, electric guitars, mixers, effect devices, and tape recorders.

The Sound Is the Starting Place

Trevor asked a musician, Park Doing, who happened also to be in his own department at Cornell University, whether he ever used vintage gear. Park was proud to announce that he was mixing his latest album in a nearby recording studio that housed the original mixing board used to make several albums by Elvis Costello and the Attractions. To understand why he wanted to use that board, he said we needed to understand the sort of music he made – rock and roll.

When he was growing up in the Midwest, Park listened to what is now called classic rock, bands such as The Who, the Rolling Stones, Aerosmith, Grand Funk Railroad, and Steppenwolf:

> And the sound, for me what a band should sound like, is a two part equation; the first part is being raised on classic rock. ... [W]hen I was twelve or thirteen that's what I heard. That's one level.

The second level for Park was punk rock, which has been a lasting influence, not least because it empowered him to form a band himself. He absorbed the punk ethos of not being overly reverent towards equipment, disparaging what he called "gear heads":

You know the Sex Pistols stole all their equipment from David Bowie goes the story, so it was never about "Look at all this great gear I have." ... I was never like a "gear head" person ... You could get a good Les Paul but you should, like, paint it or scratch it.

From his exposure to punk, Park also developed a fondness for what he calls "trashy" sound: "To get technical about it: the compression is all removed, the reverb is all taken out, the gloss is removed and you get this trebly, cacophonous, the instruments are not separated, um, raw sound." For Park, "Cool and trashy, that's rock and roll." Park believes that a proper rock band must use what he calls "real" guitars and amplifiers, "a Fender Telecaster through a Marshall stack or amp or a Gibson custom or SG." Park always searches out studios which have gear used in the 1960s and 1970s because he believes that this era was the high renaissance of sound:

> There was so much money involved in the commercialization of rock and roll, in particular the sorta psychedelic blues-rock, in the U.S. in the 70s. As a consequence, there was a lot of money to be put towards recording equipment and money that today doesn't really exist ... these guys [referring to Glyn Johns who recorded The Beatles] were just high level ... to me that era with really big magnetic tape and these vacuum tube electronic modules and these mixing boards like the one we have at the studio. I see that now as a kinda heyday of industrial investment in recording.

He elaborated further upon what this means for his recording practices:

> Those fellows in the 70s really had it and that's where the gold is in having your band sound like a rock and roll band. ... So we record in town and use the Neumann microphones that The Beatles used ... and for me they just understood about power, and meat, and energy, and aggressiveness combined with a warm and engaging sound.

Recording the Sound: Tape versus Digital

Park thus makes every effort to find and use studio equipment that will lead to the "gold." He is not worried that the sounds he is after are invariably processed through digital computers and recording consuls. Park acknowledges that nearly all studios today use computers and digital recording:

> The board we have at Mecklenberg ... we don't go to tape and that's actually rarer and rarer, I think the White Stripes did an album two albums ago and they

went straight to tape. Then if you're at a level like myself, then you make compromises, and part of the compromises come at the editing realm. Editing in digital is just a dream, you just can't imagine what goes on.

In this respect, Park is similar to all the musicians with whom we talked: although they may favor particular old instruments and equipment, they are quite willing to use digital equipment when the occasion merits it, especially if they perceive big benefits. Park, for instance, is fond of using a software program known as Protools:

> PD: I've got this sorta trashy bombastic rock sound, the level that Protools diminishes that compared to the … universe it opens up to me in terms of being able to arrange takes and arrange music, it's like [holding his left hand about a quarter of an inch above the table] it messes it up that much and I get *so much* out of it [holding his right hand about three feet above the table].
> TP: So you're not an analog purist?
> PD: If I had the money and the time you know I would go all the way … I don't have a whole lot of resources for this, so it allows me to record a record in a legitimate way and that's a huge difference … it's the all or nothing difference.

The digital recording process has become so cheap and versatile that it is difficult to resist for a small-budget musician. Indeed, all the musicians we talked to used digital recording, although they might "go all the (analog) way" if they ever became wealthy enough (Pinch and Trocco 2002; Horning 2004). Some musicians thought that tape was good in its own right because it added a particular character to the sound not found in digital recording. One Ithaca-based musician interviewed, John Robert Lennon (aka Inverse Room), had just bought a new TEAC tape deck for his home studio (all his previous recordings had been made on a computer):

> Well you know it's tangible. And I didn't start recording until digital stuff started coming out – though I've been a musician most of my life and I gradually upgraded my digital stuff and I'm working on a computer now. But there's something um intangible about digital recording that made me long to have a, you know, big old tape deck. And it's really fun to use and I like the way it sounds.
> TP: Does it sound noticeably better than the digital stuff? Or inferior?
> JRL: No it's different. No, no, it's neither. I know there are a lot of analog purists who really, who insist that tape sounds better and I suppose it does and I suppose if you consider a really high end calibrated tape deck, maybe it does sound qualitatively better than a computer system. But the fact is it's so easy to use the computer and you can edit everything. And if your outboard gear is OK, then the

sound that goes into it is good and it will come back sounding more or less the same. Whereas this, the tape machine sorta imparts a certain character to the recordings that is not there in a computer. So it's a nice addition to a digital studio.

One Philadelphia-based electronic musician we interviewed, Starkey (aka Paul Gleissenger), had also just bought (with a musician friend) an old eight-track tape recorder for $250, of which seven of the tracks were usable. Starkey found that he had in the past occasionally "bumped things to tape" because he liked the compression sound which the tape produced. For Starkey, who works almost exclusively on a laptop to make his digital music, it is analog compression that he values most:

> There is something to be said about analog processing. It does sound better in general. But a lot of the stuff I am working is like samples anyways. So what really does it matter? Where it really matters is compression. Analog compression just sounds better. There is something to be said about putting audio through tubes and tube amplifiers and adjusting sound that way. That is what I am really interested in right now, talking to friends who work with hardware.

As with John and Park, it is a special quality of the sound when processed through tape and tubes which this musician puts a premium on.

Analog versus Digital Synthesizers

In the realm of synthesizers, too, we found that the musicians were quite prepared to use a modern software synth when the need arose for live performance or recording; these software synthesizers emulate the sound of older analog synthesizers. John, who owns an impressive collection of analog synthesizers, noted: "Oh yeah I've got like some software Minimoogs. Yeah I've got a bunch of software synths and they sound quite good, I think … and most purists would say the software doesn't sound as good as the hardware, and they're probably right but it sounds very close." But the old analog synthesizers have something digital synthesizers don't have: the tactile controls of knobs and wires (used to patch in different sounds). Thus John also has a modular analog system:

> JRL: I want to turn the knobs and mess with the patch cables, you know. I like building things. It's tactile … you know there is something about … I like playing around with stuff and trying new things. And the modular system is perfect, you can … swapping out a module with a new one, it's not very costly and you can put a new one in … it's like an endless self-replenishing hobby.

John prefers the tactile interface of his modular synth (built from a kit), with its knobs and patch cables, for the flexibility it gives him to pursue his "self-replenishing hobby." But if he ever needs the famed Moog sound, he can simply pull it up on his computer. Starkey owns two analog synthesizers, including a Roland Juno 60, but uses mainly digital samples and software synths in his music. He claims the latter actually has some advantages over the original analog synths they emulate:

> Yeah a lot of things try and emulate analog stuff … but there is stuff that can't be done analog. There are even programs like Korg when they came out with their Legacy Collection of synths [Korg emulated their famous MS-20 analog synth]. They emulated them as close as possible, the sounds, the filters, the way they worked, but also made some of the synths – which were monophonic – have the option of being polyphonic, which you couldn't do on the analog. Whereas they can do that with the software, so it is like you had that hardware but you were able to mod it so that actually it did polyphony.

Starkey is here referring to a synthesizer that in its original analog version was only monophonic (one note at a time), but which became polyphonic (many notes at a time), in its software version, thus offering a modification (or "mod") that was impossible with the original hardware synth. This permits him to use analog sound, but to do it using modern digital advantages like polyphony, and thus do "stuff that can't be done analog."

The whole issue of emulation is a fascinating one in the world of synthesizers (Pinch 2003; Porcello 2004), because even early analog synthesizers claimed to be able to emulate other electric instruments, such as Hammond organs, as well as some orchestral instruments. With each succeeding generation of synthesizer claiming to emulate a greater range of instruments, including earlier synthesizers, a whole plethora of embedded emulations would seem to follow – that is to say, a digital Korg Triton emulating an analog Minimoog ought also to be able to sound like a Minimoog emulating a flute. But despite this seeming logical possibility, only one sound or a very limited range of sounds from the earlier synthesizer are actually emulated. At the heart of all emulation lies the power of the simplification entailed in the representation of sound – many possible sounds are being reduced to a smaller subset. A saxophone, for example, will sound different depending on who is playing it (Charlie Parker or the guy down the corridor), and where it is played (smoky club versus concert hall), and for what sort of music it's being played (pop or jazz) – and yet all these possibilities are reduced to one sound, simply labeled "saxophone." Furthermore, this one sound is now heard as the definitive saxophone sound and shapes perceptions of what a saxophone should sound like. The paradox is that, despite the claims that synthesizers are able to produce more and more different sorts of sounds, each synthesizer also becomes recog-

nized for distinctive and characteristic sounds, such as the famed bass filter sound of the modular moog synthesizer (carried over into the Minimoog) or the bell-like sounds made by the Yamaha DX-7. As we see throughout this chapter, it is very specific sorts of sounds, often peculiar to one instrument (or to be more precise, one part of the instrument – referred to below as "the sweet spot") that these musicians are after.

All the musicians interviewed agreed that gear from the past and present both offer unique advantages in terms of sound and sometimes tactile feel. The particular mixture of the old and new varied. All agreed, however, that the process of figuring out the right combination was detailed and extended moving from the novice listener to the experienced manipulator. Educating amateurs interested in vintage gear is a process of both listening and actively engaging in the sound being produced, guided often by a more learned third party. But more often than not, there is some luck involved as well.

"I Gotta Real Amp Too"

When Park decided to become a rock musician he knew the sort of sounds he wanted to make and knew he needed an amplifier. But he had no experience with electric guitars and amplifiers. Park describes himself as "word of mouth guy" and, unlike "gear heads," he doesn't research equipment. With the amplifier he lucked out. In Ithaca there is a guitar shop staffed with sufficiently skilled musicians (including several who have played in numerous bands) to sell Park what turned out to be an appropriate amplifier for the sort of music he wanted to play:

> So when I went into the guitar store … I didn't have a group of people or a mentor or someone to tell me what to do. I had $400 and I told the guy what I had and "I'd like to get something that's a legitimate amp" … and he instantly said "We've got this Fender Deluxe Reverb, it just came in, and I'll sell it to you for four hundred. And that's a real amp and that's what you should do." I said "OK." I bought it within fifteen seconds of the thing. I think I may have plugged the guitar in a cursory manner but I didn't really know how to play.

Park then played with the amp in his band and came to love it:

> I took it out and from that time on when I play and stuff, guitar guys love that amp. They come up to me and say, "Oh Deluxe Reverb, oh yeah that's an awesome one." You know and guys who are like heroes of mine [he names some musicians], they had Deluxe Reverbs and I remember being thankful that the guy had given me a legitimate, a cool amp so could be like "I gotta real amp too."

The sound of classic rock depends crucially on the amp and guitar in combination. Park had less luck with buying his first electric guitar. He knew that a Les Paul was a desirable guitar and wanted to find one:

> I was leaving Dayton, Ohio, and I stopped in Columbus where all my friends were ... [T]he university has about sixty thousand students ... ten thousand of them are in rock and roll bands! And I'm sitting there with a guy I just sort of casually knew and he was down on it and he couldn't pay his rent ... and he was like "I'm trying to sell my guitar and nobody will buy the guitar." And I said, "What kind of guitar is it?" And he opened it up and it was black Les Paul from 1980. But to me it was like a cool ass black guitar. He goes "I need $350 to pay my rent. If you buy this guitar, I'll go buy a case of beer and we'll have a party the rest of the night" ... and like so I couldn't resist and bought it right on the spot and took it with me on the plane.

Park slowly discovered over time that the 1980 Les Paul Artist he had purchased was part of a discontinued range in which Gibson experimented with active electronics (circuits built into the body of the guitar, which modify the sound), and as a result, the guitar has an extra three switches and knobs. Park found that the sound the guitar produced was thin and "too electronic," and also it was hard to tune. Park struggled to make the classic rock sound he was after. Things changed, however, when he was befriended and mentored by one of the major rockers on the Ithaca scene, Johnny Dowd, who guided Park to a new guitar:

> Finally Johnny Dowd said like "That guitar's ridiculous. And it's not even the sort of guitar you should have. You need a Telecaster or Stratocaster." He himself is a total gear head and knows everything about the guitars and everything. And those switches on it he didn't like any of that stuff. He called me one day [from a newly opened vintage guitar store] and he said "I've got your new guitar down here. Bring that old one with you we're going to trade it in." And I was a little bit wary, but Johnny Dowd was like a hero to me, he was like real ... the real deal. And if he said I should trade my guitar in then I should trade my guitar in.

Park had mixed feelings about the trade because his Les Paul looked "so cool and black," and Johnny now wanted him to trade the guitar for a new one built in the store:

> So I went down there and the guy looks at it and he says "OK I'll trade you even." But what was he trading me for? It wasn't a real Stratocaster he was trading me for; it was just a Stratocaster they had made in the store ... but it was made really well and it has a whammy bar, floating bridge, and it sounded like, you know

Johnny is playing it through the amps. And at that time, I knew like that Johnny
knew what a guitar should sound like. Me myself I couldn't really rig it up; like if
I had to stand there and say "This is the good sound and this is the bad sound" It
would be dicey, like I wouldn't really know.

Park had many regrets about trading in his name brand guitar, especially as he
couldn't yet tell which sounds were "good" and "bad" in the new guitar. Over
time, however, he came to realize the wisdom of Johnny's advice:

But as time went on, I love that guitar now, you know and it's like when I play
that guitar with the Fender amp, I think the guys who made the guitar, they knew
how a Strat should sound, and they got that sound and for me who couldn't real-
ly afford a new Stratocaster and definitely not a vintage one. I feel like now I have
a great sound and now I can tell. Like now I can tell it's a good sound.

What Park points to here is how he relied upon the expertise and ears of the more
experienced Johnny Dowd to buy the right sort of guitar to match his amp. He
learns the lesson that it is not the look or name brand of the guitar which matters,
but how it sounds, and how it is matched to his amplifier and to the style of music
he wants to make (Waksman 2004). Over time, as he gains more experience, Park
too learns that he can tell, "it's a good sound." More importantly, his sound is a
mixture of a new guitar and an old amplifier, coming together in the right mixture
to his ears, once trained.

Finding the Sweet Spot: Tinkering, Twiddling, and Tweaking

Having bought the correct amp and guitars is of course only the beginning. The
musician must learn to make the sorts of desired sounds. Often musicians have
several amps and guitars, and each will require a lot of work to find the right com-
bination of settings. This is the main quest and one of the major headaches for
Nick Gonedes. Nick is a Philadelphia-based musician who has a sizeable collec-
tion of vintage amps. He is what Park would refer to as a "gear head." Nick loves
to spend hours discussing the technicalities of different vintage amps – their pre-
amps, controls, tubes, transformers, and layout, and who used what amp to make
what sound. He notes that often these amps come with manuals showing how to
set up particular sounds reminiscent of famous players with equally famous tones:

The Rivera and the Boogie come with these manuals that say something like
"Stevie Ray Vaughan sound," like turn this to 4, this to 5, this to 3. I have never
been able to do that. I turn the knobs and think this doesn't sound anything like
Stevie Ray Vaughan. It is partly because the speakers are not the same, the guitar

is not the same, maybe I hit the strings on my guitar harder than they do. So you just have to sit down and figure it out yourself.

The DIY tinkering ethos, so common to young men, and documented in many other technical areas like ham radio (Haring 2007), hacking (Levy 2001 [1984], Turkle 2005 [1984]), and hotrodding (Post 1994) seems to come into play here as Nick proceeds to tinker with his setup in search of his own particular sounds. For instance, this is how he worked with one of his favorite amps, a vintage Mark I Boogie amp:

> It took me easily almost two years to get the sound I wanted out of that amp. Because I have multiple guitars … when I go out to play, I take two or three guitars with me. I have to decide what sounds good with the Strat, what sounds good with the Gibson, what sounds good with the Rickenbacker. So you have to sit there and just screw around with the thing, and there are times when you just want to throw the amp against the wall. I need to get rid of this thing. You just have to be patient, especially when the tone and volume controls are interactive. I would pick a weekend right and just block it out. The next six hours I am going to do nothing but twiddle knobs. Actually that can be a problem too, because after a while your ears get tired. I don't know if I am hearing things that well after a while.

Having found the sound he wanted for a particular guitar, Nick would use a card index system to remember how to set up the amp:

> So I have these 5 x 7 cards for every amp that I take out to indicate what the settings are that I want. So when I am setting up I can look on the card; that is what I want for the Strat; that is what I want for the Les Paul.

Nick, who works as a professor at the Wharton Business School by day, makes a card for every amp he uses. He gets frustrated by amps, such as the Mesa Boogie Tremoverb, which do not have numbers on the knobs: "That completely pissed me off! I had to write things down like 12 o'clock, 1 o'clock." He has also replaced all the chrome knobs on this amp with black ones because "I am playing out at places where there is not much light; the knob is reflecting and I can't see shit what my settings are."

For Nick the search is for the "sweet spot" in every amp. "There is [a] spot that I want for better and for worse, my musical tastes are not very broad. There are certain things that I want, certain sounds I want, and that is what I am trying to get. Once I get it, that is where I want to stay." The skill starts with knowing what sort of sound he wants to make; then buying the right piece of equipment; and finally, sitting down for a lengthy period of time to just tinker. He may use settings found

in manuals as rough guides, but in the end it is his own "twiddling knobs" for hours on end that leads to his finding the desired sweet spot. Lastly, to help make this knowledge transportable and replicable (at least the initial settings – one imagines Nick still has to tweak things in performance), he has devised his own file card system for remembering the settings.

Finding the sweet spot in equipment is not always a matter of trial and error or dependent upon a skilled musician as a mentor like Johnnie Dowd in Park's case. With the Internet, the collective wisdom of many enthusiasts for vintage equipment is available through numerous chat forums and user groups. Participants often describe in loving detail how they have restored individual instruments (blogs can be followed for particular restoration projects). They provide numerous details of the sounds they have found and so on. This is a particularly good source of information for complicated electronic instruments with a range of controls and settings such as synthesizers. By using the Internet, John was able to find the sweet spot on his Ensoniq synthesizer, which enabled him to produce what he described as one of his favorite synth solos ever on his latest recording:

> That particular sound, I found that on-line, I downloaded the sys-x code for it and I think I changed it a little, I tweaked it a little [Sys-x is a standardized system for recording particular configurations of settings on any Midi-controlled instrument like a synthesizer]. The great thing about that sound is there's this place in the filter and its on any synth filter, but I'm thinking particularly of this Ensoniq where the resonance is poised right before it overloads into self-oscillation … Before it goes out of control. And that patch is really perched on that edge … And the amount of – what do you say – the frequency that is controlled by the resonance, by the "after touch," after you hit the key when you press it harder it will start to whistle; it will go "yeeurweeeeooww," so at certain moments during the solo I was able to do that. That patch perfectly takes advantage of the strengths of that particular keyboard. You know it right before it all breaks up and that's where that patch lives …

Imprecision in Old Instruments

For John, who has numerous vintage instruments in his studio, including guitars, drums, synthesizers, pianos, a reel-to-reel tape recorder, and effects devices, the sort of sound he is after is also mediated by his deep knowledge of recording. He finds that analog effect devices in particular produce powerful emotional sounds when they are set up, so the sound almost starts to break down:

> It's the same with effects with compression and so on, you turn it up all the way, it sounds real crap, you leave it way down, it sounds sorta wimpy. But if you get it

right in that spot, it's usually the spot right before open distortion. You know like Stax records from the 60s. Motown was like a cleaner sound, the Stax engineers were always trying to overload stuff. And those vocals are right up in your face and you can hear the distortion in the preamps, and it's really emotionally satisfying.

For John this is what is dissatisfying with the numerous digital effect devices he has tried:

And it has to do with them finding the spot in the piece of gear that really worked[.] I think that in a lot of contemporary digital gear that spot doesn't exist. You know what I mean. Because it's meant to be on or off, to be clean all the way to the top of the gain. Whereas with old analog gear, you have to mess around, 'til you find the place where it's almost too much.

John's comment here is reminiscent of Starkey's earlier stated preference for analog compression devices during recording. It is often the imprecision in the analog gear that produces the desired sounds.

It is the imprecision and parts that don't quite work properly which give these old instruments and equipment their special value for a musician such as John. In a way, this is reminiscent of the value placed upon instruments before the age of mass production and electronics, when each individually crafted instrument with its own idiosyncrasies of sound and action were what people valued. If a Stradivarius violin could be mass produced so that each instrument sounded exactly the same and all the little unexpected resonances in the sound board were eliminated, then they would be less valued.

Although the musicians we interviewed were in general flexible about digital equipment, there were particular sorts of digital devices they would never use. Park was adamant that, despite having emulations of different guitars and amplifiers available on Protools, he would never use them. For Park, the most memorable sound recordings invoke unique human experiences, and because digital simulations all offer the same sound, by definition they are not going to be unique:

There is something about the sorta setting it up and the twiddling and the fiddling and the adjustments are subtle and the tubes, how they react and the whole thing, that I feel like the sound is my accomplishment and it's something that can't simply be mimicked or copied exactly. You know, with those emulator programs, the next guy who pulls up the Marshall emulator and puts it to 7 and puts it to 8, he's going to have the exact same sound as I, you know anything I do there [using the emulator] he can do. It's not unique.

John, on the other hand, finds that it is the tactile nature of real gear as opposed to simulations of gear to be fun and stimulating:

> There's something about getting to play this [hits a note on the Wurlitzer piano] that's a qualitative different experience from software and playing it on a synthesizer keyboard. It's the feeling that you can tell the key is made of wood, and that there are metal arms with wood at the end, and that the arms – there are times when I open it up and I know what it's doing when I play it – and that thing, it's a tactile experience, and it's a visual experience as well as an experience of the sound in the recording. It just makes it more fun … You know now when I have some free time and I can do some music, I can't wait to get in here and play the instruments rather than to get in here and generate simulations of the instruments.

It is the immediacy of old instruments and equipment which John finds particularly appealing:

> You know the older I get and the more I learn how to use music equipment, the more I value immediacy. Just being able to sit down and play something. If you're inspired and striking while the iron is hot. I really value that as a musician. So technologically sophisticated stuff, which is nevertheless easy to use, is I think a great thing, and I don't object to new equipment at all. But most new equipment doesn't do that. So that's one of the reasons I like the vintage stuff.

For John, having the real instrument to play with is hard to separate from his love of reading about how the instruments were created. Next to his prized gear, John's studio has a shelf of books about the history of instruments:

> I also feel like a connection to the past playing a real instrument from the past, I can imagine the people who might have played it before me. You know Ray Charles played the same keyboard; I'm a kinda tiny part of this big complex history that surrounds the instrument. It's the same reason that I have all these books about guitars and synthesizers and stuff because I love to read about how these things were developed, who got the idea, where the idea came from; the different obstacles that they overcame in coming up with the final version of it. You know that entire history. So that['s] when I sorta come down here and play stuff I feel like I'm kinda part of the next chapter of that. It's really enjoyable to think of.

Part of what is being stimulated is John's imagination about how he links to the history of an instrument and how he could be part of the "next chapter" of that history. This is not so much a longing for the past as a feeling of being in touch with

the past. For John, these old instruments are not about reliving the past, but about the next chapter of his own music.

Conclusion

Vintage gear and the sounds it enables mean a lot to these musicians, but in different ways. All of them are flexible: they will use both analog and digital equipment as the need arises, and are willing to make compromises where necessary; however, their underlying attitudes seem subtly different. At one end of the spectrum is Starkey, an electronic musician who works almost exclusively with digital samples and software synths. For him, analog instruments and effects are tools to be used on occasion to enrich the sound. They are often difficult to use because he is primarily a laptop musician and hence each analog device must be separately recorded and integrated into his digital setup. Also Starkey, unlike John, Park, and Nick, makes his living from music and must follow a tight production schedule where the ease of use and availability of digital effects are crucial. While Starkey is a digital guy who uses analog as a tool, Park is the reverse: he is an analog guy who uses digital as a tool. Park loves the 1960s- and 1970s-era equipment, but cannot afford to "go all the way." For Park, digital recording and editing are tools, indeed indispensable tools, given the precariousness of his musical livelihood. For him, real sounds are the sounds made by a proper guitar such as a Strat through a vintage amp. He values the uniqueness which he tries to bring to his sound, a uniqueness which conveys something essential about human experience.

John is not as much of an analog purist as Park is, and, as we saw, he not only uses digital recording for its ease and versatility, but also finds value in several digital instruments and software synthesizers. But John is rather different from Starkey in his analog sensibility. Compare Starkey talking about the tape machines as something "to dump tracks to" with John who describes in loving detail the tactile quality of the machine as well as the sound. John, like Park, values something in the uniqueness of analog sound, its imprecision and imperfections, and the noise it produces, which he also thinks evokes human emotion.

Nick is harder to place. Like John, he is a "gear head" who really cares about the sounds he gets from vintage gear. He knows the gear intimately and can spend hours searching for the sweet spot in a vintage amp. But he does not express the same sort of desire for imprecision and imperfection. Indeed, one senses that with Nick and his card indexes of amp settings, he would prefer the vintage amps to work in the regular controlled repeatable way of digital gear. Nick's house is stuffed chockablock with Victrolas, furniture, and clocks. Despite distinguishing himself from collectors by the way he actually uses the instruments he collects, one senses that his ethos is more towards that of a collector who happens to have a hobby of making music and playing his guitars and amps. His collection of amps

were the most pristine that David (who interviewed Nick) had ever seen – again indicating a collectors' ethos.

Where do these excursions into vintage gear leave us in terms of understanding technonostalgia? As the literature on the sociology of nostalgia shows (Davis 1979), people tend to get nostalgic when there are problems in the present – they use the image of a desired past to comment on and criticize the present. Beyond criticism, nostalgia (as the German word for nostalgia, *heimweh*, literally denotes) is commonly understood as a homesickness of sorts, an attempt by actors in the present to return to a comfortable and ideal setting. Yet all four musicians interviewed in depth make no patent appeal to return to the era in which their vintage equipment was built. Their music, though inspired in nuanced historical ways, does not sound old. They record in modern digital environments interspersed with old gear, software synthesizers mix with real analog synthesizers, new guitars get plugged into old amps, and analog effects are used to spice up digital samples. They are making what they perceive to be original musical compositions.

Technonostalgia for vintage gear, in this case, does not necessarily mean getting back to a particular past, no matter how ideally constructed, imagined, or heard. Instead, for the musicians we interviewed, technonostalgia is movement toward both new sounds and new interactions, whether aural, social, or physical, made concrete through combinations of the past and present. Nothing is more ideal than the connection to the past via a "real" instrument used for making the music of the present or future.

Notes

1. http://www.gibson.com/whatsnew/pressrelease/2002/jan22b.html, retrieved 16 September 2007.
2. http://www.relicguitars.com, retrieved 16 September 2007.
3. In all, we interviewed and interacted with fifteen musicians. For this paper, we have selected four particular musicians, Park, Nick, John, and Starkey, who are representative of the attitudes we encountered during the fieldwork.

Part IV
Earwitnessing

Chapter Eleven

Earwitnessing: Sound Memories of the Nazi Period

Carolyn Birdsall

> One ought to speak of events that reach
> us like an echo awakened by a call,
> a sound that seems to have been heard
> somewhere in the darkness of past life.
> (Benjamin 1978, p. 59)

Introduction

There is a tendency to think of sound souvenirs, whether recorded sounds, music, or song lyrics, as having the ability to produce memory effects in the listeners. Sound technologies, too, are often conceived as "metaphors of memory" and new technologies can generate nostalgia for superseded formats (Draaisma 2000). In these instances, the construction of sounds as offering traces of the past depends on external, physical objects. In what follows, however, I propose to examine the role of sound within personal and social contexts of remembering. Despite recent attempts to address witnesses as embodied subjects (Brison 1999; Young 2003), the common conception of the *eyewitness* upholds the notion of an observer who experiences and remembers in visual and semantic terms. In contrast to the visualist associations with witnessing, this essay engages with the concept of *earwitnessing*. Against this background, "sound souvenirs" will not only be explored in terms of nostalgic sound memories, but also in relation to traumatic events.

In 1977, Raymond Murray Schafer defined the earwitness as an author who lived in the historical past, and who can be trusted "when writing about sounds directly experienced and intimately known" (1994 [1977], p. 6). Schafer's understanding of the earwitness endorses the authority of literary texts for conveying an authentic experience of historical sounds. Accessing knowledge about the past, as Schafer saw it, should help to raise consciousness about the threat posed by indus-

trial urban soundscapes to listening skills. Around the same period, German-language critic and author Elias Canetti also conceived of earwitnessing as a key mode of experiencing and remembering. The earwitness, as Canetti rendered it in *Der Ohrenzeuge* (1974), has more confidence in sounds heard and spoken than in images or visuality. Canetti's earwitness can be read as an exaggerated stereotype of a passive listener who "forgets nothing," sneaks around and stores information for the purpose of incriminating others. Both accounts present the image of an ideal earwitness. Schafer's earwitness can testify to rich and complex historical soundscape, while Canetti's earwitness is capable of an exact reproduction of sound memories. However, Schafer's conception of earwitnessing in literary accounts sustains a fantasy of immediate access to the past sounds. Canetti's ironic caricature, by contrast, mocks the notion that remembering allows unmediated access to the past. In his four autobiographical works, Canetti also sought to highlight both the selectivity of remembering and the amplification of certain memories over time (Canetti 1977, 1980, 1985, 2005).

My main concern in reexamining the earwitness is to explore how remembering and witness testimony are informed by auditory experience. The analytical focus in this essay is on the various ways in which elderly people in the German city of Düsseldorf recall and produce sound memories when questioned about life during National Socialism (1933-1945). The oral history interview is offered as an important method for elucidating how earwitnesses perform, remember, and perceive the role of sound in mediating past experience. I will partly draw on the theoretical framework developed by cultural geographer Ben Anderson, which highlights the role of sound in embodied processes of remembering, with interdependent categories comprising both the personal and social (Anderson 2004). I engage with these categories to address three main instances when participants engaged in unconventional physical acts that broke out of the usual narrative coherence of the interview context. By paying particular attention to the example of wartime bombing of German cities, I focus on how body language and sound-making are prompted into action when a verbal description of traumatic events proves difficult. These discussions will work towards a consideration about how sounds of the past can be constituted as "echoes" in the present, both in terms of interviewee sound memories and broader cultural narratives concerning social memory and identity.

Performing Memory and Earwitness Experience

One of the main considerations for my examination of embodied practices of remembering is to what degree memory, as a creative and dynamic process, is non-representational. For these purposes, I have adopted an oral history methodology in order to approach the interactions of auditory experience and memory in ear-

witness testimony. Unlike written forms of autobiographical narrative or inter-
view transcriptions, the performative and interpersonal qualities of the interview
highlight the vocal sounds and physical motions that emerge when individuals
engage in remembering. Nonetheless, as Joan W. Scott stresses in "Evidence as
Experience," historians should avoid treating experience as a privileged category
existing outside of discourse (1991). Experience cannot be separated from dis-
course, Scott argues, since "language is the site of history's enactment" (p. 777).
Scott invites historians to examine the ways that experience is equally constructed
by discourses as it is by social practices, and thus to pay attention to the *produc-
tion* of sensory perception. In the case of my interview project, it must be stressed
that National Socialist propaganda also played a significant role in shaping
attitudes about auditory perception and conceiving Germans as earwitnesses par-
ticipating in and belonging to a *Volksgemeinschaft* (national community). Em-
phasis was placed on the auditory in official rituals, within youth organizations,
and the education system. Conversely, one notable impulse in Nazi propaganda
was the rejection of music and sound created by groups deemed to be outside the
acceptable social order. Such discourses generated a dichotomized view of sounds,
delineated as harmonious, intimate, and socially acceptable on the one hand, and
degenerate, chaotic, and discordant on the other (Kater 1992, pp. 33-49).[1]

When conducting oral history interviews in Düsseldorf, I was particularly in-
terested in gaining a better understanding of the sounds and rhythms of everyday
life during Nazism. The interviews were recorded in the local Ratingen Archive
using a Minidisc recorder with a small lapel microphone. I conducted interviews
with thirty individuals born mainly between 1920 and 1935 and visited a local
seniors group for women.[2] Most interviewees grew up in lower- to middle-class
households and experienced Nazism as children or young adults. The questions I
posed can be divided into two categories. The first concerned biographical infor-
mation, including questions about childhood, family, school, and routines. The
second set of questions focused on memories of sounds in everyday life, including
those about radio and other audiovisual technologies. Upon the completion of the
interview, I talked with the participants about how they felt about this exchange,
which was followed by a debriefing with an archive staff member, who accompa-
nied them from the interview room.

One common factor across all interview participants is that they were explicit-
ly engaged in narrating their autobiographical memories during the last phase of
their lives. In the exploration of sound memories, it is important to acknowledge
the ways that this remembering is filtered through one's present day situation and
the influence of the intervening sixty years since 1945. The interview testimonies
do not only reflect a temporal interval, but also a politics of memory. In the 1970s,
psychologists Alexander and Margarete Mitscherlich coined the phrase "the in-
ability to mourn," arguing that Germans had repressed their Nazi past and their

attachment to Adolf Hitler (1975). From the 1980s on, alongside concerns with *Vergangenheitsbewältigung* (coming to terms with the past), a growing number of scholars recognized an emerging "memory boom" in relation to Germany's Nazi past (Friedländer 1993; Winter 2001). Following the *Historikerstreit* (*Historians' Debate*) after 1987, these debates gained momentum in the wake of accusations of revisionism and of interpreting the place of the Holocaust in Germany's larger historical narrative. In the decade following the 1990 reunification of Germany, another trend emerged in public discourses and the cultural sphere, namely the debates about acknowledging German civilian suffering during World War II (Sebald 2003 [1997]; Friedrich 2002).

These recent developments in German public debates and popular discourses were critically investigated in the recent publication *Opa war kein Nazi* (Welzer, Moller, and Tschuggnall 2002). A team of oral history researchers conducted interviews across three generations of German families to explore how personal experience during Nazism had been absorbed into "normal" family narratives. To document this process, the researchers developed an interview methodology where they showed their participants film sequences from ten amateur films and three propaganda films. The use of visual materials was vouched for as a useful strategy for involving children and grandchildren, who experienced Nazism primarily as it was mediated through popular culture and stories. Moreover, this process of negotiating family memories about the Nazi period was described in terms of a "virtual family photo album" (p. 14). However, this primary focus on visual stimuli for prompting remembering seems insufficient. The preconception that photos and films are a neutral method for encouraging a process of remembering may overlook the selectiveness or manipulation inherent in these artifacts. Nonetheless, I do not mean to suggest that sound memories are less selective than those prompted by visual stimuli. In contrast to visual memories, sound tends toward an indexical relationship to remembering. In other words, rather than fix a determined linear narrative or image, sound can be drawn upon to prompt certain moods or feelings. The value of examining sound memories is that they can encompass both individual and group uses of sound for creating a sense of the past. Sounds can be actively used for memory recall or can unexpectedly evoke associations with the past, yet these sound memories do not necessitate an exact reproduction of those past sounds (Moores 1988).

Recent scholarship in cultural geography offers an important theoretical contribution for the study of everyday social and embodied practices. Nigel Thrift's theory of practices, called *non-representation theory*, tries to account for the role of the body and senses in constituting "our sense of the real" (Thrift 1996, p. 7; Thrift 2004). Rather than examining symbolic or semantic representations, Thrift focuses on the ways that *action-in-context* elucidates embodied skills, performativity, and social relations. As Thrift does not explicitly address the relationship of

bodily practices to sound and remembering, I draw on the work of fellow geographer Ben Anderson, whose field work examines recorded music and everyday acts of remembering in domestic spaces, including at home or inside the car (Anderson 2004).[3]

In Anderson's theorizing about how sound and embodiment engage with social practices of remembering, he establishes three categories: *habit memory, involuntary remembering*, and *intentional remembering*. In the following sections I will elaborate on these three categories, testing their applicability to the most prominent sound memories enacted during my oral history interviews about the Nazi era. The first category, habit memory, will be discussed with respect to embodied skills and acquired habits. Secondly, the role of sound in intentional acts of remembering will be situated in terms of creating a sense of continuity and group belonging. Finally, reenactments of traumatizing sounds will be introduced as the most striking example of the third category of involuntary remembering.

Habit Memory and Embodied Skills

Ben Anderson argues that the accumulation of embodied skills "*enables* the ongoing conduct of everyday life" (Anderson 2004, p. 6).[4] Habit memories are acquired through the repetition of actions, often until they are internalized as intuitive or automatic mechanisms. These corporeally inscribed habits suggest that the past continues to form part of the present in the form of lived and embodied actions. According to this definition, Anderson conceives embodied skills as the way that memory is performed by the body, whereby certain features of particular musical experience or sound technology become normalized. One example he cites of contemporary habit memory is the knowledge of how to operate a CD player or to retrieve a CD from its cover. The repetition of such culturally specific gestures and codified physical actions form an integral part of what becomes our habit memory.

During my oral history interviews, many of the elderly people tried to convey how they had experienced the punitive nature of the Nazi school and social system, often leaping out of their chairs or raising their arms to demonstrate how they had to perform the "*Heil Hitler*" salute. Several began to stamp their feet to march out the timing of walking, while on occasion, others sang out the lyrics "*Die Fahne hoch…*" from the national anthem.[5] This habit memory involves moments where the past is reencountered in the present day by means of both sound and performative gesture. The presentness of the past in such moments of habitual remembering, and the uses of gesture to convey memory, make a good case for Anderson's emphasis on sensory "acting out" in the process of remembering.

Acquiring habit memory can be seen as a social(izing) process that begins in childhood, involving not only the physical positions and habits taught to children,

but also the process where attitudes about auditory perception and sound were conveyed. As such, it suggests an *aural contract* created by the repetition of certain sounds and music in Nazi pedagogy, performed in close conjunction with codified physical actions. Even though discipline and order were also a firm part of an earlier Wilhelmine education system and family tradition, the political influence and pedagogical disciplining of children's bodies under Nazism was unprecedented (Stargardt 1998). In the months following the Nazi political takeover in 1933, the daily routines and school program of students were reorganized around a new set of rituals. Each morning, ten minutes before class, students assembled for a ceremony in the playground, where uniformed *Hitler-Jugend* (Hitler Youth) members in uniform hoisted their flag above the school playground, requiring all present to sing the national anthems and perform the *Heil Hitler* greeting.[6] Students were also required to give the official greeting at the beginning and end of all school lessons by standing up and raising their right arms in the air.

Even if students did not always comply with official procedures, these practices reflect a schooling in a specific repertoire of collective rituals. School routines not only required their bodies to take on codified positions within a group, but also created an aural-oral feedback by confirming individual voices within a collective "affirmative resonance" (Epping-Jäger 2004; Birdsall 2007a). Alongside the active performing of rituals, students were exposed to a range of media products at school, which required them to sit still and pay attention to propaganda radio broadcasts, film footage, and sometimes gramophone records.[7] The routines in schools and youth organizations thus operated on a two-fold process, through sitting still and paying attention to audio-visual propaganda material on the one hand, and the active performance of rituals, with prescribed conventions and codified gestures on the other (Gauger 1943).

The experience of Nazi pedagogy therefore remains a major component of my interviewees' corporeal or habit memory. It is usually difficult to subject habit memory to radical change, which is why it can be so easily recalled and performed. According to Henri Lefebvre's conceptualization of habit memory, the historical specificity of childhood socialization or "*dressage*" even determines the way one walks down the street (2004 [1992], p. 42). Lefebvre argues that this constitutes the formative way in which an individual takes on the identity of the society acculturating them. Habit memory, however, should not be conceived as a completely determined process, but one with the possibilities for gradual change and elements of individual agency. This brings me to the second category, "intentional remembering," which involves more negotiations between the individual and social in present-day acts of recall.

Intentional Remembering

Intentional remembering tends towards a standardized usage and meaning attributed to auditory or musical experience, whether by playing recorded music or engaging in group singing. Anderson describes this category in terms of the "deliberate use of music to recollect, reminisce or recreate the content or mood of an already defined memory" (Anderson 2004, p. 13). It does not actually represent the past but reflects the use of music to bring up the past as part of a present moment. One particular instance of intentional remembering in my research project can be found in the way that interview participants drew on a familiar repertoire of German musical genres, including hit songs from film and radio, folk songs, military, and party songs.[8] During Nazism, songs were a prominent feature across various areas of social life, and Germans were encouraged to participate in the collective knowledge of the songs and their lyrics (Bohlmann 2002). Although individual interview participants frequently sang the lyrics of songs, I will focus on a group setting in this section, since this context offers a vivid example of the social process of negotiating sound memories.[9]

The integration of music in social contexts of remembering was strikingly apparent when I was invited to join the monthly meeting of a senior's group for women, whose activities are supported by the local council. Most women were widowed, did not necessarily know other members prior to this meeting, and were of a similar age range to my individual interviewees. During several intervals, one member would begin humming a folksong as a prompt for the others before the whole group broke into song. I was initially surprised by these outbursts of song which appeared unexpected. Nevertheless, upon listening to my recording of the lunch, it became apparent that the women had chosen songs that all members could recognize and sing along to. Nor was it the first time that the women had sung these songs together. Rather, as an organizer later explained, this "spontaneous" group singing was already established over a longer period of group meetings. This particular social context of intentional remembering relied on shared codes that were likely to be appropriate and accessible for others in the meetings.

The traditional and folk songs sung by the interviewees included "Auf der Heide blüht ein kleines Blümlein," "Alle Vögel sind schon da," "Im Märzen der Bauer," and "Die Mai ist gekommen." Many of the traditional songs, including German genres of *Abendlieder, Heimatlieder, Wanderliede,* or *Fahrtenlieder,* date back to the nineteenth century and earlier, but were adapted or employed for ideological purposes during the Nazi era. Maria S. (*1926), for example, brought a CD with well-known music to the seniors' meeting:

We sang these songs as children – they are *Volkslieder* and are still sung today: "Das Wandern ist des Müllers Lust," "Bin ein fahrender Gesell," "Wir sind durch Deutschland gefahren...." " (my translation)

Maria S. went on to tell that she belongs to a weekly walking group and suggested that all members are able to join in their singing, since everyone learned these songs at home or in youth groups during the 1930s and 1940s. Such opportunities create the possibility for personal individual memories to be integrated into a present social context. These musical genres provide a sense of continuity and authenticity, not least because the lyrics usually endorse a certain nostalgia for the positive aspects of the past. It is not necessarily the content of these songs that differ from other European folksongs, but rather their ideological appropriation and use for political purposes, such as youth group meetings and official rituals during Nazism. For elderly interviewees like Maria S., folk songs provide a shared and stable reference point, which they usually described as "non political" and thus as legitimate sound memories of their childhood during Nazism. The engagement of interviewees in an intentional mode thus highlights how both personal and social dimensions of remembering are drawn upon in group situations.

Trauma and Earwitness Testimony

Ben Anderson's final category, *involuntary remembering*, approaches the unexpected ways that sounds of the past can be reencountered in interviews. These brief, unsolicited traces of the past, linked to memories of sound, can be experienced momentarily as occurring in the present. Anderson likens such memory traces to Marcel Proust's notion of *memoire involuntaire*, suggesting that involuntary memories cannot be planned or anticipated, nor can they be repeated exactly (Proust 2002 [1913-27]). They enable the past, as he says, to be "re-encountered primarily as a value, unsystematic, attitude and mood" (p. 12). In the case of my interviews in Düsseldorf, the most striking example of such sensory triggers was in relation to the sounds of bomb attacks on civilians during World War II.[10] One interviewee, Theresa B. (*1925), who had never spoken at length about the events of her past, became increasingly emotional when interviewed. When Theresa hears alarms or emergency sirens in the present day, she experiences panic and has to hold her chest before reminding herself that it is no longer wartime. This example shows a strong resemblance to the Proustian understanding of involuntary remembering, insofar as an external sensory impulse (sound) has the effect of triggering fright or shock, due to the acoustic similarities between present-day alarms and World-War-II air raid sirens.

By contrast, another interviewee reported a second form of involuntary remembering, which indicates almost the reverse phenomenon. When Jenny E.

(*1923) experiences a shock in the present day, she can only speak in *Plattdeutsch*, a German dialect she has not used since the mid-1940s. Unlike the previous example of hearing a present-day acoustic signal like sirens, Jenny's experience of shock seems to invoke or reconnect with her earlier exposure to traumatic events. Moreover, in this case the traumatic memory triggers a sonic response, having the effect of temporarily altering her present-day speech patterns and accent.

In this context, it is interesting to note a third variation on involuntary remembering. The interview process itself often prompted an affective reencounter with the past by invoking sensory reminders of earlier sounds, such as the Allied bomb attacks on Düsseldorf. For example, Gerhard R. (*1934) expressed surprise when recalling his memories of sounds. "The memories are coming back to me as I talk about them now," he said, "and they've been buried inside me for a long time." In the course of talking and reflecting on his childhood, Gerhard observed that the sounds were "now ringing in my ears." This is suggestive of how an oral-aural connection is produced in the process of responding to questions about past events.

Lastly, another instance of involuntary remembering occurred with the use of vocal sound effects in the moments when interviewees could not easily integrate (traumatic) events into their verbal narratives. Indeed, when talking about their memories of World War II attacks on German cities, most interview participants were able to describe the sirens and precautions taken for air raids, but often could not describe the actual event of bombings. Instead they used their arms to act out the flying over of planes and used their voices to mimic the sounds of bombs exploding. There were certain routines associated with the bomb raids that were easily described by interviewees, such as the sounding of alarms, waking up, getting dressed, and going to a bomb shelter. Accounts of these routines were integrated without difficulty into a narrative. The bomb attacks themselves, by contrast, did not follow such a schema, occurring at a varying frequency, duration and time of day. When it came to describing these events, many interviewees performed the sounds of sirens and the explosions of falling bombs, as though occurring in the present moment, with exclamations like "Here comes another one," or "The rumbling bombs are coming in waves and the ground trembles."

Such moments, when the past "spills" into the present, suggest a lack of control or integration of the event and may point to a trauma: Traumatic events have been defined as those outside the normal realm of human experience, which are "not experienced fully at the time" (Caruth 1995, pp. 3-4). One consequence of traumatic events can be the inability to create coherent narratives about them or the repetitive "acting out" of unassimilated trauma. Trauma in witness testimony thus constitutes not only a disrupted state of consciousness, but also an inability to own the experience of the event (Van Alphen 2002). While the sounds associated with bombings, such as sirens, were referred to as memories located in the past,

the actual event of the bombing was acted out as occurring in the present. The vivid sensations of traumatic memory offer a stark contrast to the common understanding of memory diminishing with time. Indeed, the basis for discussing "sound *memories*" is challenged when traumatic sounds are encountered as part of the present. This case illustrates how reencounters with traumatizing sounds can disrupt past and present distinctions, and test the efficacy of language for describing the auditory and sensory inscriptions of a traumatic event.

Scholars have often analyzed the relationship between visual images and trauma (Baer 2002; Saltzmann and Rosenberg 2006; Guerin and Hallas 2007), which is possibly reinforced by the frequent investments in photography and cinema as technologies of memory. In her work on Holocaust representation and remembrance, Leslie Morris has stressed the elusiveness of sound, along with its need for a medium of transmission:

> This lack of a frame for the aural, in contrast to the visual, demands that an inquiry into the relationship between sound and memory will be, perhaps, more speculative and open-ended than the one that examines the visual sphere. (2001, p. 368)

Since the overwhelming sounds of wartime have left few remaining evidential traces, unlike photos and film, it would seem difficult to theorize this as (collective) trauma. Moreover, historian Andreas Huyssen has cautioned that there is a risk of putting "the whole history of the twentieth century under the sign of trauma" (2003, pp. 8-9). There is also a certain difficulty posed by appropriating concepts of trauma at the collective or national level, since they refer to individual cognitive processes (Pillemar 2004). This concern about the relativization of the term trauma is well taken. Indeed, most elderly interviewees were able to provide fairly coherent accounts of their life stories. Nor should it be forgotten that there was a public acknowledgement of bomb raids, mainly in newspaper depictions of the Allied enemies as conducting "terror attacks" (Steinacker 2003; Zimmermann 2005). Official Nazi organs also emphasized the braveness and unity of community in the face of aerial attacks. It would seem that the characterization of wartime sounds as traumatic is at least partially constituted by the public discourse about Allied bombings, along with postwar representations that have employed the "sonic icons" of sirens to connote air attacks (Flinn 2004, p. 4; Hillman 2005, p. 33).

While interviewee testimonies in the present day refer primarily to the *event* of the bombings, these attacks were also a catalyst for the complete breakdown of social life and civil order under Nazism. The extended period between the last war months and establishment of a postwar Allied administration meant that most students missed an entire year of their education (Jakobs 2003, pp. 16, 88). For

children used to the restrictions of Nazi pedagogy and social institutions, the rup-
tures to social life and routine caused by bomb attacks undermined the whole
worldview established under the regime. Recent social research about children in
contemporary political dictatorships has found that the *sounds* of bomb blasts
contribute significantly to the trauma children experience during aerial attacks
(Somasundaram 1996, p. 1465). Such trauma is often enhanced by post-attack
conditions, such as material need, displacement, and the disruptions to daily rou-
tines and education. On this basis, it seems tenable to emphasize the loss of com-
munity and the breakdown of social order as contributing to a specific childhood
trauma associated with the sounds of wartime bomb attacks. Nonetheless, public
discourses and cultural representations of wartime attacks represent an influen-
tial factor in designating these sounds of bomb attacks as traumatic.

Conclusion: Echoes of Memory

The act of remembering, as Walter Benjamin observed, might be less like a visual
déjà vu than "an echo awakened by a call" (1978, p. 59). As an echo sounds out, it
usually reflects off different surfaces, causing it to lose momentum or pick up extra
information. As such, the echo allows for the alterations produced by its sur-
roundings. This is one of the reasons why the auditory constitution of self (as
Echo) has been suggested as a counterpoint to the (visual) Narcissus (Spivak 1993;
Scott 2001). The echo also offers a useful metaphor for describing the re-sound-
ings of the past in embodied practices of remembering. Sound memories are not
necessarily predicated on the exact reproduction of past sounds, nor does the ear-
witness account reveal "how it really was" to the researcher.

By attending to the sound memories produced in interview testimony, this
chapter has attempted to denaturalize a visually biased notion of witnessing. The
relevance of sound memories for a concept of the earwitness is that they reveal
processes of remembering as embedded in both auditory perception and corpore-
al experience. The oral history interview, moreover, foregrounds acts of listening
and speaking for the construction of life narratives. In addition to the embodied
and interpersonal qualities of the interview context, my case study has drawn at-
tention to critiques about the status of experience in historical analysis. In the con-
text of Nazism, auditory experience must be considered in relation to the influ-
ence of public discourses about music and sound as well as the (ideological)
production of sensory perception. These acts of memory, likewise, should be ex-
amined against the background of countless cultural representations, extensive
discussions about the status of German memory, and attempts to "come to terms"
with the Nazi past.

My response to the question of earwitnessing has drawn on an adapted theory
of practices or "non-representational theory." Ben Anderson's tripartite model

for practices of remembering provides valuable conceptual categories for approaching the sound memories generated during my oral history interviews. The first category of habit memory involved the ongoing collective knowledge and embodied skills acquired in childhood during Nazism, both of which could be easily accessed and performed in the present. In the interview setting, habit memories were closely connected to social experiences of music and physical ritual. Using Ben Anderson's second category of intentional remembering, I emphasized the ways in which individual sound memories are (re)shaped in a shared context of social remembering, illustrated in the practice of group singing of folk and popular songs. For the third and final category of involuntary remembering, I explored how the overwhelming sounds of bomb attacks constituted a vivid component to the interviewees' participation in earwitness testimony. I focused on the various ways that interviewees reencountered sounds of the past associated with traumatic events, whether caused by a sensory trigger in the present day or resulting in effects such as altered speech patterns. In acting out these past events, sound and physical gesture were employed as a way to convey things that individual interviewees could not express in words. While more work is needed regarding the collective dimensions to sound and traumatic memory, I have drawn attention to the pervasive effects of wartime bomb attacks for both individuals and community.

Notes

1. It should be noted that this discourse regarding a harmony-dissonance binary is not unique to Nazism. See, for instance, Forrester's account of the perceptual basis for the opposition between harmony and dissonance (2000, pp. 33-49).

2. The individual participants volunteered to be interviewed after an article appeared on the front page of the regional daily newspaper (Hartleb 2004a). A follow-up article was published six months later (Hartleb 2004b). The first article invited potential interviewees to leave their details with the Ratingen Archive if they were willing to participate in my oral history project. The decision to visit the women's group was not an explicit methodological decision, but rather due to an invitation from the group's organizer.

3. Ben Anderson's categories correlate respectively with three types of remembering identified in Bob Snyder's account in cognitive musicology: *reminding* (cues a memory response or habit memory), *recollection* (involves repetition and is prompted intentionally), and *recognition* (corresponds to involuntary remembering) (2000, pp. 69-80).

4. Ben Anderson is drawing on the concept of habit memory developed in Henri Bergson's *Matter and Memory* (1988 [1896]).

5. The two official national anthems after 1933 were "*Das Deutschlandlied*" and the "*Horst-Wessel-Lied*," which referred to the death of Horst Wessel, an early Nazi party member in 1930. On the politics surrounding the German national anthem, see Hermand 2002.

6. The flag could only be hoisted at schools where over ninety percent of the students were members of the *Hitler-Jugend* ("Letter to Principal" in Görgen and Hemming 1988, p. 275).

7. This combination of corporeally inscribed habits with collective singing and "call-and-response" interactions within Nazi pedagogy was reconfirmed in the twice-weekly meetings, activities, and marching sessions organized by the *Hitler-Jugend* youth organizations.

8. Elsewhere I have focused on the specific sound memories and practices associated with radio listening during Nazism, with particular attention to *Sondermeldungen* (special news announcements) in wartime Germany (Birdsall 2007b).

9. In addition to the folk songs in the group setting, individual interviewees also sang lyrics from military and campaign songs like "Vorwärts, vorwärts" and "Wir fahren gegen Engeland," along with well-known war songs such as Lale Andersen's "Lili Marleen" (1939) or Zarah Leander's "Ich weiss, es wird einmal ein Wunder geschehen" (1942).

10. In the case of Düsseldorf, Allied bombing over the city began in May 1940 and ended with the American occupation of the city on 17 April 1945. At the end of the war, more than ninety percent of all housing was damaged or destroyed (Hüttenberger 1989, p. 632; *Verwaltungsbericht* 1949). The theme of sound-related trauma and the incommunicability of the acoustic event has also been discussed in recent research on soldier experiences of World War I trench warfare (Lethen 2005).

Chapter Twelve

All the Names: Soundscapes, Recording Technology, and the Historical Sensation[1]

Ruth Benschop

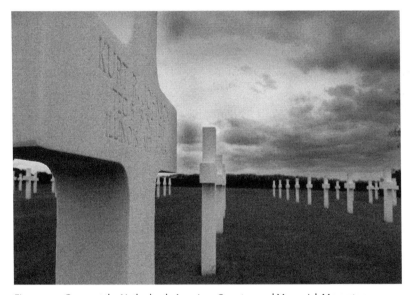

Figure 12.1 - Graves at the Netherlands American Cemetery and Memorial, Margraten

All the Names

It was a glorious summer's day when I visited the Netherlands American Cemetery and Memorial for World War II in the gently sloping hills in the south of the Netherlands. The grass at the cemetery was green and, as always, perfectly trimmed. The long curves of the headstones shone white in the sunlight, attracting hundreds of harvest spiders to dance among them. I had come to listen to *Alle Na-*

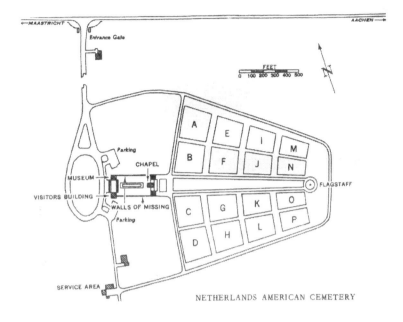

Figure 12.2 - Map of the Netherlands American Cemetery and Memorial, Margraten

men [*All the Names*],[2] a soundscape made by the sound and music studio Intro | in situ.[3] In the leaflet announcing the work, *Alle Namen* was described as "a sound field that can be heard on tape at the cemetery".[4] The piece consisted of eight "atmospheres," each to be heard from two speaker sets. The speaker sets were distributed among the graves and a route had been set out to guide people through the "atmospheres" (Interview Op den Camp 2005). Four more speakers were also placed in the corners of the cemetery (figures 12.2 and 12.3).

The soundscape composition was made up primarily of recorded voices. Schoolchildren as well as "adopters" (local residents who volunteered to take care of the graves) were asked to pronounce the names of the war victims buried at the cemetery.[5] Their voices were recorded and intermingled with the sounds of a heartbeat, electronic sounds, organ chords, the sounds of marching, some radio excerpts, and the voice of a chaplain (De Beer 2004).[6] "The silence of death, the counterpoint of the clash of arms, was only breached by the names that interwove to be become 'music,' spoken sounds that recalled their existence" (Jansen 2004, p. 8). Visitors could walk among the graves and listen to the names of "Leonard, Harold, Ralph, Achilles, Esposito, and ten thousand others.... In section G the sound of a heart beating could be heard. The speaker in section K let the names be accompanied by organ chords. Elsewhere you imagined an accordion" (De Beer 2004).

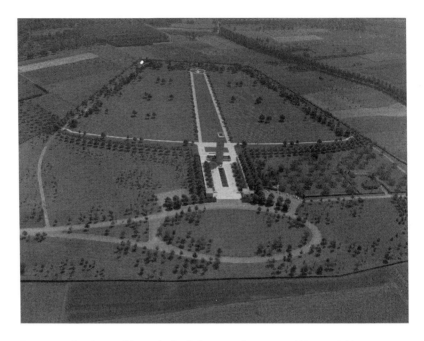

Figure 12.3 - Aerial view of the Netherlands American Cemetery and Memorial, Margraten

Alle Namen was a success "with an exceptional number of 6,000 visitors,"[7] and it received substantial attention in the media. While *Alle Namen* was specifically not meant as a memorial, that is how it was experienced. A local television station "opened with a story on the memorial at Margraten", and a newspaper announced that Intro | in situ would "pay attention to the liberation of South Limburg and Belgium in a special way".[8] Also, some of the funding bodies noted this aspect of commemoration:

> The board of our foundation very much appreciates the very special and piercing way in which the "60 years liberation" will take shape in Margraten. Through the use of contemporary artistic techniques, the choice for an "emotionally charged" location, and the involvement of many young children from several villages on both sides of the border, a large and very fragmented field of tension emerges that will leave a personal and indelible impression on every visitor.[9]

It appears as a memorial also in the way visitors spoke of how the soundscape affected them. "It was like walking through a ghost world," one visitor related. Another claimed it was "like walking in the underworld, the world of the dead." Yet another heard a "threatening rumbling" and said it made him realize that "war and dying are not orderly".[10]

Surely, the way *Alle Namen* was experienced was shaped by the cemetery in which it was staged, a cemetery inviting the respectful and silent behavior that has come to belong there (on cemetery rituals see, for instance, Francis, Kellaher, and Neophytou 2005). As such, it also a part of a long tradition of engraving names in memorials and of commemorations through the naming of the dead (Laqueur 1994). Yet the way *Alle Namen* was experienced and interpreted by the Dutch press, funding bodies, and visitors also fits particularly well with one of Intro | in situ's aims of trying to connect with the past.[11] Intro | in situ "organizes projects on location based on the idea that the 'genius loci' should inspire the 'concertante performances.' Material and immaterial cultural heritage: landscapes and cities, but also (local) dialect and legends are of vital importance".[12] Intro | in situ invites composers to engage with a particular place as an inspiration and as a site of performance. In these productions, recording technology is often used. Sounds are, for instance, recorded at the chosen site and edited into a composition, which can then be heard at the original site.[13] Paul Coenjaarts, founder and former director of Intro | in situ, formulates his inspiration in terms of the local history of a place. In his collaborations with engineer Arno op den Camp, of which *Alle Namen* is an example, he tries "to intensify and poetically inspirit [i.e., inspire] the landscape by adding sound elements to the natural (sound) environment. They depart not only from the auditive and visual character of the landscape, but also its history – what happened here?"[14]

Alle Namen thus also aims to create an experience of connection with the past and to evoke the question "what happened here?" This experience is known in the philosophy of history as a "historical sensation," defined as an intense and unexpected feeling of connection with the past. The exemplary case for eliciting the sensation is an encounter with a work of art. The Dutch historian Johan Huizinga coined this term to describe the enjoyment he experienced while looking at Jan van de Velde's prints (Huizinga 1920, p. 258n). Other examples of this historical sensation also can be found in the work of the philosopher of history, Frank Ankersmit, when he talks of a painting by Francesco Guardi (Ankersmit 2005), as well as in art historian Henk van Os's writing about an anonymous portrait of Queen Wilhelmina (Van Os 2005, pp. 9-10). The application of this concept in encounters with works or art will be taken up here. I will introduce the literature on this concept and then use it to gain an understanding of how *Alle Namen* might have summoned up such an experience. At the same time, I will use the empirical investigation of the making of *Alle Namen* to explore the theoretical concept of historical sensation that until now has been examined only in a primarily conceptual way. I will focus specifically on the role of the recording technology in *Alle Namen*, because it instantiates the tensions surrounding the concept.[15]

The Historical Sensation

As mentioned above, the historical sensation was originally described by Huizinga (see, for instance, Huizinga 1920, 1950), and denotes the unexpected feeling that may overcome someone when encountering a historical object.[16] Huizinga describes it as an immediate and transformational moment of contact with a past that overwhelms the person upon seeing it. Although not an expert on sound or music, Ankersmit refers to Huizinga to emphasize the likeness between a historical sensation and the experience of listening to music. He argues that experiencing a historical sensation is more like hearing the past rather than seeing it (Ibid., p. 123), since hearing suggests an immersive experience.[17] *Alle Namen* is a composition created to be listened to, which thus suggests that it *could* evoke a historical sensation.

However, Huizinga also stressed that the "contact with the past that the historical experience provides us with … is always accompanied … by an outright conviction of reality and truth, and can be brought about by a print, a line from a document, or some sounds from an old song" (Ankersmit 1993, p. 11; my translation). According to Tollebeek and Verschaffel (1992), the sensation cannot be summoned on demand, but may be evoked by remains from the past. What matters is their origin in a time to which we no longer have access, and their being real and truly old. For this reason, Tollebeek and Verschaffel ridicule "historical evocations (*reenactments*) [that] try to incite a historical sensation by *staging* the past" (Tollebeek and Verschaffel 1992, p. 22; my translation).

> The organizers of historical parades and full-blown spectacles build a "watertight" scene to make the present "invisible" and to eliminate the visual contrast between the present and the past. Next, the stage is populated with characters and things that "appear" historical, that look like they belong to another time. In this way they hope to bring about the delusion in the spectator that he is situated in the past, that he can see the past, and therefore can know and understand it. It is obvious that such historical evocations must end in disillusionment (Ibid.).

Tollebeek and Verschaffel insist that "by definition, a fake historical reconstruction cannot elicit a historical sensation exactly because the spectator *knows* that the evocation is unreal" (Ibid.).

Although *Alle Namen* is by no means a straightforward reenactment of World War II, the stress on authenticity versus reconstruction suggests that *Alle Namen* could not evoke a historical sensation. After all, people visiting *Alle Namen* know they will encounter a work of art, not any real relics: the cemetery and its names may be authentic, but the soundscape certainly is not. On the contrary, since its invention and throughout its transformations in the context of music, recording

technologies have been criticized for their "schizophonic" (Schafer 1994 [1977]) ability to destroy the connection between the listener and what is being listened to. Drawing on Benjamin and Adorno, some critics argue that music has changed from a participatory, embodied practice into a commercial enterprise for passive consumers.[18] Following this reasoning, *Alle Namen* and its recorded sounds and names could never evoke a historical sensation through the immersive experience of listening suggested by Ankersmit, and constitute nothing more than a technologically mediated reenactment interfering with the authenticity of the cemetery.

Like Tollebeek and Verschaffel, Runia criticizes the effectiveness of what he calls metaphorical reenactments in bringing about an experience of connection with that past. He suggests, rather, that "metonymy is the vehicle of a historical sensation" (Runia 2005, p. 415; my translation). There is a vast literature on metaphors and metonyms, ranging from discussions on literature to cognitive science, but I focus here on Runia's understanding of the terms. Quoting Lakoff and Johnson, he defines metaphor as "understanding and experiencing something in the light of something else" (Runia 2005, p. 403; my translation) and metonym as "the replacement of a word or a phrase by another word or phrase" (Ibid., p. 404). While metaphors make likenesses between different domains and are about the "transfer of meaning" (Ibid., p. 403), metonyms are meaningless stand-ins and, as such, make something present while skirting interpretation. Metonyms are essentially "*Fremdkörper* [foreign bodies]" (Runia 2006a, p. 310) that are "alarmingly present" (Runia 2005 p. 403; my translation).[19] According to Runia, the commemorative practices of naming victims is a good example of the effective use of metonyms (Runia 2006b, p. 309).

> By providing the names of the dead, absent lives are made present, in the here and now. A name is a cenotaph for the person who bore it, an abyss in which we may gaze into the fullness of a life that is no more. In the names of the dead, in short, we glimpse the numinosity of history. They have that effect, I believe, because ultimately they throw us back on ourselves (Ibid., p. 310).

Runia remains ambiguous about naming names. At times he seems to mean the listening to the recitation of names; at others the reading of names chiseled out on memorials or graves. Still, the effectiveness of the metonymic naming of names lies in its refrainment from providing a context or perspective. Names almost incidentally carry along with them the presence of the deceased person and thus allow people to sense the past without distorting it with interpretation (Runia 2006a). Runia's view on what can evoke a historical sensation suggests that *Alle Namen* might indeed be able to do so since the victims of war are metonymically named. His stress on the uncomfortable presence of metonyms suggests that the recording technology's ability to bring sounds to places where they do not normally occur

might be the very quality listeners need to experience a historical sensation.

The literature on historical sensation focuses in a quite abstract manner on encounters in which it might emerge. I take this as encouragement to explore what sort of situation was in fact created at *Alle Namen* and how it came about. The differences of opinion in the literature of how such a sensation might emerge suggest several questions: Might *Alle Namen* as music evoke a historical sensation, or does its recorded nature preclude such an experience? Is the authenticity of the historical object involved crucial to experiencing a historical sensation and, if so, does this condition therefore render *Alle Namen* an inauthentic reenactment? Do the recorded names in *Alle Namen* make use of meaningful metaphors or of an uncomfortable presence?

Names and Voices

According to the sound artist making the composition, *Alle Namen* refers to his own experience as a child in the war (Interview Coenjaarts 2005). The participating engineer emphasized how the aim was to remove the anonymity of the fallen soldiers and "maybe also a little bit to show the absurdity of such a war. That so many soldiers are lying there, people like you and me, who fought there. The terribleness really." *Alle Namen* was about "the bringing to life a little bit of those names,", and to remove "the anonymity lying there at the place itself" (Interview Op den Camp 2005). Playing devil's advocate, Intro | in situ's director wondered whether the cemetery itself did not fulfil this function. "With a cemetery, of course you can also say that this can be done justice simply by having it be quiet, very peaceful. Why in heaven's name would you do something there?" (Interview Luijmes 2004) But having visited the cemetery quite often, he noticed

> that you don't realise anymore that there are people lying there. At a certain moment you only see a white field, fantastic, crosses, and…. So at a certain moment when I heard a voice, I thought, oh yes, there are people lying here. So the sound of a voice takes it out of a kind of anonymity (Ibid.).[20]

But how to bring the names alive? In sound fields like this, if you want it to "sound like *then*, if you want to make it seem a little bit realistic, then you have to use quadrophony. Then you get the idea that you are in it. To experience it, you really have to be able to sit in it" (Interview Op den Camp 2005).[21] To produce this effect, the placement of the speakers was important, but so was the visual appearance of the technology. White casings were made especially for the CD players and the speakers "for protection, but also that you don't see it immediately".[22] In an earlier project, the speakers were put halfway into the ground, so "they should not interfere, the landscape should remain virginal".[23] In *Alle Namen* it would also

Figure 12.4 - White casings to hide technology

have been preferable for the speakers not to be visible "because they disturb the view," but "of course you can forget about that, with grass as holy as that!" (Interview Luijmes 2004) (figure 12.4).

The arrangement and visual appearance of *Alle Namen* was intended to draw attention away from the technologically mediated nature of the work, and to turn it into something to be listened to. The intention was for it to appear not as a simulation but only as sound – sound that produces an experience of being "in it." To create this effect, to "make something clear of what has happened at that place, in history," the makers also decided to use "as few military sounds as possible. You shouldn't use airplanes and bombers flying overhead, because that is too obvious. You just don't do that." At the same time, "something of Hitler is in there and from Churchill, and marching soldiers. But only for a moment, and some people don't even recognize that it is in there" (Interview Op den Camp 2005). By not using too many explicitly military sounds, "you get more imagination. If you don't pronounce things explicitly, you can guess. And everyone knows what that place is. It is so obvious". To bring the names alive, to evoke a historical sensation, like Tollebeek and Verschaffel and Runia suggest, the conspicuously reproduced nature of a reenactment of the sound of war was considered too obvious. "Voices would have been enough, I think" (Interview Luijmes 2004).

Rather than reenacting the past by using recordings of war sounds, in *Alle Namen* the names themselves played the lead. But not just names. Here, the names as recited by voices are crucial. When constructing the soundscape from the recorded voices, it was decided to "keep the names pure," to "not touch the names" (Interview Op den Camp 2005). This purity was not necessary to ensure that the prospective listeners pay better attention to the names, but to allow the voices reciting the names to become better "note material" to create a composition with.[24] As the engineer warned, you really "shouldn't say 'the names' but 'the sound boxes'; the children and the people we spoke to" (Interview Op den Camp 2005). That the voices reciting the names were used as sonic entities – sound boxes or note material – is apparent in the editing process. The engineer explained how only a little editing was done to clean up the recordings. They "time stretched" once and edited names to produce the effect of a swarm of bees (Ibid.), but overall they looked for interesting combinations in the pronunciations. Grunts, sighs, and the scraping of throats were grouped together (Interview Coenjaarts 2005), and "older and younger, squeaky voices, with a lot of additional sounds, or with very clear voices" were combined (Interview Op den Camp 2005).

But there are limits to how far the voiced names could be turned into sonic entities. Although the cemetery is located near the borders of both Belgium and Germany, no German schools were asked to participate. *Alle Namen*'s initiator had not wanted the occasion to become a political one.

It should not become an issue. We thought that was very important. Then it gains political overtones and that is what we absolutely didn't want. Then we put it to the superintendent of the cemetery. Well, he thought the same. It doesn't tally with our aims. We are an art organization and not a political one. (Interview Luijmes 2004)

Not only were not all the voices used, not all the names were used. Runia has argued that "the indiscriminate recitation of the names – *all* the names – of the victims of a certain historical event" is necessary because it "implies the ostentatious refrainment of every attempt to give meaning" (Runia 2006a, p. 242; my translation). Intro I in situ's director agreed that all the names should be used. But although the title promises to do just that, the engineer argued that the investment of editing and composing all 8,000 names would be too great and would not improve the composition. In the end, all the names were gathered and recorded, but only between 1,000 and 2,000 names were used to make the soundscape composition (Interview Op den Camp 2005).

The making present of the dead in *Alle Namen* was achieved not by the names alone, but also by the voices reciting the names. These voices function *acousmatically* as note material or sound boxes. The acousmatic function of the voices draws attention to the composition's aim of being something to listen *to* (the sonic quality that is heard) rather than something to listen *through* (the reality of the war), and belongs to the genre of soundscape composition to which much of Intro I in situ's work also belongs. The founding father of *Musique Concrète*, Pierre Schaeffer, is famous for using recording technologies in an innovative way in his research on sound and listening. He has made compositions intended for "reduced" (a term coined by Michel Chion, see for instance, Emmerson 2000) or "acousmatic" (see for instance, Wishart 1996, pp. 66n) listening, a type of listening that refrains from associating the sound with the source producing it. In everyday life, the beep of a car will stop us in our tracks as we cross the street to make sure we can continue safely: we automatically relate the sound to its source and respond to it. With his compositions, made by manipulating recorded sounds in different ways, Schaeffer tried to create "sonic objects" which invited the listener to explore their sonic qualities rather than automatically listening through them. Emmerson argues that over time the realization of the physical impossibility of only listening to and not through sounds resulted in "genres of music which balanced on a knife edge between conjuring up a real space in front of our ears and yet doing so with exquisite sound shapes and colours" (Emmerson 1999, p. 137). Soundscapes – like *Alle Namen* – were thus made to be appreciated for how they sounded as well as what the sounds elicited.

Although it is as if Runia's demand for the refrainment from any attempt to give meaning is achieved by using the voices as note material, the choice not to use Ger-

man voices nor the complete list of the names indicates that the voiced names con-
stitute not only metonymic but acousmatic note material as well. These choices
suggest that the voiced names also have the ability to conjure up a world behind
the composition. Authenticity is not at issue in *Alle Namen* in the sense that an
original object is present. Rather, *Alle Namen* seems to be an attempt at watertight
reenactment in its hiding of the recording technology to highlight the immersive
aspect of sound. The recorded voices, however, can be understood as introducing
a different kind of authenticity, not that created by old objects but by voices, as
will become apparent in the next section.

Recording Voice

Against the expectations of critics of the use of recording technology, it appears
that *Alle Namen*'a aim was to evoke an experience that awakened in people a feel-
ing of connection to the past. As we have seen, not only names, but also voices
were crucial for achieving this.

 When starting to work on *Alle Namen*, the sound artist came up with the idea
of having children recite the names on the graves. Intro | in situ approached about
twenty-five schools in Dutch Limburg and Belgian Wallonia, of which eight re-
sponded, asking for their participation. The children – about eleven or twelve
years old – were informed beforehand about what the project would involve for
them and the schools received a list of the 8,000 names on the graves.[25] The chil-
dren were fascinated by the war, "proud to be asked" to participate, and very in-
tent on doing well (Interview Termeer 2007). In the lesson preceding the record-
ing, Intro | in situ initiated a discussion with the children "partly about the history
of the war and partly about the content of the soundscape." The children asked
questions like: "What is a soundscape? Is it still music? Are there violins in it? Do
we have to sing? Intro | in situ tried to make the children aware of the different
sounds that different pronunciations can have".[26] This is "exactly" what Intro | in
situ wanted, "that you have conversations about that" (Interview Luijmes 2004).

 While the discussions were meant especially to awaken the children's interest in
the reality of war and the character of music, the recording itself served a similar
function of engaging the children in *Alle Namen*.[27] The children certainly seemed
to enjoy it "because everything that is about recording, studio, technicians ... of
course they loved it" (Interview Luijmes 2004). Their interest was kindled "espe-
cially because it was recorded. They really liked that, that they were taken so seri-
ously. That something would also be done with it, okay. But they were being
recorded" (Interview Termeer 2007).

 The recording itself thus turned out to be important, which was neither Intro |
in situ's nor the adopters' intention. The idea to also record the adopters came up
when Intro | in situ's director "happened to read about them in a local newspaper"

(Interview Luijmes 2004). It seemed to be a good idea "because adopters are adults and they have a very different timbre voice" (Ibid.) than children do. The adopters' organization provided 250 to 300 of their members' names so Intro I in situ could ask them to take part in the recording sessions. More than a hundred people responded (Ibid.). "From your reactions it appears how much you feel connected with the deceased soldiers and their family members".[28] This feeling of connection was also apparent during the recording sessions. It "was very nice but also strange that people came from far and wide for ten names. Especially the first evening, when they had to wait sometimes for an hour and a half" before it was their turn to recite the names (Interview Luijmes 2004). All those reciting would read several names including their "own grave" (Interview Op den Camp 2005). But while some people were prepared to read other names, "on the first day, a man came and said 'I'll read one name, of *my* adoptee'" (Ibid.).

"The adopters of the graves read out loud *their* soldier, *their* name, and that produced a very great involvement that you normally never get," they really experienced it "as a gift, a tribute" (Interview Luijmes 2004). The inclusion of the adopters in the recital of names was grounded in their prior involvement with the cemetery, but it also helped produce a connection to *Alle Namen*. The adopters felt able to express their involvement through the tribute of recording. Many of the adopters who had participated in the recording later "walked through the cemetery and tried to recognize their voice" (Ibid.).

For the adopters, the recording was an important event not because they had supplied note material, but because it served as a means by which their connection with the cemetery was recognized. The recording technology did not create distance between listener and listened that thereby prevented a historical sensation from emerging. Rather, the practice of recording their voices and making them part of a soundscape at the cemetery which they cared for on a day-to-day basis produced, unexpectedly, perhaps not a historical sensation *pur sang*, but still an experience of connection and appreciation among the adopters.

During the recording, both the children and the adopters displayed a combination of nerves and bravado. In a "quiet room" the voices of individual children were recorded.[29] "It was deliberately decided to let the children who read aloud the names to pronounce them in their own way. Some classes had really rehearsed, others saw the names for the first time".[30] Some children were tense, "not scary tense, but fun tense: Oh it's my turn, skipping to the quiet room" (Interview Termeer 2007). Some were "nervous, and started to giggle" while others "really entered into it, they really adopted a military voice like they hear in movies" (Interview Luijmes 2004). Some of the adopters practiced alone at a table, but others had no preparation and would stutter. They had "no camera experience" and were also nervous about the recording (Interview Coenjaarts 2005). But there was also one "remarkable figure, I think he used to be a captain or in the army. And he real-

ly had a voice, the way he came in already: great!" (Interview Op den Camp 2005).

Intro I in situ thus collected a large amount of sound boxes, which were characterized by their sonic variety. This sonic variety made the dead buried at Margraten present, but so did the children and adults who uttered their names in untrained, sometimes hesitant, sometimes stuttering voices, coloured by language, dialect, age, and nerves. It was the presence of the latter, however, that created a new kind of authenticity, not of an old object, but of tense, uncertain voices – "a child has such an honest voice" (Interview Termeer 2007) – pronouncing names not in spite of, but through a process of recording that forged connections of its own.

Conclusion

One of the teachers who participated in the project still vividly remembers her visit to *Alle Namen*.

> It is always impressive to stand there, but because of this [*Alle Namen*] it became so very fragile. And then you hear those children's voices who name all those people one by one and suddenly they were all given a name. Of course I know they have a name, it says so on the crosses, but it became real, they were there, it touched me in my soul. And even if you couldn't understand what they said, that cloud of voices that became mixed up was even more oppressive: There are so many! (Ibid.)

Alle Namen was an attempt to evoke the historical reality buried in the cemetery in Margraten without presenting it simply or crudely. Instead, nervously voiced names, as well as other sounds relating to the historical reality of war, were used as note material to make a soundscape. The shift in focus in my analysis from the names to the voices reciting the names is intended to draw attention to the sonic quality of metonymic memorials. The names not only rendered the dead present, but also had a sonic presence of their own. This presence invited listeners, as many soundscapes do, to listen both to what the sounds signified (or simulated, in Tollebeek and Verschaffel's terms, or evoked metaphorically in those of Runia) and to the acousmatic quality of the sounds themselves. None of the sounds recorded and edited to make *Alle Namen* were authentically old. The accented voices of the children and of the adopters, however, provided an authenticity to the work. Besides providing a way to record these authentic voices, the recording technology used when recording the voices (and the class discussions that preceded them) was supported by and produced a *different kind* of connection. It drew the children into thinking about the history of war as well as the nature of music, and it paid tribute to the children's interest in the war and the adopters' care for the graves. This feel-

ing of tribute made adopters come to *Alle Namen* to listen to their names – their voices.

Using the notion of a historical sensation here has thus been productive not because it rendered unambiguous whether or not such a sensation could or did emerge, but because it drew attention to the ways in which unexpected experiences of connections with the past emerged in the making of *Alle Namen*. Although the literature on historical sensation has used paintings and prints as exemplary cases, this chapter suggests that the notion could be beneficial particularly in the analysis of sound artists' work, for many aim at the immersion of the listener, sometimes in the past.

Looking at what the exploration of *Alle Namen* brings to our understanding of the concept of a historical sensation, we might argue that if a historical sensation is to emerge from something besides an authentic object from the past, the analysis of *Alle Namen* suggests that the metonymic making present of the past by names is effective not only because of the lives it conjures up, but also because it invites visitors to linger on the sonic qualities of the recited voices. It also suggests that *Alle Namen* created a "conviction of reality and truth" (Ankersmit 1993, p. 11), not through presenting an authentic object or by straightforwardly reenacting the past, but through using authentic voices. This study of *Alle Namen* suggests that the close connection to aesthetics in the literature on historical sensations results in a too-exclusive focus on works of art on the one hand and the perceiver of this work on the other, rather than on the practice in and through which such sensations emerge. In the case of *Alle Namen*, the recording of the voices of children and adopters was instrumental in forging connections between the children, the adopters, music, the cemetery, and the historical reality of war, as well as in producing the authenticity of the voices in the cemetery which allowed visitors to be drawn into *Alle Namen*.

Interviews

Interview Ruth Benschop with Arno op den Camp, Maastricht, 3 March 2005.
Interview Ruth Benschop with Johan Luijmes, Maastricht, 15 December 2004.
Interview Ruth Benschop with Paul Coenjaarts, Maastricht, 7 March 2005.
Interview Ruth Benschop with Marleen Termeer, Maastricht, 9 August 2007.

Notes

1. Elsewhere (Benschop 2007) I have described how the recording technology in *Alle Namen* conjures up a lost world that is not a world of sounds of the past we no longer have access to, but a world of generic modernity we no longer listen to. *Alle Namen*, I argued, invites us to lis-

ten attentively again. My dissatisfaction with the inattentiveness in that article to the central role of the names prompted the current interpretation. I have used some short excerpts from that article here.

2. Concept: Johan Luijmes; composition: Paul Coenjaarts and Arno op den Camp, played 17-19 September 2004, American Cemetery in Margraten.

3. In this chapter I will follow the participants' habits of calling *Alle Namen* a soundscape. Whether it is appropriate to do so is a fraught issue. The term soundscape was coined in the 1960s (Barthelmes 2000; Winkler 2006, p. 30), and refers to "the environmental sound as found in given places and at given times" (LaBelle 2006, p. 201), but the originator of acoustic ecology R. Murray Schafer's concerns about the sonic pollution of the modern world also inspired attempts to compose soundscapes allowing audiences to listen anew. Already in *The Soundscape*, Schafer speaks of "the acoustic designer" who "may incline society to listen again to models of beautifully modulated and balanced soundscapes such as we have in great musical compositions" (Schafer 1994 [1977], p. 237). Generally, soundscapes involve spontaneously, but not necessarily naturally, occurring sounds, rather than sounds produced for instance by musical instruments that are recorded and edited to make a composition that is played in and as an auditory field overlaying, and sometimes intermingling with, an existing space. This field serves to awaken the listener to the auditory qualities of his or her location. *Alle Namen* consists of a field of sound, using recorded sounds aiming to awaken the listener. However, the sounds are not those of the cemetery, but sounds relating to what the cemetery commemorates. On soundscape composition, see Schafer 1994 [1977] and Westerkamp 1999.

4. "Musica Sacra Maastricht: 'Heilige' Oorlog, vrijdag 17 t/m zondag 19 september 2004: Alle namen & Insonnia," Leaflet, p. 1.

5. The adopters are members of the Association for Adopting Graves at the American Cemetery in Margraten. See http://www.adoptiegraven-margraten.nl/.

6. Fieldwork 17 September 2004; Interview Luijmes 2004; Interview Op den Camp 2005. Inter.

7. *Alle Namen* was part of the annual *Musica Sacra Festival* in Maastricht, which is itself always well attended. In 2005, the festival's theme was "holy war." Archives Intro| in situ (hereafter AII), Maastricht, Annual Report Intro| in situ 2004.

8. Interview Luijmes 2004; Ibid.; AII, File "Subsidies," Josch Frusch, "Bijzonder project op begraafplaats Margraten" (n.d.).

9. AII, File "Alle Namen," "Letter from Brand Cultuurfonds Limburg", 18 March 2004.

10. Fieldwork 19 September 2004.

11. Although Intro | in situ also organizes concerts performed in concert halls, it mostly tries to take music "out of the concert hall" (Interview Luijmes 2004), to produce compositions in such a way that the audience is given a less passive role – "searching for a beauty of sound in a non-traditional environment where the imagination and experience is addressed optimally" – than is traditionally the case in concert halls. "In this way Intro | in situ wants to cultivate different 'listening attitudes' in the audience" (*Muziek-klankwerkplaats intro/in situ: Beleidsplan 2005-2008* (Maastricht: Intro| in situ, n.d.), and http://introinsitu.nl/.

12. Stichting Intro | in Situ, *Alle Namen*, Leaflet, 2004.

13. For instance, in the summer of 2005, Intro | in situ used recordings of local songs from Ter-
 schelling Island for the *op 'e' riid* production, which was also performed on the island. Al-
 ready in one of the first Intro | in situ soundscape productions, *Machomet I* (1997), record-
 ings of the sounds from the *voerstreek* in Belgium were played back in that same area.

14. "Musica Sacra Maastricht: 'Heilige' Oorlog, vrijdag 17 t/m zondag 19 september 2004: Alle
 namen & Insonnia," Leaflet, p. 2.

15. This analysis is based on fieldwork before, during, and after *Alle Namen*, including observa-
 tions, interviews, and documentation (leaflets, letters, press reviews, etc.) relating to the
 performance, gathered either during or after the fieldwork. Use was also made of a DVD
 commissioned by Intro | in situ to document its work and to use for publicity (Richard Dols,
 Alle Namen [DVD] (Maastricht: Intro| in situ, 2004, 25 min.). Citations from these docu-
 ments and interviews that were originally in Dutch have been translated into English by
 the author. Excerpts from interviews used here have sometimes been adjusted to facilitate
 understanding. My translations of the theoretical literature are indicated separately in the
 text.

16. In much of the theoretical literature, historical sensations do not happen to just anyone. One
 needs a certain sensitivity, interest, or prior knowledge to be overcome by one. Not only is
 background knowledge necessary for the sensation to occur, an interest in gaining further
 knowledge is also what the subject gains from experiencing it. The sudden insight belonging
 to the sensation is properly followed up by study and writing. As a part of the reflexive litera-
 ture on the academic discipline of history, historical sensations are thus thought to happen
 to historians. However, the concept and others like it are also used in the context of changing
 policies of history museums, and seems applicable to events like *Alle Namen* that belong to
 a broader trend linked to what is known as the experience society (Pine and Gilmore 1999;
 Schulze 1992). This notion marks a societal shift towards the supply and demand for intense
 experiences. This shift is also apparent in those domains in which knowledge about the past
 plays a role.

17. A historical sensation is also likened to the sensations of smelling and feeling, which togeth-
 er with hearing, are opposed to the supposedly more objective nature of vision (Ankersmit
 2000, 2005; Natter and Zandvliet 2005). Ankersmit's and Huizinga's comparison of a his-
 torical sensation and listening to music suggests a too-unchangeable understanding of how
 music is heard. As Johnson has shown for the opera in Paris from the mid-eighteenth to the
 mid-nineteenth century, what music evokes depends as much on shifting concepts and
 practices of making and performing music as on the societal and cultural role of music. He
 shows that the opera changed from being a site where the elite came to see and be seen
 rather than to listen to the performance into an occasion to listen and show one's sensitivity
 by being overcome by the music (Johnson 1995). Now, the lights no longer illuminate the au-
 dience but the stage, and listening to music is something that has less to do with emotional
 sensitivity as with intellectual and silent appreciation (Smithuijsen 2001).

18. See Adorno 1978 [1938]; Benjamin 1996-2003 (b) [1935-1938]; Levin 1990.

19. Dutch art historian Van Os' conviction (2005) that a feeling of estrangement increases the receptivity for a historical experience is in accordance with this view.

20. Runia distinguishes two kinds of metonyms: active ones that immediately display their uncomfortable nature, and dormant ones that hide it because we have gotten so used to them. *Alle Namen*, we might say, aims to awaken and render effective the dormant (Runia 2006a, p. 248) metonym of the cemetery.

21. Quadrophony is the use of four speakers in the corners of a square with the listener in the middle (Interview Op den Camp 2005). This system was one of many supposed to produce a relatively realistic immersive listening experience. See, for instance, Pope, Holm, and Kouznetsov 2000.

22. AII, "Timeschedule week 38" (n.d.); Muijres in Fieldwork 22 February 2005.

23. Paul Coenjaarts cited by Frusch in: AII, Annual Report 1997. The engineer Arno op den Camp indicates the limits of visually hiding speakers in terms of the quality of the sound (Interview Op den Camp 2005).

24. AII, File "Alle Namen," "Letter from Johan Luijmes to L. Hilkens, secretary advisory committee action programme cultural reach, n.d., no page numbers.

25. AII, File "Alle Namen," "Letter Intro | in situ to Mrs. Hilkens," 30 August 2004; Interview Termeer 2007.

26. AII, File "Alle Namen," "Letter Intro | in situ to Mrs. Hilkens," 30 August 2004.

27. Intro | in situ later invited the schools to come to the playing of *Alle Namen* and offered to arrange bus transportation for the children. But most of the schools did not take up the offer, and only a few children visited *Alle Namen* individually. Intro | in situ speculated that the children did not come because the letters were sent to the heads of the schools rather than to individual teachers (personal communication, Luijmes and Muijres, 21 August 2007), but a teacher pointed out that the children who had participated in the project had already left the school when *Alle Namen* was played in September (Interview Termeer 2007).

28. AII, File "Alle Namen," "Letter Johan Luijmes to the adopters of the war graves at Margraten," 2 May 2004.

29. AII, File "Alle Namen," "Letter Johan Luijmes to teachers primary school," 22 March 2004.

30. AII, File "Alle Namen," "Letter Intro | in situ to Mrs. Hilkens," 30 August 2004.

References

JerryAdler, "Truth and Doo-Wop," *Newsweek*, 4 June 2007, 39.

Theodor Adorno, "On the Fetish-Character in Music and the Regression of Listening," *The Essential Frankfurt School Reader*, eds. Andrew Arato and Eike Gebhardt (New York: Urizen Books, 1978 [1938]) 270-299.

—, *Critical Models: Interventions and Catchwords* (New York: Columbia University Press, 1998).

—, *The Culture Industry: Selected Essays on Mass Culture* (London: Routledge, 1999).

John Alderman, *Sonic Boom. Napster, MP3, and the New Pioneers of Music* (Cambridge, MA: Perseus Publishing, 2001).

Ernst van Alphen, "Caught by Images: On the Role of Visual Imprints in Holocaust Testimonies," *Journal of Visual Culture* 1 (2002): 205-221.

Rick Altman (ed.), *Sound Theory/Sound Practice* (New York: Routledge, 1992).

Ben Anderson, "Recorded music and practices of remembering," *Social and Cultural Geography* 5 (2004): 3-20.

Frank Ankersmit, *De historische ervaring* (Groningen: Historische Uitgeverij, 1993).

—, "Representation as the representation of experience," *Metaphilosophy* 31.1-2 (2000): 148-168.

—, *Sublime historical experience* (Stanford, CA: Stanford University Press, 2005).

Antonin Artaud, *Les tarahumaras* (Paris: Gallimard 1987).

—, *Le théâtre et son double* (Paris: Gallimard 1998).

Jan Assman, *Das kulturelle Gedächtnis. Schrift, Erinnerung und politische Identität in frühen Hochkulturen* (Munich: Beck Verlag, 1999).

Jacques Attali, *Bruits: Essai sur l' économie politique de la musique* (Paris: Fayard, 2001).

Michael D. Ayers (ed.), *Cybersounds: Essays on Virtual Music Cultures* (New York: Peter Lang, 2006).

Joseph Auer, "Making Old Machines Speak: Images of Technology in Recent Music," *ECHO* 2.2 (2000). URL: www.humnet.ucla.edu/echo accessed 19 July 2007.

Marc Augé, *Oblivion* (Minneapolis: University of Minnesota Press, 2004).

Philip Auslander, *Liveness: Performance in a Mediatized Culture*. Second, revised edition (London: Routledge, 2008 [1999]).

Dieter Baacke, *Beat: Die sprachlose Opposition* (Munich: Juventa, 1968).

Doris Bachmann-Medick, *Cultural Turns: Neuorientierungen in den Kulturwissenschaften* (Reinbek bei Hamburg: Rowohlt, 2007).

Ulrich Baer, *Spectral Evidence: The Photography of Trauma* (Cambridge, MA: MIT Press, 2002)

Liam J. Bannon, "Forgetting as a Feature, Not a Bug: The Duality of Memory and Implications for Ubiquitous Computing," *CoDesign* 2.1 (2006): 3-15.

Barbara Barthelmes, "Music and the City," *I Sing the Body Electric: Music and Technology in the 20th Century*, ed. Hans-Joachim Braun (Frankfurt am Main: Wolke Verlag, 2000) 97-105.

Jean Baudrillard, "Simulacra and Simulations," *Jean Baudrillard: Selected Writings* (Stanford, CA: Stanford University Press, 1988).

Roland de Beer, "Reportage: Musica Sacra in Maastricht speelt zich dit jaar af op de laatste rustplaats van de oorlogsslachtoffers," *De Volkskrant*, 20 September 2004.

Walter Benjamin, "Berlin Chronicle" [1932], *Reflections: Essays, Aphorisms, Autobiographical Writings*, ed. Peter Demetz (New York: Shocken, 1978): 3-60.

—, *Selected Writings, Volume 2: 1927-1934* (Cambridge, MA: Belknap Press of Harvard University Press, 1996-2003a).

—, "The Work of Art in the Age of Its Technological Reproducibility," Second edition, *Walter Benjamin, Selected Writings, Volume 3: 1935-1938* (Cambridge, MA: Belknap Press of Harvard University Press, 1996-2003b) 101-133.

Ruth Benschop, "Memory machines or musical instruments? Soundscape compositions, recording technologies and reference," *International Journal of Cultural Studies*, 10.4 (2007): 485-502.

Henri Bergson, *Matter and Memory* (New York: N.M. Paul and W.S. Palmer, 1988 [1896]).

"Bezit van duurzame consumptiegoederen in het huishouden (Tabel 4.4)," *Jaarboek Welvaartsverdeling 2000* (Heerlen: Centraal Bureau voor de Statistiek, 2000). URL: http://www.cbs.nl/NR/rdonlyres/7B9D2B1A-908B-421C-8A04-DE79CD850122/0/welvaartsverdeling.pdf accessed 17 July 2006.

Karin Bijsterveld, "'What Do I Do with My Tape Recorder...?' Sound hunting and the sounds of everyday Dutch life in the 1950s and 1960s," *Historical Journal of Film, Radio and Television*, 24.4 (October 2004): 613-634.

— and Trevor Pinch (eds.), Special Issue on Sound Studies. *Social Studies of Science*, 34.5 (2004).

Carolyn Birdsall, "'Affirmative Resonances' in the City? Sound, Imagination and Urban Space in Early 1930s Germany," *Sonic Interventions*, eds. Sylvia Mieszkowski, Joy Smith and Marijke de Valck (Amsterdam and New York: Rodopi Press, 2007a): 57-86.

—, "'All of Germany Listens to the Führer': Radio's Acoustic Space and 'Imagined

Listening Community' in Nazi Germany," *Hearing Places: Sound, Place, Time and Culture*, eds. Ros Bandt, Michelle Duffy, and Dolly MacKinnon (Newcastle: Cambridge Scholars Press, 2007b): 192-201.

Ernst Bloch, *The Principle of Hope* (Oxford: Blackwell, 1986).

Viggo Blücher, *Freizeit in der Industriellen Gesellschaft. Dargestellt an der jüngeren Generation* (Stuttgart: Enke, 1956).

Susan Bluck, "Autobiographical Memory: Exploring its Functions in Everyday Life," *Memory* 11.2 (2003): 113-123.

Philip V. Bohlman, "Landscape-Region-Nation-Reich: German Folk Song in the Nexus of National Identity," *Music and German National Identity*, eds. Celia Applegate and Pamela Potter (Chicago: Chicago University Press, 2002) 105-127.

Heinz Bonfadelli et al., *Jugend und Medien* (Frankfurt am Main: Metzner, 1986).

Peter Borscheid, *Das Tempo-Virus: eine Kulturgeschichte der Beschleunigung* (Darmstadt: Wissenschaftliche Buchgesellschaft, 2004).

Jérôme Bourdon, "Some Sense of Time: Remembering Television," *History & Memory* 15.2 (2003): 5-35.

G.H. Bower and J.P. Forgas, "Affect, Memory, and Social Cognition," *Cognition and Emotion*, eds J.P Forgas, K. Eick, and G.H. Bower (Oxford: Oxford University Press, 2000) 87-168.

Svetlana Boym, *The Future of Nostalgia* (New York: Basic Books, 2001).

Hans-Joachim Braun (ed.), *Music and Technology in the 20th Century* (Baltimore and London: Johns Hopkins University Press, 2002).

Martha Brech, *Können eiserne Brücken nicht schön sein? Über den Prozess des Zusammenwachsens von Technik und Musik im 20. Jahrhundert* (Hofheim: Wolke Verlag, 2006).

Christian Breunig, "Mobile Medien im digitalen Zeitalter. Neue Entwicklungen, Angebote, Geschäftsmodelle und Nutzung," *Media Perspektiven* (2006): 2-15.

Douglas Brice, *The Folk Carol of England* (London: Herberg Jenkins, 1967).

Susan J. Brison, "Trauma Narratives and the Remaking of Self," *Acts of Memory: Cultural Recall in the Present*, eds. Mieke Bal, Jonathan Crewe, and Leo Spitzer (Hanover: Dartmouth College, 1999) 39-54.

Jenelle Brown, "The Jukebox Manifesto," *Salon.com*. URL: http://www.salon.com/tech/feature/2000/11/13/jukebox/ accessed 12 December 2005.

Samuel Brylawski, "Preservation of Digitally Recorded Sound," *Building a National Strategy for Preservation: Issues in Digital Media Archiving*, ed. Council on Library and Information Resources and the Library of Congress (Washington, D.C.: Council on Library and Information Resources and the Library of Congress, 2002).

Barbara Buchholz (ed.), *Theremin: Russia with love* (Mainz: Intuition, Schott Music International, CD Intuition 3382-2, 2004).

Michael Bull, *Sounding Out the City: Personal Stereos and the Management of Everyday Life* (Oxford: Berg, 2000).

—, *Sound Moves: iPod Culture and Urban Experience* (Oxford: Routledge, 2008).

— and Les Back (eds.), *The Auditory Culture Reader* (Oxford: Berg, 2003).

W. van Bussel, *Prisma Bandrecorderboek* (Utrecht and Antwerpen: Het Spectrum, 1965).

Elias Canetti, *Der Ohrenzeuge: Fünfzig Charaktere* (Munich: Hanser, 1974).

—, *Die gerettete Zunge: Geschichte einer Jugend* (Munich: Hanser, 1977).

—, *Die Fackel im Ohr: Lebensgeschichte 1921-1931* (Munich: Hanser, 1980).

—, *Das Augenspiel: Lebensgeschichte 1931-1937* (Munich: Hanser, 1985).

—, *Party im Blitz: Die englischen Jahre* (Frankfurt am Main: S. Fischer, 2005).

Cathy Caruth, "Introduction," *Trauma: Explorations in Memory*, ed. Cathy Caruth (Baltimore: Johns Hopkins University Press, 1995) 1-12.

Manuel Castells et al., *Mobile Communication and Society: A Global Perspective* (Cambridge, MA: MIT Press, 2006).

David Chaney, *Lifestyles* (London: Routledge, 1996).

Paul Conway, "Preservation in the Digital World," *Report*. URL: http://www.clir.org/pubs/reports/conway2/ accessed 12 December 2005.

Alain Corbin, *Village Bells: Sound and Meaning in the Nineteenth-Century French Countryside* (New York: Columbia University Press, 1998).

Antonio Damasio, *Looking for Spinoza: Joy, Sorrow and the Feeling Brain* (Orlando: Harcourt, 2003).

Hermann Danuser, "Neue Musik," *Musik in Geschichte und Gegenwart*, Vol. 7 (Kassel and Stuttgart: Bärenreiter and Metzler, 1997).

Fred Davis, *Yearning for Yesterday* (New York: Macmillan, 1979).

Timothy Day, *A Century of Recorded Music: Listening to Musical History* (New Haven and London: Yale University Press, 2000).

Tia DeNora, *Music in Everyday Life* (Cambridge: Cambridge University Press, 2000).

José van Dijck, *Mediated Memories in the Digital Age* (Stanford, CA: Stanford University Press, 2007).

— and Karin Bijsterveld (eds.), Themanummer "Geluid," *Tijdschrift voor Mediageschiedenis* 6.2 (2003).

Peter Donhauser, *Elektrische Klangmaschinen. Die Pionierzeit in Deutschland und Österreich* (Vienna, Cologne, and Weimar: Böhlau, 2007).

Susan J. Douglas, *Listening in: Radio and the American Imagination from Amos 'n' Andy and Edward R. Morrow to Wolfman Jack and Howard Stern* (New York: Times Books, 1999).

—, *Listening in: Radio and the American Imagination* (Minneapolis: University of Minnesota Press, 2004).

Douwe Draaisma, *Metaphors of Memory: A History of Ideas about the Mind* (Cambridge: Cambridge University Press, 2000).

Rob Drew, "Mixed Blessings: The Commercial Mix and the Future of Music Aggregation," *Popular Music and Society* 28.4 (October 2005): 533-551.

Fritz Eberhard, *Der Rundfunkhörer und sein Programm. Ein Beitrag zur empirischen Sozialforschung* (Berlin: Colloquium-Verlag, 1962).

Simon Emmerson, "Aural landscape: musical space," *Organised Sound*, 3.2 (1999): 135-140.

— (ed.), *Music, Electronic Media and Culture* (Aldershot: Ashgate, 2000).

Cornelia Epping-Jäger, "Embedded Voices: Stimmpolitiken des Nationalsozialismus," *Phonorama: Eine Kulturgeschichte der Stimme als Medium*, ed. Brigitte Felderer (Berlin: Matthes und Seitz, 2004).

Veit Erlmann (ed.), *Hearing Cultures: Essays on Sound, Listening and Modernity.* (Oxford: Berg, 2004).

Aden Evans, *Sound Ideas: Music, Machines and Experience* (Minneapolis: University of Minnesota Press, 2005).

Carolina Eyck, *The Art of Playing the Theremin* (Berlin: Servi Verlag, 2007).

Cornelia Fales, "Short-Circuiting Perceptual Systems: Timbre in Ambient and Techno Music," *Wired for Sound: Engineering and Technologies in Sonic Cultures*, eds. Paul D. Greene and Thomas Porcello (Middletown, CT: Wesleyan University Press, 2005) 156-180.

Mike Featherstone, "Archiving Cultures," *British Journal of Sociology* 51.1 (2000): 161-184.

Andreas Fickers, *"Der Transistor" als technisches und kulturelles Phänomen. Die Transistorisierung der Radio- und Fernsehempfänger in der deutschen Rundfunkindustrie von 1955-1965* (Bassum: GNT-Verlag, 1998).

—, *Imagined Topographies. The Radio Station Scale and the Symbolic Appropriation of Wireless Landscapes* (unpublished manuscript, 2006).

—, "Design as mediating interface. Zur Zeugen- und Zeichenhaftigkeit des Radioapparates," *Berichte zur Wissenschaftsgeschichte* 30.3 (2007): 199-213.

Erika Fischer-Lichte, *Ästhetik des Performativen* (Frankfurt am Main: Suhrkamp, 2004).

Caryl Flinn, *The New German Cinema: Music, History, and the Matter of Style* (Berkeley: University of California, 2004).

Michael Forrester, *Psychology of the Image* (London: Routledge, 2000).

Adrian Forty, *Objects of Desire. Design and Society since 1750* (London: Thames & Hudson, 1986).

Doris Francis, Leonie Kellaher and Georgina Neophytou, *The Secret Cemetery* (Oxford: Berg, 2005).

Robert Frank, "La mémoire empoisonnée," *La France des années noires, tôme 2*, ed. Jean-Pierre Azéma and François Bédarida (Paris: Éditions du Seuil, 2000) 545.

Saul Friedländer, *Memory, History, and the Extermination of the Jews in Europe* (Bloomington: Indiana University Press, 1993).

Jörg Friedrich, *Der Brand: Deutschland im Bombenkrieg, 1940-1945* (Berlin: Propyläen, 2002).

Simon Frith, "Towards an Aesthetics of Popular Music," *Music and Society: The Politics of Composition, Performance and Reception*, eds. Richard Leppert and Susan McClary (Cambridge: Cambridge University Press, 1987) 133-150.

—, *Performing Rites: On the Value of Popular Music* (Oxford: Oxford University Press, 1996).

Phil Gallo, "Rhino, Pubcaster Set up Doo-wop Projects," *Variety*, 22 August 2000, 4.

Kurt Gauger (ed.), *Bestimmungen über Film und Bild in Wissenschaft und Unterricht.* (Stuttgart and Berlin: W. Kohlhammer, 1943).

Stefan Gauß, "Das Erlebnis des Hörens. Die Stereoanlage als kulturelle Erfahrung," *Um 1968:Die Repräsentation der Dinge*, ed. Wolfgang Ruppert (Marburg: Jonas-Verlag, 1998) 65-93.

Paul du Gay et al., *Doing Cultural Studies: The Story of the Sony Walkman* (London: Sage, 1997).

Arnold von Gennep, *Les rites de passage* (Paris: Nourry, 1909).

Tarleton Gillespie, *Wired Shut: Copyright and the Shape of Digital Culture* (Cambridge, MA: MIT Press, 2007).

Albert Glinsky, *Theremin. Ether Music and Espionage* (Urbana, Chicago: University of Illinois Press, 2000).

N. Gobits and H. Broekhuizen, *Avonturen met een bandrecorder* (Bussum:.n.p., 1969 [1964]).

David Gonzalez, "Doo-Wop Dream Lives, Even in Death," *New York Times*, 27 July 1995, §A, 1.

Alan Goodwin, "Sample and Hold: Pop Music in the Digital Age of Reproduction," *Critical Quarterly* 30.3 (1988): 34-49.

Hans-Peter Görgen and Heinz Hemming, *Schule Im Dritten Reich: Dokumentiert am Beispiel Benrather Jungengymnasiums* (Düsseldorf: Pädagogisches Institut der Landeshauptstadt Düsseldorf, 1988).

Martin Gottlieb, "Far from the Street Corner, Doo-Wop Lives," *New York Times*, 17 January 1993, §H, 1.

Paul Grainge, "Nostalgia and Style in Retro America: Moods, Modes, and Media Recycling," *Journal of American and Comparative Cultures* 23.1 (2000): 27-34.

Leigh Grant, *Twelve Days of Christmas: A Celebration and History* (New York: Harry N. Abrams, 1995).

Paul D. Greene and Thomas Porcello (eds.), *Wired for Sound: Engineering and Technologies in Sonic Cultures* (Middletown, CT: Wesleyan University Press, 2005).

Anthony J. Gribin and Matthew M. Schiff, *Doo-Wop: The Forgotten Third of Rock 'n Roll* (Iola, WI: Krause, 1992).

Francis Guerin and Robert Hallas (eds.), *The Image and the Witness: Trauma, Memory and Visual Culture* (London: Wallflower Press, 2007).

Maurice Halbwachs, *On Collective Memory* (Chicago: University of Chicago Press, 1992).

Mikael Hård and Andrew Jamison, *Hubris and Hybris: A Cultural History of Technology and Science* (London: Routledge, 2005).

Kristen Haring, "The 'Freer Men' of Ham Radio. How a Technical Hobby Provided Social and Spatial Distance," *Technology and Culture*, 44.4 (2003): 734-761.

—, *Ham Radio's Technical Culture* (Cambridge, MA: MIT Press, 2007).

Regina Hartleb, "Die Klangwelten des Krieges," *Rheinische Post*, 27 March 2004a.

—, "Die Klangwelten des Bombenkrieges," *Rheinische Post*, 10 September 2004b.

Rolf Hasbargen and Andrea Krämer, " 'Eine der schönste Kommunicationsofferten, die man nützen kann': Mixtapes im Kommunikationsprozess," *Kassettengeschichten: Von Menschen und ihre Mixtapes*, ed. Gerrit Herlyn and Thomas Overdick (Münster: LIT Verlag, 2005) 69-78.

Dick Hebdige, *Subculture: The Meaning of Style* (London: Methuen & Co. Ltd, 1979).

Joachim Heinig, *Teenager als Verbraucher* (Erlangen-Nürnberg: unpublished dissertation, 1962).

Antoine Hennion, "Baroque and Rock: Music, Mediator, and Musical Taste," *Poetics* 24 (1997): 415-435.

Gerrit Herlyn and Thomas Overdick (eds.), *Kassettengeschichten: Von Menschen und ihre Mixtapes* (Münster: LIT Verlag, 2005).

Jost Hermand, "On the History of the 'Deutschlandlied'," *Music and German National Identity*, eds. Celia Applegate and Pamela Potter (Chicago: University of Chicago Press, 2002) 251-268.

Roger Hillman, *Unsettling Scores: German Film, Music, and Ideology* (Bloomington: Indiana University Press, 2005).

Michele Hilmes, *Radio Voices. American Broadcasting, 1922-1952* (Minnea-

polis: University of Minnesota Press, 1997).

Nick Hornby, *High Fidelity* (London: Penguin Books, 1995).

Susan Schmidt Horning, "Engineering the Performance: Recording Engineers, Tacit Knowledge and the Art of Controlling Sound," *Social Studies of Science* 34.5 (2004): 703-731.

Andrew Hoskins, "New Memory: Mediating History," *Historical Journal of Film, Radio, and Television* 21.4 (2001): 333-46.

Shuhei Hosokawa, *Der Walkman-Effekt* (Berlin: Merve, 1987).

Johan Huizinga, "Het historisch museum," *De Gids* 84 (1920): 251-262.

—, *Verzamelde werken VII* (Haarlem: Tjeenk Willink, 1950).

David Huron, *Sweet Anticipation: Music and the Psychology of Anticipation* (Cambridge, MA: MIT Press, 2006).

Peter Hüttenberger, *Düsseldorf: Geschichte von den Anfängen bis ins 20. Jahrhundert*, Vol. 3: Die Industrie- und Verwaltungshauptstadt (20. Jahrhundert), ed. Hugo Weidenhaupt (Düsseldorf: Schwann, 1989).

Andreas Huyssen, *Present Pasts: Urban Palimpsests and the Politics of Memory* (Stanford, CA: Stanford University Press, 2003).

Annelies Jacobs, *De ongetemde tapes. Een onderzoek naar de domesticatie van de bandrecorder* (unpublished MA thesis, Maastricht University, 2006).

Hildegard Jakobs, *Zeitspuren in Düsseldorf 1930-1950: Ein Stadtführer* (Essen: Woeste, 2003).

Kasper Jansen, "De partijdige God sanctioneert de 'heilige' oorlog: De 'pijnlijke werkelijkheid' van het gewijde krijgsbedrijf beheerst het Maastrichtse festival Musica Sacra," *NRC Handelsblad*, 20 September 2004, 8.

James H. Johnson, *Listening in Paris: A Cultural History* (Berkeley: University of California Press, 1995).

Michael Kater, *Different Drummers: Jazz in the Culture of Nazi Germany* (New York: Oxford University Press, 1992).

Donald Katz, *Home Fires: An Intimate Portrait of One Middle-Class Family in Postwar America* (New York: HarperCollins, 1992).

Mark Katz, *Capturing Sound. How Technology Has Changed Music.* (Berkeley: University of California Press, 2004).

Lydia Kavina (ed.), *Music from the Ether: Original Works for Theremin* (New York, NY: Mode records CD, Mode 76, 1999).

Charles Keil and Steven Feld, *Music Grooves* (Chicago: University of Chicago Press, 1996).

Quinn Kennedy, Mara Mather, and Laura Carstensen, "The Role of Motivations in the Age-Related Positivity Effect in Autobiographical Memory," *Psychological Science* 15.3 (1994): 208-214.

William Howland Kenny, *Recorded Music in American Life: The Phonograph and Popular Memory 1890-1945* (Oxford: Oxford University Press, 1999).

Caroline van Kimmenade, *The Aura as Practice: Benjamin, Tape-recording and the Value of Reproductions* (unpublished MA thesis, Maastricht University, 2006).

H. Knobloch, *Der Tonband-Amateur: Ratgeber für die Praxis mit dem Heimtongerät und für die Schmalfilm-und-Dia-Vertonung* (Munich: Franzis-Verlag, 1963 [1954]).

Hans L. Koekoek, *Het bandrecorderboek* (Amsterdam: L.J. Veen, 1968).

Joseph A. Kotarba, "Rock 'n' Roll Music As a Timepiece," *Symbolic Interaction* 25.3 (2002): 397-404.

Caroline Kramer, *Zeit für Mobilität: Räumliche Disparitäten der individuellen Zeitverwendung für Mobilität in Deutschland* (Stuttgart: Steiner Verlag, 2005).

Annette Kuhn, "A Journey through Memory," *Memory and Methodology*, ed. Susannah Radstone (Oxford: Berg, 2000) 183-196.

Stefan Kursawe, *Vom Leitmedium zum Begleitmedium. Die Radioprogramme des Hessischen Rundfunks 1960-1980* (Cologne: Böhlau, 2004).

Brandon LaBelle, *Background Noise: Perspectives on Sound Art* (New York and London: Continuum, 2006).

Thomas W. Laqueur, "Memory and Naming in the Great War," *Commemorations: The Politics of National Identity*, ed. John R. Gillis (Princeton, NJ: Princeton University Press, 1994) 150-167.

James Lastra, *Sound Technology and American Cinema: Perception, Representation, Modernity* (New York: Columbia University Press, 2000).

Brent Lee, "Issues Surrounding the Preservation of Digital Music Documents," *Archivaria* 50 (2000): 193-204.

Henri Lefebvre, *Rhythmanalysis: Space, Time and Everyday Life* (London: Continuum Press, 2004 [1992]).

Daniel LeMahieu, *A Culture for Democracy: Mass Communication and the Cultivated Mind between the Wars* (New York: Oxford University Press, 1988).

Carsten Lenk, *Die Erscheinung des Rundfunks: Einführung und Nutzung eines neuen Mediums 1923-1932* (Opladen: Westdeutscher Verlag, 1997).

Helmut Lethen, "Geräusche jenseits des Textarchivs: Ernst Jünger und die Umgehung des Traumas," *Hörstürze: Akustik und Gewalt im 20. Jahrhundert*, eds. Nicola Gess, Florian Schreiner, and Manuela K. Schulz (Würzburg: Königshausen & Neumann, 2005) 33-52.

Thomas Y. Levin, "For the Record: Adorno on Music in the Age of Its Technological Reproducibility," *October*, 55 (Winter 1990): 23-47.

Steven Levy, *Hackers: Heroes of the Computer Revolution* (New York: Penguin, 2001 [1984]).

Merete Lie and Knut H. Sorensen, *Making Technology Our Own? Domesticating Technology into Everyday Life* (Oslo: Scandinavian University Press, 1996).

"Liebe Tonband FEINDIN!," *Ton+Band* (1965): 4-5.

J.M. Lloyd, *The All-in-One Tape Recorder Book* (London: Focal Press, 1975 [1958]).

René T.A. Lysloff and Leslie C. Gay (eds.), *Music and Technoculture* (Middletown, CT: Wesleyan Press, 2003).

Peter Manning, *Electronic and Computer Music*, revised and expanded edition (Oxford/New York: Oxford University Press, 2004).

Inge Marßolek, "Radio in Deutschland 1923-1960: Zur Sozialgeschichte eines Mediums," *Geschichte und Gesellschaft* 27 (2001): 207-239.

Karl Marx, *Capital: A Critique of Political Economy*, Vol. 1 (London: Penguin, 1990).

Mara Mather, "Aging and Emotional Memory," *Memory and Emotion*, eds. D. Reisberg and P. Hertel (Oxford: Oxford University Press, 2004) 272-307.

Grant McCracken, *Culture and Consumption: New Approaches to the Symbolic Character of Consumer Goods and Activities* (Bloomington: Indiana University Press, 1988).

Jeffrey Melnick, "'Story Untold': The Black Men and White Sounds of Doo-Wop," *Whiteness: A Critical Reader*, ed. Mike Hill (New York: New York University Press, 1997).

Pascal Mercier, *Perlmann's zwijgen* (Amsterdam: Wereldbibliotheek, 2007 [1995]).

Wim Meter, *The Story of a Collector* (Hilversum: Studio Meter Publishing, 2005).

Michael Meyer, *Hauptsache Unterhaltung. Mediennutzung und Medienbewertung in Deutschland in den 50er Jahren* (Münster: LIT, 2001).

Barbra A. Misztal, *Theories of Social Remembering* (Maidenhead: Open University Press, 2003).

Alexander Mitscherlich and Margarete Mitscherlich, *The Inability to Mourn* (New York: Grove Press, 1975).

Thurston Moore (ed.), *Mix Tape: The art of cassette culture* (New York: Universe, 2004).

Shaun Moores, "'The Box on the Dresser': Memories of Early Radio and Everyday Life," *Media, Culture and Society* 10 (1988) 23-40.

Leslie Morris, "The Sound of Memory," *The German Quarterly* 74 (2001) 368-378.

Steve Morse, "Forever Oldies," *Boston Globe*, 24 January 1992, 37.

David Morton, *Off the Record: The Technology and Culture of Sound Recording in America* (New Jersey: Rutgers University Press, 2000).

Helga de la Motte-Haber, "Zwischen Performance und Installation," *Klang-*

kunst: Tönende Objekte und klingende Räume, ed. Helga de la Motte-Haber (Laaber: Laaber Verlag, 1999).

National Library of Australia, *Guidelines for the Preservation of Digital Heritage* (N.p.: UNESCO, Information Society Division, 2003).

Bert Natter and Kees Zandvliet (eds.), *De historische sensatie: het Rijksmuseum geschiedenisboek: 50 verhalen over unieke voorwerpen in het Rijksmuseum* (Amsterdam: Thomas Rap, 2005).

Katherine Nelson, "Self and Social Functions: Individual Autobiographical Memory and Collective Narrative," *Memory* 11.2 (2003): 125-36.

Friedrich Nietzsche, *The Birth of Tragedy and the Case of Wagner* (New York: Vintage Books, 1967).

—, *The Use and Abuse of History* (Indianapolis: Bobbs-Merrill, 1957 [1873]).

C.G. Nijsen, *The tape recorder: a complete handbook on magnetic recording* (London: Iliffe Books, 1964).

Geoffrey O'Brien, *Sonata for Jukebox. Pop Music, Memory, and the Imagined Life* (New York: Counterpoint, 2004).

Kenton O'Hara and Barry Brown (eds.), *Consuming Music Together: Social and Collaborative Aspects of Music Consumption Technologies* (Dordrecht: Springer, 2006).

Jason Oakes, *Losers, Punks, and Queers (and Elvii too): Identification and 'Identity' at New York City Music Tribute Events* (unpublished Ph.D. dissertation, Columbia University, 2004).

"Oh Yes, They're Great Pretenders," *Asbury Park Press (New Jersey)*, 25 September 2006, 18A.

Otto Gerhard Oexle, "Memoria und Erinnerungskultur im Alten Europa—und heute," *Gedenken im Zwiespalt. Konfliktlinien europäischen Erinnerns*, ed. Alexandre Escudier (Göttingen: Wallstein Verlag, 2001) 9-32.

Sherry B. Ortner, *New Jersey Dreaming: Capital, Culture, and the Class of '58* (Durham, NC: Duke University Press, 2003).

Henk van Os, *Moederlandse geschiedenis* (Amsterdam: Stichting Collectieve Propaganda voor het Nederlandse Boek, 2005).

Erich Ott and Thomas Gerlinger, *Die Pendler-Gesellschaft. Zur Problematik der fortschreitenden Trennung von Wohn- und Arbeitsort* (Cologne: Bund-Verlag, 1992).

Nelly Oudshoorn and Trevor Pinch (eds.), *How Users Matter: The Co-construction of Users and Technology* (Cambridge, MA: The MIT Press, 2003).

Cord Pagenstecher, *Der bundesdeutsche Tourismus: Ansätze zu einer Visual History: Urlaubsprospekte, Reiseführer, Fotoalben 1950-1990* (Hamburg: Kovac, 2003).

Monika Pater and Uta C. Schmidt, "'Vom Kellerloch bis hoch zur Mansard ist alles drinvernarrt'—Zur Veralltäglichung des Radios im Deutschland der 1930er Jahre," *MedienAlltag. Domestizierungsprozesse alter und neuer Medien*, ed. Jutta Röser (Wiesbaden: VS Verlag, 2007) 103-116.

Armin Peiseler, Jörn Radzuweit, and Alexander Tsitsigias, "'My Favorite Chords' Mixtapes und Musikgeschmak," *Kassettengeschichten: Von Menschen und ihre Mixtapes*, ed. Gerrit Herlyn and Thoman Overdick (Münster: LIT Verlag, 2005) 56-68.

John Durham Peters, *Speaking Into the Air: A History of the Idea of Communication* (Chicago: University of Chicago Press, 1999).

Robert Philip, *Performing Music in the Age of Recording* (New Haven and London: Yale University Press, 2004).

David B. Pillemar, "Can the Psychology of Memory Enrich Historical Analyses of Trauma?" *History and Memory*, 16.2 (2004): 140-154.

Trevor Pinch, "Emulating Sound: What Synthesizers Can and Can't do: Explorations in the Social Construction of Sound," *Wissen und soziale Konstruktion*, ed. Claus Zittel (Berlin: Akademie Verlag, 2003) 109-127.

— and Frank Trocco, *Analog Days: The Invention and Impact of the Moog Synthesizer* (Cambridge, MA: Harvard University Press, 2002).

B. Joseph Pine II & James H. Gilmore, *The Experience Economy: Work is Theatre & Every Business a Stage* (Boston, MA: Harvard Business School Press, 1999).

Stephen Travis Pope, Frode Holm, and Alex Kouznetsov, "ATON Report 2000.3: A Representation and Infrastructure for Flexible Sound Spatialisation." URL: http://www.create.ucsb.edu/ATON/ last accessed 2 September 2007.

Thomas Porcello, "Speaking of Sound: Language and the Professionalization of Sound Recording Engineers," *Social Studies of Science* 34.5 (2004): 733-758.

—, "Afterword," *Wired for Sound: Engineering and Technologies in Sonic Cultures*, eds. Paul D. Greene and Thomas Porcello (Middletown, CT: Wesleyan University Press, 2005) 269-281.

Robert Post, *High Performance: The Culture and Technology of Drag Racing, 1950-2000* (Baltimore: Johns Hopkins University Press, 1994).

Marcel Proust, *In Search of Lost Time: Finding Time Again* (London: Allen Lane. 2002 [1913-1927]).

F. Purves, *The Philips Tape Recording Book* (London: Focal Press, 1962).

Don Michael Randel, *The Harvard Dictionary of Music*, 4th edition (Cambridge, MA: The Belknap Press of Harvard University Press, 2003).

Paul Ricoeur, *Oneself as Another* (Chicago: University of Chicago Press, 1992).

—, *Memory, History, Forgetting* (Chicago: University of Chicago Press, 2004).

Michael Riordan and Lilian Hoddeson, *Crystal Fire. The Birth of the Information Age* (New York: Norton, 1997).

Clara Rockmore, *The Art of the Theremin* (Santa Monica: Delos CD 1014, 1987): 3.

Andreas Rödder, *Wertewandel und Postmoderne. Gesellschaft und Kultur der Bundesrepublik Deutschland 1965-1990* (Stuttgart: Stiftung Bundespräsident-Theodor-Heuss-Haus, 2004).

Eric W. Rothenbuhler, "Commercial radio as communication," *Journal of Communication* 46 (1996): 125-143.

— and John D. Peters, "Defining Phonography: An experiment in theory," *Musical Quarterly* 81.2 (1997): 242-264.

Eelco Runia, "De pissende Pulcinella: Het Metonymische Karakter van de Historische Ervaring," *De Gids* 168.5 (2005): 397-416.

—, "Namen noemen," *Tijdschrift voor Geschiedenis* 119.2 (2006a): 242-248.

—, "Spots of Time," *History and Theory* 45 (October 2006b): 305-316.

John Michael Runowicz, Echo and Harmony: Race, Nostalgia and the Doo-wop/ Oldies Community (unpublished Ph.D. dissertation New York University, 2006).

Kelly Russell, *Why Can't We Preserve Everything?* (St. Pancras: Cedars Project, 1999).

Oliver Sacks, *Musicofilia: Verhalen over muziek en het brein* (Amsterdam: Meulenhoff, 2007). Originally published as *Musicophilia: Tales of Music and the Brain* (New York: Knopf, 2007).

Lisa Saltzman and Eric Rosenberg (eds.), *Trauma and Visuality in Modernity* (Lebanon: Dartmouth College, 2006).

Donald Sassoon, *The Culture of the Europeans. From 1800 to the Present* (London: Harper Collins, 2006).

Raymond Murray Schafer, *The Soundscape: Our Sonic Environment and the Tuning of the World* (Rochester, VT: Destiny Books, 1994 [1977]).

Dorothea-Luise Scharmann, *Konsumverhalten von Jugendlichen* (Munich: Juventa, 1965).

Michael Brian Schiffer, *The Portable Radio in American Life* (Tucson and London: University of Arizona Press, 1991).

Axel Schildt, *Moderne Zeiten: Freizeit, Massenmedien und „Zeitgeist" in der Bundesrepublik der 50er Jahre* (Hamburg: Christians, 1995).

Rainer Schönhammer, *Der 'Walkman': Eine phänomenologische Untersuchung* (Munich: Kirchheim, 1988).

Matthew D. Schulkind, Laura K. Hennis, and David C. Rubin, "Music, Emotion, and Autobiographical Memory: They're Playing Your Song," *Memory and Cognition* 27.6 (1999): 948-955.

Gerhard Schulze, *Die Erlebnisgesellschaft: Kultursoziologie der Gegenwart* (Frankfurt: Campus, 1992).

Joan Scott, "The Evidence of Experience," *Critical Inquiry* 17 (1991): 773-797.

—, "Fantasy Echo: History and the Construction of Identity," *Critical Inquiry* 27 (2001): 284-304.

W.G. Sebald, *On the Natural History of Destruction: With Essays on Alfred Andersch, Jean Amery and Peter Weiss* (London: Penguin, 2003 [1997]).

C. Nadia Seremetakis (ed.), *The Senses Still: Perception and Memory as Material Culture in Modernity* (Chicago: University of Chicago Press, 1996).

"Shirelles Still Smooth as Honey," *St. Petersburg Times*, 16 May 1997, 14.

Detlef Siegfried, *Time is on my side. Konsum und Politik in der westdeutschen Jugendkultur der 60er Jahre* (Göttingen: Wallstein Verlag, 2006).

Roger Silverstone and Eric Hirsch (eds.), *Consuming Technologies: Media and information in domestic spaces* (London: Routledge, 1992).

James R. Smart, "Emile Berliner and Nineteenth-Century Disc Recordings," *Quarterly Journal of the Library of Congress* 37.3-4 (1980): 422-40.

Michaela A. Smith and Brant Leigh, "Virtual subjects: using the Internet as an alternative source of subjects and research environment," *Behaviour, Research Methods, Instruments and Computers* 29 (1997): 496-505.

Cas Smithuijsen, *Een verbazende stilte: Klassieke muziek, gedragsregels en sociale controle in de concertzaal* (Amsterdam: Boekmanstudies, 2001).

Bob Snyder, *Music and Memory: An Introduction* (Cambridge, MA: MIT Press, 2000).

Michael E. Sobel, *Lifestyle and Social Structure: Concepts, Definitions, Analyses* (New York: Academic Press, 1981).

Daya J. Somasundaram, "Post-traumatic Responses to Aerial Bombing," *Social Science and Medicine* 42.2 (1996): 1465-1471.

Jo Spence and Patricia Holland, *Family snaps: the meanings of domestic photography* (London: Virago, 1991).

Lynn Spigel, *Make Room for TV: Television and the Family Ideal in Postwar America* (Chicago: University of Chicago Press, 1992).

Gayatri Spivak, "Echo," *New Literary History* 24.1 (Winter 1993) 17-43.

Nicholas Stargardt, "German Childhoods: The Making of a Historiography," *German History*, 16 (1998) 1-15.

Bob Starrett, "Do Compact Discs Degrade?," *Roxio Newsletter*. URL: http://www.roxio.com/en/support/discs/dodiscsdegrade.html accessed 12 December 2005.

Olaf Steinacker, *Bombenkrieg über Düsseldorf* (Gudensberg-Gleichen: Wartberg, 2003).

Christian Stelzer, "Musik im Kopf. Der Walkman verändert Hörgewohnheiten," *Medien und Erziehung* 2 (1988) 68-74.

Jonathan Sterne, *The Audible Past: Cultural Origins of Sound Reproduction* (Durham: Duke University Press, 2003).

—, "The Death and Life of Digital Audio," *Interdisciplinary Science Review* 31.4 (2006a): 338-348.

—, "The MP3 as Cultural Artifact," *New Media and Society* 8.5 (2006b): 825-842.

Kathleen Stewart, "Nostalgia—A Polemic," *Cultural Anthropology* 3 (August 1988): 227-241.

Rolf W. Stoll, booklet text in Barbara Buchholz & Lydia Kavina (eds.), *touch! don't touch! Music for the theremin* (Mainz: Schott Music & Media, CD WERGO, WER 6679-2, 2006).

Will Straw, "Exhausted Commodities: The Material Culture of Music," *Canadian Journal of Communication* 25.1 (2000): 175-185.

Melanie Swalwell, "The Remembering and the Forgetting of Early Digital Games: From Novelty to Detritus and Back Again," *Journal of Visual Culture* 6.2 (2007): 255-273.

Joe Tacchi, "Radio Texture: Between Self and Others," *Material Cultures: Why Some Things Matter*, ed. Daniel Miller (London: UCL Press, 1998) 25-45.

Philip M. Taylor, "The Case for Preserving Our Contemporary Communications Heritage," *Historical Journal of Film, Radio and Television* 16.3 (1996): 419-424.

Timothy D. Taylor, *Strange Sounds: Music, Technology and Culture* (New York: Routledge, 2001).

Michael Thompson, *Rubbish Theory: The Creation and Destruction of Value* (New York: Oxford University Press, 1979).

Nigel Thrift, *Spatial Formations* (London: Sage, 1996).

—, "Intensities of Feeling: Towards a Spatial Politics of Affect," *Geografiska Annaler B: Human Geography* 86.1 (2004): 57-78.

Cecelia Tichi, *Electronic Hearth: Creating an American Television Culture* (Oxford: Oxford University Press, 1991).

Jo Tollebeek and Tom Verschaffel, *De vreugden van Houssaye: apologie van de historische interesse* (Amsterdam: Wereldbibliotheek, 1992).

Thomas Turino, "Signs of imagination, identity, and experience: A Peircian semiotic theory for music." *Ethnomusicology* 43.2 (1999): 221-255.

Sherry Turkle, *The Second Self: Computers and the Human Spirit* (Cambridge, MA: MIT Press, 2005 [1984]).

Victor Turner, *The Anthropology of Performance* (New York: PAJ Publications, 1987).

Verwaltungsbericht der Landeshauptstadt Düsseldorf vom Zeitpunkt der Besetzung der Stadt 1945 bis zum 31. März 1949 (Düsseldorf: Statistischen Amt Düsseldorf, 1949).

Steve Waksman, "California Noise: Tinkering with Hardcore and Heavy Metal in Southern California," *Social Studies of Science* 34.5 (2004): 675-702.

Qi Wang and Jens Brockmeier, "Autobiographical Remembering as Cultural Practice: Understanding the Interplay between Memory, Self, and Culture," *Culture and Psychology* 8.1 (2002): 45-64.

Brian Ward, *Just My Soul Responding: Rhythm and Blues, Black Consciousness, and Race Relations* (Berkeley: University of California Press, 1998).

Heike Weber, *Das Versprechen mobiler Freiheit. Zur Kultur- und Technikgeschichte Von Kofferradio, Walkman und Handy* (Bielefeld: Transcript, 2008).

Klaus Heiner Weber, "Knopf im Ohr und Bässe im Bauch: Jugendkultur und Kultgegenstand: der Walkman," *Medien praktisch* 2 (1992): 33-35.

Harald Welzer, *Das kommunikative Gedächtnis. Eine Theorie der Erinnerung* (Munich: Beck Verlag, 2002).

—, Sabine Moller, and Karoline Tschuggnall, *"Opa war kein Nazi": Nationalsozialismus und Holocaust im Familiengedächtnis* (Frankfurt: Fischer, 2002).

Hildegard Westerkamp, "Soundscape Composition: Linking Inner and Outer Worlds." URL: http://www.sfu.ca/~westerka/writings.html accessed 21 August 2007 [1999].

Alan Williams, "Is Sound Recording Like a Language?" *Yale French Studies* 60.1 (1980): 51-66.

Herbert Williams and Martin Jurga (eds.), *Inszenierungsgesellschaft: Ein einführendes Handbuch* (Opladen and Wiesbaden: Westdeutscher Verlag, 1998).

Raymond Williams, *The Long Revolution* (Harmondsworth, Middlesex: Penguin, 1961).

—, *Marxism and Literature* (New York: Oxford University Press, 1977).

—, *Politics and Letters: Interviews with New Left Review* (London: Verso, 1981).

Sherri Williams, "Doo-wop Traveling Show Rekindles Fond Memories of '50s Tunes for Performers, Audience," *Columbus Dispatch*, 9 February 2008.

Paul Willis, Simon Jones, Joyce Canaan, and Geoff Hurd, *Common Culture: Symbolic Work at Play in the Everyday Cultures of the Young* (Boulder, CO: Westview Press, 1990).

Justin Winkler, "Space, sound and time: A choice of articles in Soundscape Studies and Aesthetics of Environment 1990 – 2003." URL: http://www.humgeo. unibas.ch/, accessed 26 January 2006.

Jay Winter, "The Memory Boom in Contemporary Historical Studies," *Raritan* 21.1 (Summer 2001) 52-56.

Trevor Wishart, *On Sonic Art* (Amsterdam: Harwood Academic Publishers, 1996).

James E. Young, "Between History and Memory: The Voice of the Eyewitness," *Witness and Memory: The Discourse of Trauma*, eds. Ana Douglass and Thomas A. Vogler (New York: Routledge, 2003) 275-284.

Volker Zimmermann, *In Schutt und Asche: Das Ende des Zweiten Weltkriegs in Düsseldorf* (Düsseldorf: Grupello, 2005).

List of Contributors

Editors

Karin Bijsterveld is a professor in the Department of Technology & Society Studies at Maastricht University. Her publications focus on science, technology, and sound – including noise and music. She is the author of *Mechanical Sound: Technology, Culture, and Public Problems of Noise in the Twentieth Century* (MIT Press, 2008). With Trevor Pinch, she has just started working on a Sound Studies Handbook (Oxford University Press). For her additional sonic projects, see http://www.fdcw.unimaas.nl/staff/bijsterveld.

José van Dijck is a professor of Media and Culture and Dean of the Faculty of Humanities at the University of Amsterdam. She has published widely on the relation between science, technology, and media. She is the author of four books, including *The Transparent Body. A Cultural Analysis of Medical Imaging* (University of Washington Press, 2005). Her most recent book is entitled *Mediated Memories in the Digital Age* (Stanford University Press, 2007). Her homepage address is http://home.medewerker.uva.nl/j.f.t.m.vandijck.

Other contributors

Ruth Benschop is a postdoc at the Department of Technology & Society Studies at Maastricht University. Her Ph.D. thesis (*Unassuming Instruments: How to Trace the Tachistoscope in Experimental Psychology*, 2001, University of Groningen) analyzes the role of technology in visual psychological experiments. Her current research focuses on the role of recording technology and the notion of "experiment" in sound art. Her most recent publication is "Memory Machines or Musical Instruments? Soundscapes, Recording Technologies, and References," *International Journal of Cultural Studies* 10 (2007): 485-502. For more about her interests, see http://www.fdcw.unimaas.nl/staff/benschop.

Carolyn Birdsall recently completed her Ph.D. at the Amsterdam School for Cultural Analysis, University of Amsterdam. Her doctoral research focused on developing soundscape theory in relation to sound technology and cultural practices during Weimar and Nazi Germany. With Anthony Enns she is co-editor of *Sonic Mediations: Body, Sound, Technology* (Cambridge Scholars Press, 2008). She has published articles on German radio history, urban soundscapes, documentary film, and sound design.

Hans-Joachim Braun is a professor of Modern Social, Economic, and Technological History at the Helmut-Schmidt-Universität in Hamburg. He has published widely on technology and music, and is editor of *Music and Technology in the* 20^{th} *Century* (Johns Hopkins University Press, 2002). He is currently comparing processes of engineering design with those of musical composition and editing a volume entitled *Creativity: Technology and the Arts* (Peter Lang, 2008). His homepage address is:
http://www.hsu-hh.de/histec/index_tcqC9PXwYAaBdOCl.html.

Michael Bull teaches in the Media and Film Department at the University of Sussex, Brighton. He is the author of *Sounding Out the City: Personal Stereos and the Management of Everyday Life* (Berg, 2000), co-editor of *The Auditory Culture Reader* (Berg, 2003), and chief editor of *The Senses and Society Journal*. His most recent monograph is entitled *Sound Moves: iPod Culture and Urban Experience* (Routledge, 2007). For more about his interests, see www.sussex.ac.uk/mediastudies/profile119032.html.

Annelies Jacobs is a Ph.D. candidate in the NWO-funded project *Soundscapes of the Urban Past* at Maastricht University. She has been trained as an architect and also holds an M.A. in Arts and Sciences. She has published on the sound of modern architecture in *Mosaiek: Interdisciplinair Cultuurhistorisch Tijdschrift*.

Andreas Fickers is an associate professor at the Literature & Arts Department of Maastricht University. He has published widely on the cultural history of communication technologies, mainly radio and television. His current research focuses on comparative European media history. *A European Television History* edited by Fickers and Jonathan Bignell is forthcoming (Blackwell, 2008). For more about his activities, see http://www.fdcw.unimaas.nl/staff/fickers.

Bas Jansen has an M.A. in musicology and media studies. He is currently a Ph.D. candidate at the Amsterdam School for Cultural Analysis, University of Amsterdam. His dissertation focuses on transforming actor positions in the mutual shaping of sound technologies and cultural practices in popular music.

Trevor Pinch is a professor and the chair of the Department of Science and Technology Studies at Cornell University. His publications focus on the sociology of scientific knowledge, technology, and music. With Frank Trocco he is co-author of *Analog Days. The Inventions and Impact of the Moog Synthesizer* (Harvard University Press, 2002). With Nelly Oudshoorn he co-edited *How Users Matter: The Co-Construction of Users and Technologies* (MIT Press, 2003). His homepage address is www.soc.cornell.edu/faculty/pinch.shtml.

David Reinecke is an M.Sc. student Science and Technology Studies at Cornell University.

Jonathan Sterne teaches in the Department of Art History and Communication Studies and the History and Philosophy of Science Program at McGill University. He is author of *The Audible Past: Cultural Origins of Sound Reproduction* (Duke 2003) and has written numerous articles on media, technology and the politics of culture. His next book is tentatively entitled *MP3: The Meaning of a Format.* Visit his website at http://sterneworks.org.

Timothy D. Taylor is a professor in the Departments of Ethnomusicology and Musicology at the University of California, Los Angeles. He is the author of *Global Pop: World Music, World Markets* (Routledge 1997), *Strange Sounds: Music, Technology, and Culture* (Routledge 2001), and *Beyond Exoticism: Western Music and the World* (Duke University Press, 2007) and is currently writing a history of music used in advertising.

Heike Weber is a historian of technology and presently teaches at the Berlin Institute of Technology. In her Ph.D. thesis she examined the design and use of portable media equipment, from the portable radio of the 1950s to today's cell phone, and the ongoing negotiations of place, body, and identity that resulted from the mobile use of such electronics. It has been published as *Das Versprechen mobiler Freiheit. Zur Kultur- und Technikgeschichte von Kofferradio, Walkman und Handy* (Bielefeld, Transcript, 2008). See her website at http://www.lrz-muenchen.de/~Heike_Weber/.

Printed in Poland
by Amazon Fulfillment
Poland Sp. z o.o., Wrocław

25420811R00124